CREATIVE PHOTOSHOP
PORTRAIT TECHNIQUES

Duncan Evans &
Tim Shelbourne

ILEX

Creative Photoshop Portrait Techniques

First published in the United Kingdom in 2006,
and updated in 2009, by:
ILEX
The Old Candlemakers
West Street, Lewes
East Sussex
BN7 2NZ

ILEX is an imprint of The Ilex Press Ltd
Visit us on the web at:
www.ilex-press.com

Publisher: Alastair Campbell
Creative Director: Peter Bridgewater
Rights Director: Roly Allen
Managing Editor: Chris Gatcum
Senior Editor: Adam Juniper
Editor: Kylie Johnston
Art Director: Julie Weir
Designers: Chris & Jane Lanaway
Design Assistant: Emily Harbison
Development Art Director: Graham Davis
Technical Art Editor: Nicholas Rowland

British Library Cataloguing-in-Publication Data
A catalogue record for this book is available from
the British Library

ISBN 978-1-905814-50-3

Printed and bound in China

For more information on this title please visit:

www.web-linked.com/cpppuk

CONTENTS

INTRODUCTION

Portrait photography, whether professional or amateur, is one of the most popular of the photographic genres. The enduring appeal of portrait photography is the emphasis on connection—the rapport generated between first the photographer and the subject, and later, the connection between the subject and the viewer. The relationship has a resonance that simply isn't present in landscape photography, for example. With portraits, it is the suggestion of a narrative that is so compelling.

However, in addition to drawing out something elusive and meaningful about the subject, to shoot great portraits requires a skilled understanding of light and composition—and, of course, making sure your camera does exactly what you want it to. Sometimes—whether it's the equipment that's technically lacking, the concept that is wanting, or the connection with the subject that really isn't happening—your best-laid plans can produce mediocre results. When that happens, don't be disappointed—all is not lost. Instead, think about how you might improve your images with a little assistance from Photoshop. *Creative Photoshop Portrait Techniques* is at hand to guide you, step by step, through all the essential Photoshop techniques to help you recover, restore, rebuild, and reinvigorate your lackluster portraits to produce something that you can be proud of!

Featuring over 65 tutorials, you'll discover how to fix every problem and add something special to every image. You will learn how to correct and enhance colors, create impressive lighting effects (without the need for an expensive studio setup), produce high- and low-key images, introduce backgrounds, digitally enhance your subject's complexion, create interesting lens effects, convert your color images to monochrome, borrow from the styles of the most significant periods in photography, and emulate some of the world's most influential photographers to produce special effects with your images. By the time you've experimented with the tricks, tips, and techniques in this guide, you will be shooting like a professional.

The key to a good portrait shot is having sharp focus, a narrow depth of field to focus attention on the subject, and being able to enhance the image to look its absolute best.

A GUIDE TO HARDWARE

This book is primarily about the effects you can create with Photoshop once your pictures have been taken, but that doesn't negate the importance of knowing something about the essential pieces of equipment required to ensure you get the right shots in the beginning. In this first section, we take a look at the cameras, lenses, and lights you need to take the all-important source images.

The range of cameras available to you for taking portrait shots is limited to the digital compact, the prosumer compact, and the digital SLR. To achieve portraits with a good level of sharpness in the foreground and narrow depth of field, as below, a digital SLR is essential.

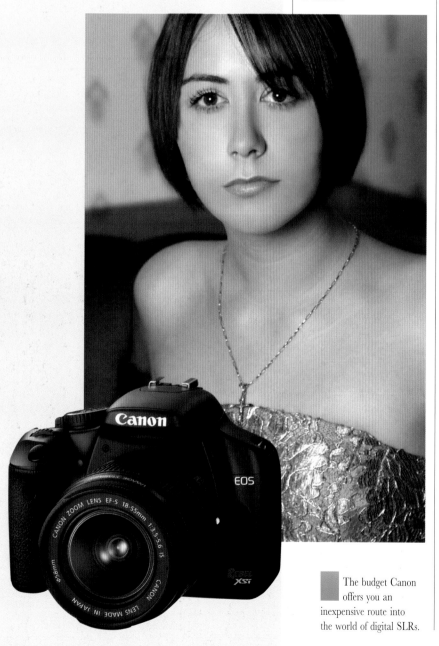

The budget Canon offers you an inexpensive route into the world of digital SLRs.

FILM OR DIGITAL?

Let's start by asking the question: Film or digital? While film—medium- or large-format, in particular—continues to be more appropriate for landscape photography, the advantages of digital for portrait photography are overwhelming. In 2004, digital sales completely overtook film sales across the board.

CAMERAS

The next question you need to ask is: What camera do I need? A basic compact, a prosumer compact, or a digital SLR? Well, it all depends on how much money you want to spend and how professional you want the results to be. For many, there's nothing wrong with a digital compact—you can get sound results with this level of camera. For a few dollars more, the keen amateur can invest in a feature-rich, prosumer compact. It looks like a mini-SLR, and offers greater control, resolution, and zoom range than the basic compact, but has a built-in rather than interchangeable lens.

The differences—technical ones, such as CCD noise and lens performance—aside, is that compact cameras have smaller, cheaper lenses than the prosumer compact models, and both use smaller CCDs than an SLR. This results in a much shorter focal length, which is great for macrophotography, but means that there is as much as five times the depth of field at the same aperture with a compact compared to an SLR, and no flexibility. (Depth of field is the zone of sharpness from front to back in the image.) For portraits, there is nothing worse than too much depth of field. Rather than being able to focus solely on the subject, the background appears to be just as sharp as the foreground and competes for attention. At worst, objects that looked far away at the time of shooting later appear to grow out of the subject's head, like a cheap magician's trick. Sure, there are times when good depth of field is desirable, such as shooting in an environment that offers useful contextual detail about the sitter or which has a story to tell in itself. For the most part though, a shallow depth of field is best—and with a compact, you simply don't get the option.

Another problem with digital compacts is that the lenses are standard and don't have a significant zoom range. Invariably, they are used close up at the wide-angle setting and this distorts the subject, exaggerating whatever is closest to the camera, whether that's a limb, nose, or head.

A good compromise is a prosumer digital compact. This offers a longer zoom range (typically 5x–10x), enabling you to stand further back and zoom in on the subject, minimizing distortion. In addition, the longer the focal length, the less depth of field, so it works well on two counts.

Of course, while good-quality compacts and prosumer models can take perfectly good pictures, for real quality you either need to spend more time in post-production, or upgrade to a digital SLR. If you choose the latter route, however, you also need to know what lenses to use with your SLR.

Using a long telephoto lens enables you to capture candid portraits. (300 mm, ƒ6.3, 1/600 sec)

The image, above, shows the distortion from using a wide-angle lens, close to the subject. (28 mm, ƒ2, 1/125 sec)

This photo uses the telephoto end of the zoom, and the photographer is standing back. There is no distortion using this method. (140 mm, ƒ2, 1/125 sec)

The distortion caused by using a wide-angle lens can be exploited for close-up, dynamic pictures. (28 mm, ƒ3.5, 1/1000 sec)

LENSES

The terrible temptation when first buying a digital SLR—and they are now more readily affordable—is to buy a superzoom lens to go with it. A 28–300mm lens may seem like the perfect lens, offering a wide-angle at one end and long reach at the other. Perfect—except that it isn't. A superzoom will not offer the same quality as a dedicated lens at any point on the zoom. That's just for starters—there is also the focal length multiplier to consider, although this applies to prime lenses as well as zooms.

The difference in quality between a combined and a dedicated lens occurs because the current generation of digital SLRs use a chip that is smaller than a piece of 35mm film. The sensor is placed in the camera body so that it only receives the middle portion of the light coming through the lens. There are technical reasons why camera companies make them like this, not the least of which is that CCDs require much straighter light beams to hit the surface to make an accurate picture than does film. At the edges of the lens, the light is much more wayward. Thus, it's the middle of the light beam that is used and this produces a jump in focal length of around 1.5x. The result is that a 28mm lens actually gives the field of view of a 42mm lens—not very wide at all, but accompanied by all the distortion of a wide-angle lens. The other main reason to avoid superzooms and go for either much shorter zooms or prime lenses, is one of aperture. The longer the superzoom, the narrower the aperture at both the wide-angle end and the telephoto end. With telephoto, it's difficult to avoid camera shake, but with wide-angle, it means that instead of a sound ƒ1.8, which

throws all the background out of focus, you get ƒ3.5 or ƒ4, which turns into f5.6 by the time you use the zoom to get to around 60mm.

So, what's the best lens to use for portraits? The standard 35mm-format lens for portraits is a 50mm, ƒ1.8, across the board. On a digital this means it gives you the field of view of a 75mm lens, but this is no bad thing as it tightens the crop. Any lens from 50mm to 80mm is fine for standard portraits, but won't be suitable for group shots. For the latter you need around 28mm, translating into 42mm field of view. Just remember that even a 28–70mm zoom will have a better aperture range than the 28–300mm superzoom.

A final option is to use a 100–200mm telephoto lens that allows you to shoot candid photos from a distance. When doing this, the value of a prime lens is less because it's harder to frame the exact image you want—it isn't viable for you to sprint backwards and forwards trying to get the composition right because it's a prime lens. Also, at telephoto focal lengths, there is considerably less depth of field, so the increased aperture only makes it harder to get a fast enough shutter speed, rather than a blurred background. Once again though, a 170–300mm zoom lens will give you faster apertures than a 28–300mm superzoom.

A good use of a long lens is to compress the perspective and narrow the field of view so that it isolates the subject. (300 mm, ƒ6.3, 1/400 sec)

A GUIDE TO HARDWARE

PRIME LENSES
A prime lens is one which is set at a particular focal length, unlike a zoom lens which can go through a range of lengths. The advantage of the prime lens is the superior quality—and also aperture. You get a wider aperture at the same focal length than with a zoom.

LIGHTS, CAMERA, ACTION
How well you light your subject makes the difference between achieving an ordinary, dull photograph and a great one. While lighting is a big enough subject to fit a book all on its own (and there are numerous examples), let's look at a few different types of lighting you can use to illuminate your photos.

AMBIENT
The simplest and most immediate form of lighting is natural or "ambient" light, and while you can't dictate the direction of it or its strength, you can change the exposure settings of your camera to exploit it. Natural light can be used to light subjects indoors from a window, and this produces a very attractive, soft, diffuse light, particularly on an overcast day. Less effective is direct, bright sunlight, which is uncomfortable for the subject, and also presents too wide and dynamic a range of tones for the camera to adequately cover. A way around this is to go deeper into shadow and to use a reflector to bounce light onto your subject. This will produce a soft, flattering effect. The main consideration when using natural light indoors is one of shutter speed—you will require a tripod to avoid camera shake.

TUNGSTEN
Tungsten is another, if not ideal, lighting source. Household lights and lamps are normally tungsten, but the light is weak and gives off an orange-red color cast. Film-users can attempt to counter this by using color-correction filters or by using tungsten-balanced film that is formulated to work at tungsten's lower light temperature. Digital-users can set the white balance on their cameras manually, but this does not often produce satisfying results.

Specialized tungsten lamps for photography are much better than household lamps and are cheaper than electronic flash (also known as strobe) units. They have a higher color temperature (around 3200K rather than 2500K), so require less correction. They also tend to be much brighter, which reduces problems with the amount of light required and camera shake. The constant light source also makes it much easier to model and place in the scene and it is easier to find the correct exposure as the camera's built in metering can read it. The disadvantages are that it can get hot and that the light is fairly harsh, and you can't use diffusing accessories on the lamp head itself because of the heat.

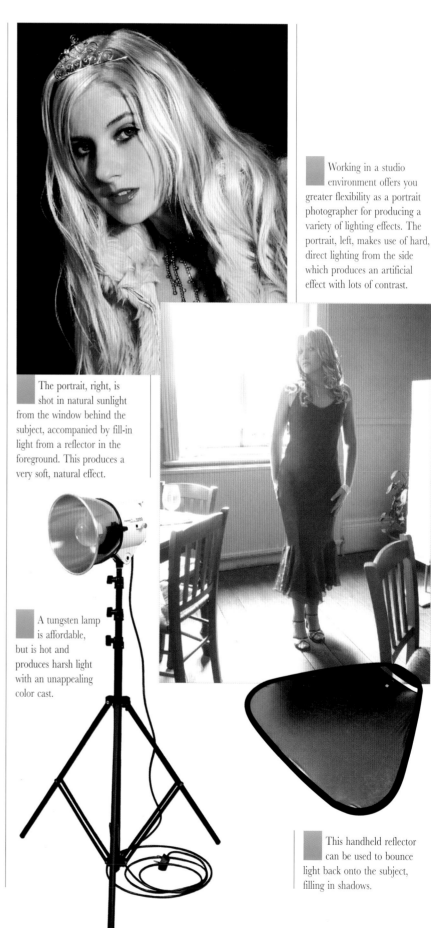

Working in a studio environment offers you greater flexibility as a portrait photographer for producing a variety of lighting effects. The portrait, left, makes use of hard, direct lighting from the side which produces an artificial effect with lots of contrast.

The portrait, right, is shot in natural sunlight from the window behind the subject, accompanied by fill-in light from a reflector in the foreground. This produces a very soft, natural effect.

A tungsten lamp is affordable, but is hot and produces harsh light with an unappealing color cast.

This handheld reflector can be used to bounce light back onto the subject, filling in shadows.

FAST LENSES

The expression "fast lens" doesn't refer to the ability to focus quickly, but rather pertains to the widest aperture it can use. The wider the aperture, the more light that comes in, and the faster the resulting shutter speed—hence: fast lens. When using a telephoto lens, it's important to have enough light to generate a fast shutter speed, otherwise camera shake will result.

ELECTRONIC FLASH

The ultimate in lighting is the electronic flash unit, which can either be an all-in-one unit, which is cheaper, or a large power pack that fires the flash head, which is more expensive. On its own, the flash head produces an instant burst of very bright, white light. It has numerous advantages. It doesn't get hot, diffusing accessories such as brolleys and softboxes can be used to get very even, diffuse light, and the color temperature of the light is the same as daylight. The disadvantages are, first, that it is slightly more expensive than professional tungsten, though there are budget units available. Secondly, because the light is a burst, you need to meter it with a separate handheld meter and connect the camera to the flash unit. The handheld meter activates the flash and provides you with the settings to put into the camera. Typically, you will set the shutter speed at a speed that the camera can synchronize with the lights—this is usually 1/125 sec. The power output of the flash then determines what aperture needs to be used. If you want less depth of field, then lower the output of the flash and open up the aperture accordingly.

Without softbox

With softbox

The advantage of using a softbox fitted to the front of the flash unit is that it softens the light. The first picture was taken without the softbox, producing harsh shadows. The second picture used the same settings but with a softbox. The light is much softer, and there is less shadow.

COLOR TEMPERATURE

All light has a color temperature that is measured in degrees Kelvin. Daylight at noon is typically rated at 5500K, and this is what film and digital cameras rate as normal to render white as white, rather than with a color cast. Tungsten and candlelight have much lower color temperatures and so produce color casts of red and orange if not corrected. Very bright skies and snow have a high color temperature and will produce a blue color cast if not corrected. Digital cameras have what is known as "white balance," which assesses the scene and automatically tries to compensate for the color temperature of the light. You can also adjust the settings manually.

If you are shooting on location, the weather plays a large part in how the color temperature of your light is recorded—and how you respond to it. Deep-blue skies, such as the one below, have a high color temperature. Use the white balance facility to correct the relative blue color cast in the image.

LIGHTING STYLES AND TECHNIQUES

The more you know about lighting and the way it can be manipulated, the more you can do with your portrait photography by enhancing it later in Photoshop. The greatest range of effects can be achieved in the studio using electronic flash, rather than any with any other means. However, that's not to say you can't get great pictures with other light sources, just that they aren't as flexible.

The typical positioning of a single flash head is to one side and above the subject. This creates shadow detail and highlights on the face. The light from the softbox connected to the flash is soft and flattering.

USING NATURAL LIGHT

If you start with natural light there are two main ways to use it. The first is to set up near to a large window and diffuse the light through very light, filmy fabric, such as muslin. This will cast soft light and shadow over the face, particularly if it is overcast. Position the sitter with his or her face turned half into it, so that part of the face is lit and the other half is in shadow. If the sun is beaming in, however, make use of the extra brightness on the background. Use a reflector to bounce light back at your subject, while keeping them out of the direct glare of the light, as this will make the subject squint, and create harsh shadows and impossible exposure ranges.

USING TUNGSTEN

Tungsten is a little like a portable sun. It has many of the same elements. It creates hard shadows and will show up all surface skin textures and flaws. Use a reflector to bounce light back into the opposite side of the face from the lamp, thus reducing the contrast range. Don't simply point the lamp straight on at the subject—you want some variation in your lighting. A tungsten lamp is what the studios used for classic Hollywood star portrait photography in the 1930s and 1940s.

USING FLASH

Electronic studio flash offers the best combination of lighting types and styles. You can use it without a diffuser for hard, deep shadows, or attach a brolly or softbox to soften and diffuse the light, making it more even and flattering. There are pros and cons to both methods, and which is best for your portrait depends on a number of factors. For example, the portrait setups in shopping malls make use of a brolly, simply because it takes up less space than a softbox. It isn't as easy to control reflected light from a brolly, as the spread is wider than from a softbox, but if you want to illuminate a large area and drop people into it, this is the best option to choose. Ultimately, using a softbox does give the most flattering results, and, depending on where you place the flash, still provides shadow detail. The standard positioning for one flash head is to put it 45 degrees to the right of the camera and above the sitter's head, pointing downward. For even light, place a second softbox in the same position, on the left.

When you want to get clever, you can add extra lights to the setup and use them at different power levels. The main light is then referred to as the key light, and secondary ones at lower power are fill lights. There are lots of extras you can use to aid your lighting. Barn doors can be attached to limit the spread of light, snoots channel the light into a spot, and grids cast shadow patterns over the scene. There is a whole world of lighting that you can use to enhance your photography (or emulate in Photoshop).

Here, bright daylight pours through a window into a restaurant, adding background highlights. A reflector bounces light back onto the subject to ensure she is brightly lit.

LIGHTING STYLES AND TECHNIQUES

This image demonstrates a more radical use of a single flash head. It is positioned entirely to one side of the subject so that the other side is thrown dramatically into shadow.

Positioning a tungsten lamp or bare flash above the subject enables you to create portraits in the classic Hollywood style of the 1930s and '40s. Here, the light directly above the subject is called butterfly lighting because of the shadow effect under the nose.

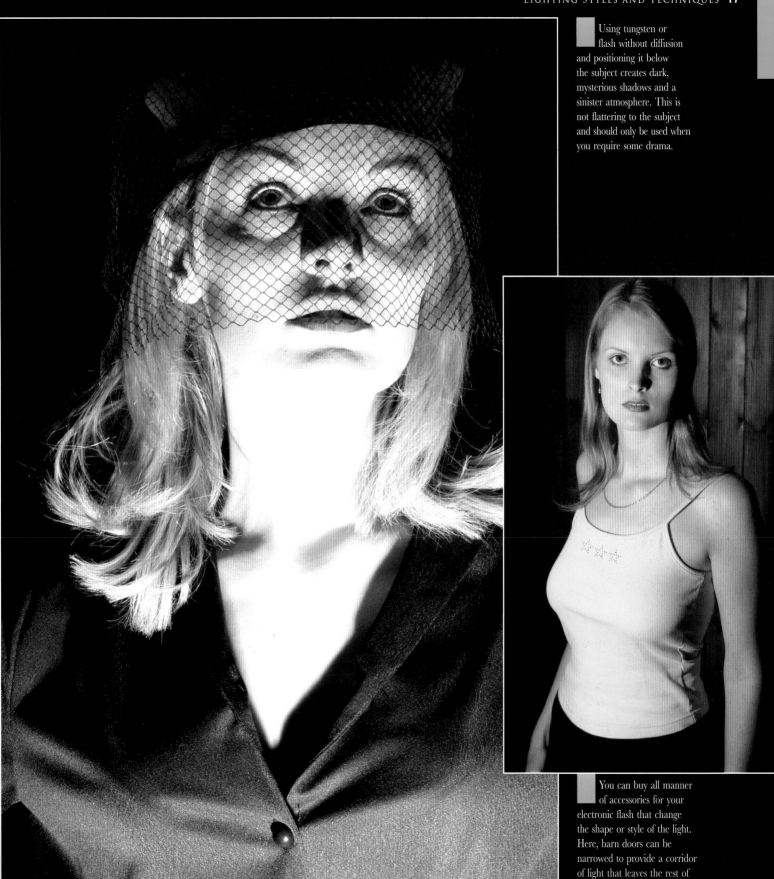

Using tungsten or flash without diffusion and positioning it below the subject creates dark, mysterious shadows and a sinister atmosphere. This is not flattering to the subject and should only be used when you require some drama.

You can buy all manner of accessories for your electronic flash that change the shape or style of the light. Here, barn doors can be narrowed to provide a corridor of light that leaves the rest of the photo in shadow.

COLOR CORRECTION AND ENHANCEMENT

EXTREME SHADOWS AND HIGHLIGHTS

No matter how good digital cameras become, they will never be able to make decisions based on exactly what you want from a portrait shot; that's a decision that will always remain squarely in your lap as the photographer. Here's an object lesson in getting the most out of a digital photograph, and using Photoshop to exaggerate what is important about not only the image, but also about the subject itself. This particular image is all about character, and that's exactly what we want to capitalize on with this technique, taking the extremes of light and dark to the extent where we make the absolute most of the signs of age and wisdom within this face. We'll start by taking advantage of the powerful Shadow/Highlight command within CS4 to adjust the tonal palette of the image, and then resort to some old fashioned manual adjustment to make the very best of this face. If you'd relied on the initial image output from the camera here it may not have captured the essence of the character, but follow this walkthrough, and you'll soon discover what's hidden in the tonal murk!

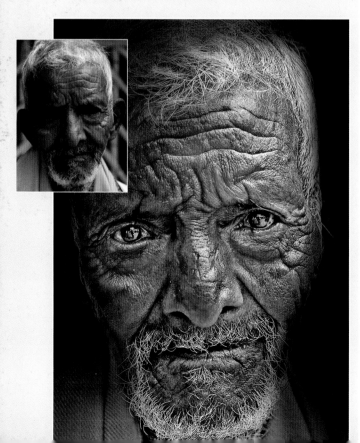

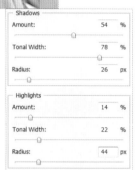

1 Open the start image. On the Background Layer go to **Layer > Smart Object > Convert To Smart Object.** You'll see the layer thumbnail change in the Layers palette to indicate the layer's new Smart Object status. Now go to **Image > Adjustments > Shadows and Highlights.** Check Show More Options and set the sliders as shown in the screenshot. Click OK to apply the changes.

2 Create a new Levels adjustment layer. Adjust the sliders below the histogram in the adjustment panel as per the screenshot. We want to stamp a copy of the visible layers so, on the keyboard, hold down the Ctrl/⌘, Alt/⌥ and Shift keys, and with these keys held down hit the E key. Go to **Image > Adjustments > Desaturate** then press Ctrl/⌘+I to invert. Set the Blending Mode for this layer to Overlay.

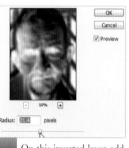

3 On this inverted layer add a Gaussian blur via **Filter > Blur > Gaussian Blur.** Use a Blur Radius of between 20-22 pixels and click OK.

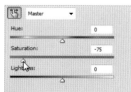

4 Click on the Levels adjustment layer below and, in the Adjustments panel, hit the Hue/Saturation button (this creates a new Hue/Saturation adjustment layer). Drag the Saturation slider to the left, to a value of -75.

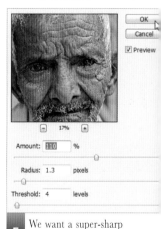

5 We want a super-sharp effect in this image. Click again on the Smart Object layer and go to **Filter > Sharpen > Unsharp Mask.** Use the settings shown in the screenshot and click OK. Remember, because this is applied to a smart object layer, you can always adjust this setting by clicking its entry in the Layers palette.

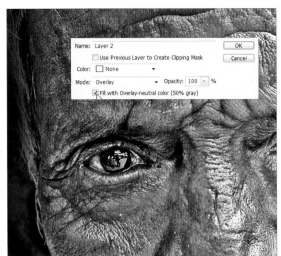

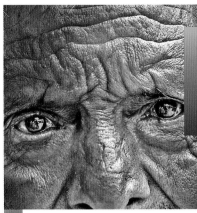

6 Click on the top layer in the stack and go to **Layer > New Fill Layer > Solid Color**. From the Color Picker, choose a very dark, rich brown. Click OK. Now click on the layer mask attached to this layer, go to the Masks panel, and click Invert.

8 We'll use a special layer here for dodging and burning the tones in the face. Go to **Layer > New > Layer**. In the New Layer dialog, set the Mode to Overlay and check the Overlay Neutral Color Fill box. Click OK to apply the layer. Choose the Brush Tool with a small soft brush and set the brush Opacity to 10%. Start painting with black over the skin creases and dark details in the image to darken them even more.

10 Now change your Foreground color to white. Use the brush over the tiny highlights in the face to lighten them. Again, take your time with this, taking care to gradually make selected highlights very bright, such as the catchlights in the eyes.

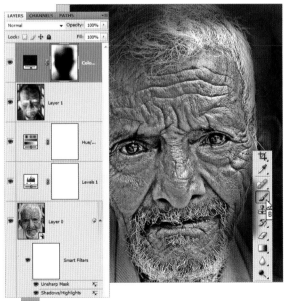

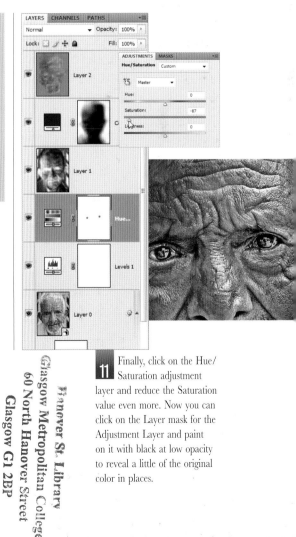

7 Choose the Brush Tool and select a large soft brush from the Brush Picker. Reduce the Opacity of the brush to 35% in the Options bar. Ensure that your Foreground color is White. Now click on the mask attached to the solid fill layer and paint around the head to paint out the unwanted background. Also paint over the distant parts of the head and shoulder to create effective shadow areas.

9 Take your time to carefully target tiny skin texture with the brush. Use the brush at a bigger size to generally darken larger areas of shadows an midtones over the head. Here you can see the 50% gray layer in isolation, showing the black brushwork painted on to it.

11 Finally, click on the Hue/Saturation adjustment layer and reduce the Saturation value even more. Now you can click on the Layer mask for the Adjustment Layer and paint on it with black at low opacity to reveal a little of the original color in places.

CREATING HDR PORTRAITS

It's virtually impossible for even the best digital cameras to capture as much highlight and shadow detail as the human eye can register, but there is a way that we can produce portraits which render far more shades between light and dark than you'd normally be able to achieve—HDR (High Dynamic Range). Photoshop can merge a number of different exposures to achieve a much broader tonal range. These different exposures are merged into a special 32-bit file then manipulated via a "Tone Map" while being converted to a traditional 8-bit image. To take the series of images you'll need a digital camera with an auto bracketing mode, so that you can shoot one frame correctly exposed and two shots either side of the proper meter reading one stop apart. It's important you use a tripod when you're shooting and that there is plenty of light so you can use a fast shutter speed to avoid any movement between shots. Here we'll show you how to merge these three exposures together.

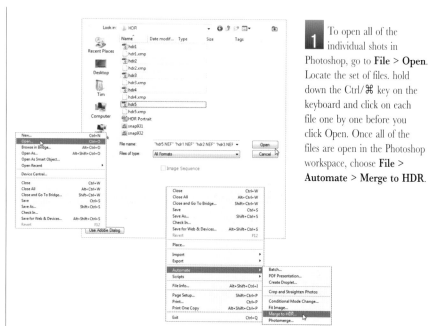

1 To open all of the individual shots in Photoshop, go to **File > Open**. Locate the set of files. hold down the Ctrl/⌘ key on the keyboard and click on each file one by one before you click Open. Once all of the files are open in the Photoshop workspace, choose **File > Automate > Merge to HDR**.

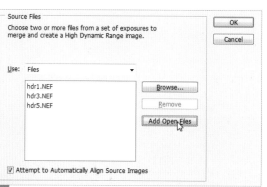
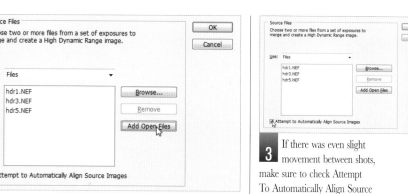

2 In the Merge to HDR dialog, choose the Add Open Files button. This informs Photoshop to merge the files that are currently open in Photoshop. Without the files open in Photoshop, you would click browse to locate the files in a folder. After clicking Add Open Files, the filenames will be added to the Source Files list in the dialog.

3 If there was even slight movement between shots, make sure to check Attempt To Automatically Align Source Images. This will instruct Photoshop to align each of the images based on each layers contents. It's generally worth doing this to avoid any ghosting in the final HDR image. Now hit OK to start merging the separate images.

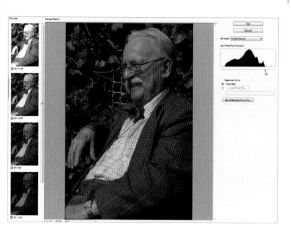

4 You're now presented with the 32-bit image preview. Each of the component images are shown on the left, and you can use the check marks to see what they contribute to the tonal range of the final image. You can also use the slider beneath the histogram to preview the entire tonal range of the image. The setting of this slider is a preview only, and will have no effect on the merged file.

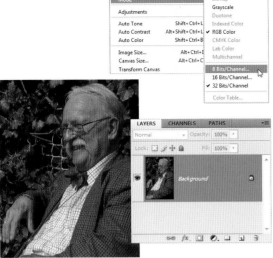

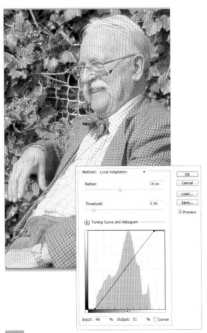

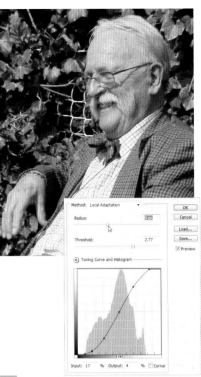

5 Choose 32 Bit/Channel from the Bit Depth option and click OK. Your merged 32-bit file will now be created. To enable this image to be printed, and worked on normally in Photoshop, it needs to be converted to 16 or 8 bits per channel, during which process we'll be able to map the tones in the image, so now go to **Image > Mode > 8Bits/Channel** to begin the conversion process.

8 If you move your pointer outside the HDR Conversion dialog, and over your image, you will see it changes to an eyedropper tool. With this tool, you can click on a tone in the image and its position on the curve will be indicated by a small circle as you hold down the mouse button. By remembering where this point is, you can click on the curve at this position and adjust that particular tone.

10 The Threshold slider determines local contrast, so you need to adjust this to taste. The Radius slider determines the edge width that is considered for this contrast adjustment, and if you use to high a value you'll produce unwanted and unsightly halos around contrasting edge, so keep this value fairly low. When you're happy with the tone mapping, hit OK and Photoshop will convert the image to a standard 8-bit file.

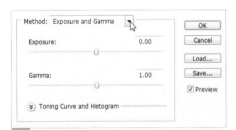

6 The best conversion method is Local Adaptation, so choose that now from the Method: option. Hit the small down pointing arrows to display the Toning Curve And Histogram. At this stage, the image will have a strange appearance, but we'll correct that in the next step.

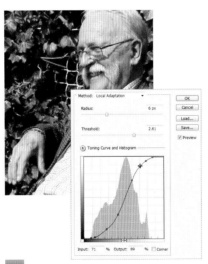

7 Start by grabbing the white point at the bottom right of the curve and dragging it across to the very start of the histogram. Now do the same with the white point at the top right corner of the Curve dialog.

9 On the curve, you can darken a tone by clicking a point in the correct position on the curve and dragging it down to darken or upwards to lighten. You can create some quite complex curves here to map the tones in the image, as we're dealing with a huge 32 bits of brightness data. This tone mapping is the crucial part of creating the HDR image, so it's worth taking your time to make very fine adjustments to the curve.

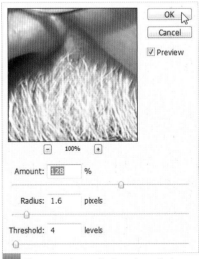

11 You can make any final tweaks to the image in the usual way—including Unsharp Mask and Color Balance—since following the conversion it is a standard image file. Now save your picture as a JPEG or TIF image file via **File > Save As**.

COLORED FILTERS

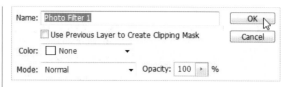

In traditional film photography, color filters played a pivotal role in the art of adding subtle color effects to an image or compensating for unwanted color casts as a result of artificial light. Back in those days, these filters needed to be physically attached to the camera lens prior to shooting. With today's digital photography this is no longer the case as Photoshop enables us to add the effect of colored filters on the computer.

The role of the Photo Filter command is to mimic the effect not only of traditional filters, but to apply custom filters of any color you choose. This filter is available in CS+ versions of Photoshop, but here we'll also look at ways of creating the same filter effects in earlier versions.

1 Although Photo Filters are available as a standalone command, it's often best to use them via an adjustment layer, as this give you a greater flexibility should you wish to change the particular color of the filter at a later stage. Open the image and go to **Layer > New Adjustment Layer > Photo Filter**. You can rename the adjustment layer in the first dialog if you wish. If not, just click OK.

2 There are two filters in the subsequent list that are great for correcting white balance anomalies in digital photographs or scans: the Warming Filter (LBA) and the Cooling Filter (LBB). Here, we'll select the Warming Filter. As you'll see, this not only warms up the skin tones in the image, but also imparts a warm bias to the whole image.

3 With all of the Photo Filters, the intensity of the color tint is controlled via the Density slider. If your aim is just to correct color balance, the default density will be ideal, although it can be increased if desired. Make sure that Preview is checked so that you can judge the result on the actual image. To apply the filter, click OK.

4 Double-click the adjustment layer in the Layers palette, and this time choose the Cooling Filter (LBB) from the filter list. As one might expect, you'll see that this has the opposite effect to the Warming Filter, increasing the cool blue bias of the image. This filter can be very useful for reversing the effects of shooting under tungsten lights.

5 There are many more filter color choices in the list of filters. Here, I've chosen Sepia. So far we used the filter with the Preserve Luminosity box checked, which maintains the original image brightness levels through the filter, but for a more pronounced, darkening effect, uncheck this option.

6 As well as choosing the preset filters from the list, by clicking the Color radio button, you can choose your own custom filter color. After checking the Color button, simply click in the swatch and choose your color from the Color Picker.

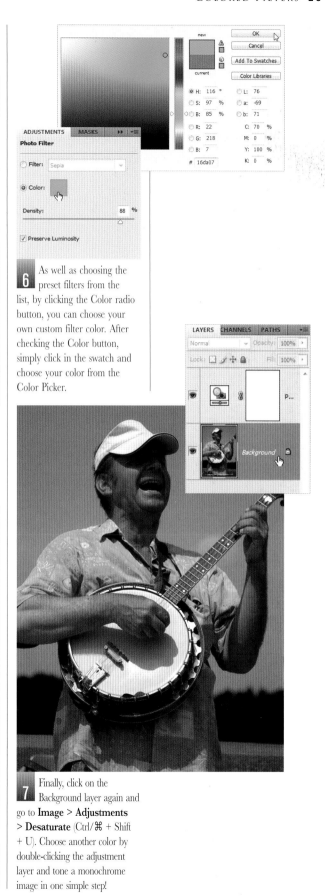

7 Finally, click on the Background layer again and go to **Image > Adjustments > Desaturate** (Ctrl/⌘ + Shift + U). Choose another color by double-clicking the adjustment layer and tone a monochrome image in one simple step!

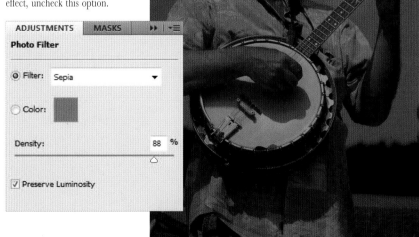

CHEMICAL DISTORTION

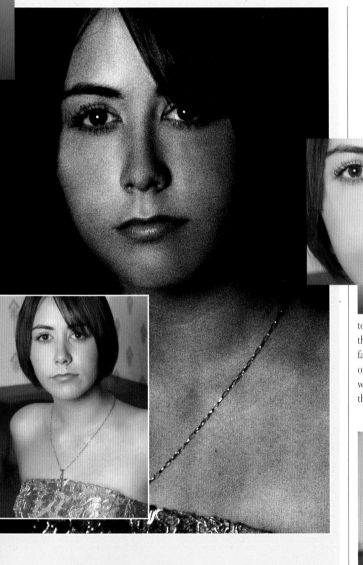

In the 1960s and 1970s, fashion photographer David Bailey experimented with a printing technique which involved distressing an image while toning it in a specific color. This was executed at the printing stage in a chemical bath. Fortunately, with digital photography we can experiment in just the same way to create striking pictures, but without the dangerous chemical fumes.

To use this technique, select a portrait that features a close-up of the subject—at least the top half. In this instance, the top of the head has been cropped in the shot, which is a signature style of Bailey portraits from this period, although the rest of the picture is not.

1 Use the Clone Stamp tool at 20–30% Opacity to make basic enhancements to the portrait, such as removing facial blemishes, reducing lines, or covering blocked pores, as it will be impossible to do so at the end.

2 Check the background. Ideally you want one that is completely blank as the treatment is going to add a pattern and you want to avoid too much competition. This image isn't ideal in that respect as the subject is in front of some wallpaper. However, the image was shot with a wide aperture so the wallpaper is out of focus already. To further diffuse a problem background, make a rough selection with the Lasso tool then go to **Select > Feather** and apply a heavy feathering, about 15 pixels. Finally choose **Filter > Blur > Gaussian Blur** and set the Radius at 15. Remember to repeat this for the wallpaper on the other side of the subject's head.

3 Select **Image > Adjustments > Channel Mixer**, and check the Monochrome box to convert the image to black and white. Experiment with the RGB settings to produce a result with a decent amount of contrast. If the image needs more of a boost, go to **Image > Adjustment > Curves**. In the resulting dialog the cursor will switch to a cross. Click on the diagonal line with the cross and drag the line to create an S-shape curve to add more definition.

4 Go to the Layers palette and create a new blank layer by clicking the Create A New Layer icon at the bottom of the palette. Fill the new layer with a color you want to tint the image. I've used a pastel blue. Select a large paintbrush (around 250 pixels) and using a slightly darker version of the same color—this is easy to get wrong if it's too dark—make some vertical lines with large gaps between. Reduce the brush size (you can do this easily using the [key) and make some thinner lines in the gaps in between.

6 If the striations of the effect are too strong, reduce the opacity of the layer further. If they are too weak, select the Tint layer again and use the Burn tool set at 12% strength to make them stronger. Change the blend mode to Normal to check the layer more closely when using the Burn tool. Change it back to Color Burn when completed.

8 At this stage, black out the wallpaper entirely. With the background image selected, make a rough selection of the wallpaper, feather the selection by 15 pixels, and go to **Image > Adjustments > Levels**. Drag the bottom-center slider to the right until the wallpaper is indistinguishable from the girl's hair. Repeat this process to the other section of wallpaper. Finally, select **Layer > Flatten Image**, complete any Curves adjustments required to make the picture stand out, and save.

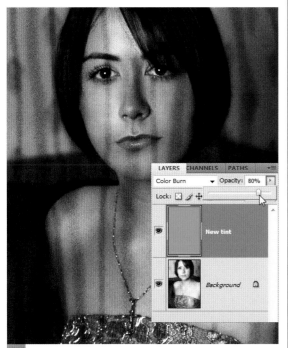

5 Add noise to the Tint layer by going to **Filter > Add Noise > Noise**. Set it at 15% strength. Set the blend mode of the Tint layer to Color Burn and reduce to 80% Opacity. You can also try other modes—Overlay, for example—which produces a lighter effect.

7 With the Tint layer selected, click on the Add Layer Mask icon at the bottom of the Layers palette and select the Brush tool from the Toolbar. Select black as the Foreground color and set Opacity at 10%. Dab at the mask to block the effect and to create lighter patches. The idea is to get variation in vertical running patches, not the wholesale removal of the effect.

EXTREME COLOR AND CONTRAST

1 The overall effect of the image works better if the starting image is a little soft, otherwise the skin tones become too blotchy. Create a duplicate layer by dragging the background thumbnail onto the Create A New Layer icon at the bottom of the Layers palette (Ctrl/⌘ + J). Select **Filter > Blur > Gaussian Blur** and set at 4-pixel strength. Hit OK.

2 Click on the Add Layer Mask icon in the Layers palette to add a mask to the blurred layer. Select a medium-sized brush from the Toolbar, set the Foreground color to black, and set the Opacity to 50%. Next carefully paint over the clothing areas in the image. If you turn off the background layer by clicking on the eye icon as you paint the clothes will disappear leaving a transparent background underneath. Click the eye icon again to reveal the Background layer.

To really give your portraits maximum impact you can use this technique to rack up the contrast and color for a striking result. It's important that you have a suitable photo for this in the first place—think sexy, sassy, and lots of attitude. It also works best if the background is a single color, so shooting the subject against a plain backdrop makes for an easy setup. Unfortunately, this kind of imagery doesn't translate well to CMYK, which is what commercial printing uses—this book is an example—so the images you see here are not as bright as those you can achieve yourself from editing in RGB mode.

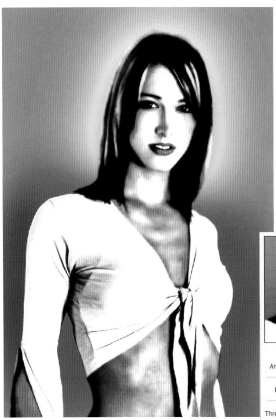

3 Next, you're going to address the skin tones. Select **Layer > Flatten Image** then go to **Filter > Sharpen > Unsharp Mask**. Increase the Amount and Radius to maximum values and the Threshold to zero. Preview areas that might look as though they are burning out and, if necessary, reduce the Amount and Radius.

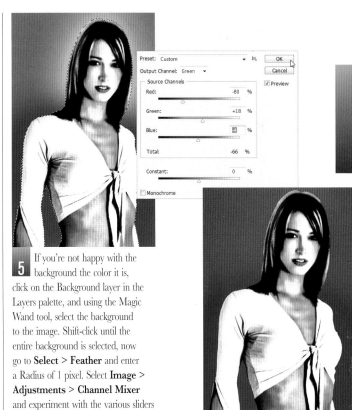

5 If you're not happy with the background the color it is, click on the Background layer in the Layers palette, and using the Magic Wand tool, select the background to the image. Shift-click until the entire background is selected, now go to **Select > Feather** and enter a Radius of 1 pixel. Select **Image > Adjustments > Channel Mixer** and experiment with the various sliders and color selections until you're happy.

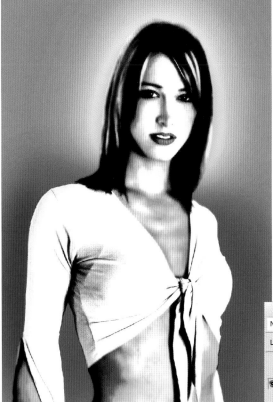

4 This might be as much work as required, it really depends on the image. If you find the skin tones are too red and blotchy in areas, select **Layer > New Adjustment Layer > Hue/Saturation** to create a Hue/Saturation adjustment layer. Select red and slide the Hue slider to the right until you're happy with the result. If some areas have been affected that you were happy with before, click the mask thumbnail, select a medium-sized brush, and with the Foreground color set to white, paint over any areas you want to revert to the original color.

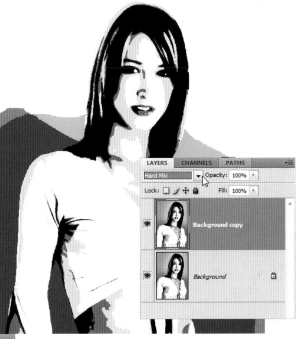

6 One alternative at the end of step 3 is to duplicate the layer and change the blend mode of the duplicated layer to Hard Mix. This produces a very vivid, reduced-color, graphic image. Note that the image on the page is less bright than it will appear on your screen, as the printed image is CMYK while your screen is displaying RGB.

CROSS PROCESSING

Back in the days of wet-process photography, there were very specific chemical processes for developing each type of film stock. True creativity is as much about breaking rules as adhering to them, and as a result, cross processing broke all of the rules by deliberately developing slide film with the chemicals developed for its print film sibling. These images have a unique appearance, which is difficult to achieve by any other method, and while it can be a bit of a hit-and-miss affair, when cross processing works, it works very well indeed. The specifics of the effect are over-saturated colors and a marked overall color shift, blown highlights, rich blacks, and increased contrast. In Photoshop we have much more control over the effect as we can fiddle with individual color channels and tweak layers. In terms of digital imaging, breaking rules can be a force for good!

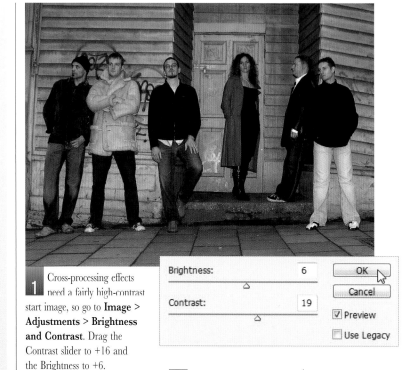

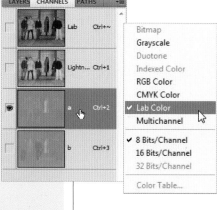

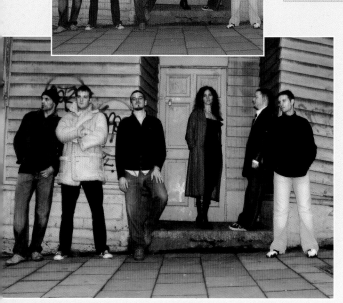

1 Cross-processing effects need a fairly high-contrast start image, so go to **Image > Adjustments > Brightness and Contrast**. Drag the Contrast slider to +16 and the Brightness to +6.

2 To make the major color adjustments on a duplicate file, go to **Image > Duplicate**. The color mode of this image is RGB, but we need to access the channels in Lab mode, so go to **Image > Mode > Lab Color**. Click on the tab for the Channels palette, or go to **Window > Channels** to display it. Now click on the A channel. Blur this channel to soften its effect via **Filter > Blur > Gaussian Blur**. Use a Blur Radius of 5 pixels.

3 Adjust the Levels in this channel via **Image > Adjustments > Levels.** In the left-hand Input Level box enter 77. Leave the central and right-hand boxes at their default values.

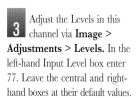

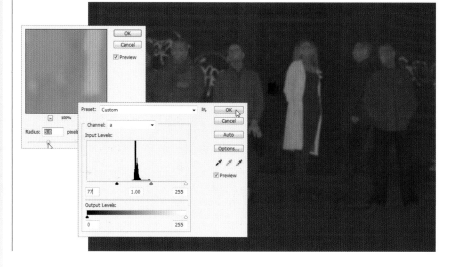

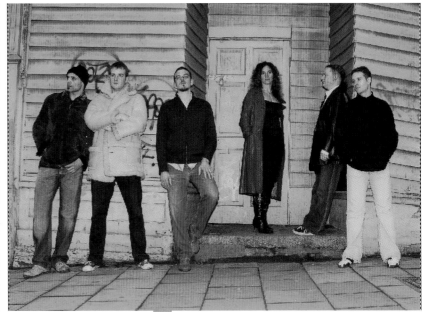

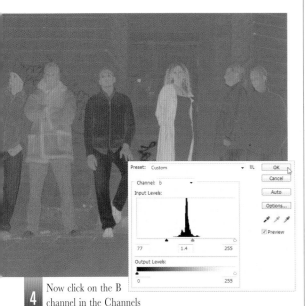

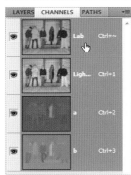

4 Now click on the B channel in the Channels palette. Return to **Image > Adjustments > Levels** and enter the following values in the Input Levels boxes from left to right 77, 1.4, and 255.

5 Click on the Lab channel at the top of the palette. Now copy and paste this channel into the original image, so go to **Select > All**, followed by **Edit > Copy**. Close this duplicate copy file without saving and return to the original image.

6 Return to the Layers palette and go to **Edit > Paste**. This will paste the channel you just copied onto a layer above the Background layer. Now set the blending mode for this layer to Overlay. You can reduce the intensity of the cross-processing effect by modifying the opacity of this pasted layer.

7 You can add a little more effect and interest to the cross-processing appearance by adding a slightly blurred layer to the image. Click on the Background layer and duplicate it (Ctrl/⌘ + J). On this duplicated layer go to **Filter > Blur > Gaussian Blur.** Reduce the opacity of this blurred layer to taste—the lower the opacity, the less obvious this extra glow will become. Set the Opacity to 74%.

HAND COLORING

In days gone by—photographically speaking—if you wanted a photograph with color, the photographer would need to color by hand a black-and-white print with special colored dyes—a very demanding and time-consuming process. Fortunately, with the power of Photoshop at our disposal, we can recreate the same kind of effect much more easily. Starting with a desaturated image, we'll use powerful Gradient Map layers to apply subtle colors. Gradient Map layers come complete with layer masks attached. By filling these masks with black, and painting onto them with white, we can restrict these colors to particular areas of the image. The object of the exercise is not to create a clone of a modern full-color digital image, rather to recreate some of the charm of old-fashioned, hand-colored photographs.

1 Although you could manually hand-color the whole image, there is a more effective and successful technique. Start with a monochrome image, but ensure that the color mode is RGB so that you have color information to work with. To check this, go to **Image > Mode** and make sure there's a check against RGB.

2 First, color the clothes blue. Click the Foreground color swatch and choose a light blue from the Picker. Now click the Background swatch and choose a darker blue shade. You'll use these two blues to color the garments. Go to **Layer > New Adjustment Layer > Gradient Map**. Photoshop automatically makes the gradient for the map from the Foreground and Background colors. If the image looks like a negative, hit the Reverse check box.

3 Set the blending mode for this Gradient Map layer to Overlay in the Layers palette. Although the image is now colored, we only want the blue color showing over the woman's clothes. Fortunately, Photoshop supplies the Gradient Map layer complete with a layer mask of its own, which we'll use to isolate the color. First, go to **Edit > Fill** and choose Black for Contents. By filling the mask with black, the whole layer is hidden.

4 Next, paint into the mask to reveal the color exactly where you want it. Choose the Brush tool from the Toolbar, and select a hard-edged brush from the Brush Picker; set the diameter to about 19 pixels. Make the Foreground color white, and begin to paint over the clothes. Zoom into the image and use a small brush around intricate areas, making sure to keep to the edges.

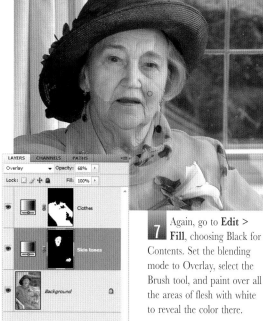

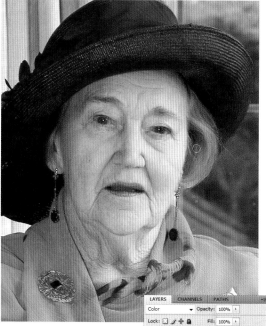

7 Again, go to **Edit >
Fill**, choosing Black for
Contents. Set the blending
mode to Overlay, select the
Brush tool, and paint over all
the areas of flesh with white
to reveal the color there.

5 If you overlap an edge,
or paint color where
you don't want it, paint black
over this area to hide the color
before returning to painting
with white and trying again.
You can adjust the intensity
of the color tint by adjusting
the opacity for this layer.

6 Return to the Background
layer and click on the
Foreground color swatch.
Choose a midtoned flesh color.
You can get a good color for
this by typing 9c6c5d in the #
(hexidecimal) color value box.

Click the Background swatch
and choose a light flesh tone
(f5c0ae is a suitable color). Go
to **Layer > New Adjustment
Layer > Gradient Map**. This
layer will serve as the skin tones.

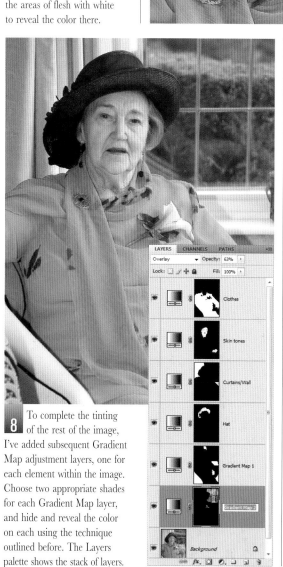

8 To complete the tinting
of the rest of the image,
I've added subsequent Gradient
Map adjustment layers, one for
each element within the image.
Choose two appropriate shades
for each Gradient Map layer,
and hide and reveal the color
on each using the technique
outlined before. The Layers
palette shows the stack of layers.

9 To color the remaining
few small details of
color—for example, the mouth,
eyes, and hair—add a final new
layer, setting the blending mode
for this layer to Color. Choose
the appropriate colors from the
Foreground color swatch and
use a soft brush at low opacity
to apply subtle color to these
areas. Also, use the brush at a
bigger size and very low opacity
to add some delicate touches of
color to the flesh.

SPLIT TONING IN ADOBE CAMERA RAW

Thanks to Photoshop CS4 and Camera Raw, traditional split toning is no longer the preserve of the chemically inclined. It's still a unique and attractive effect, but one we can simulate digitally.

In split toning, we start with a black and white image and apply one particular tint of color to the Shadows, and a tint of another color to the highlights. This effect can be particularly attractive when it comes to portraits, adding an extra touch of warmth, color, and atmosphere.

Although we're starting with a Raw image, you could also open a TIFF or even JPEG image in Adobe Camera Raw and achieve the same effect. In contrast to trying to recreate this effect in Photoshop alone, using the tools in Camera Raw makes this technique much easier and gives you a greater degree of control over the distribution of the color tints.

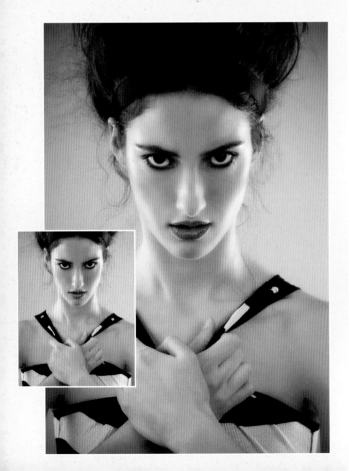

1 Go to **File > Browse In Bridge**. In Adobe Bridge, navigate to the folder containing your file and locate it. This image was converted to monochrome via the **Image** > Adjustments > Black & White command. Right-click the file and choose Open In Camera Raw from the menu on screen.

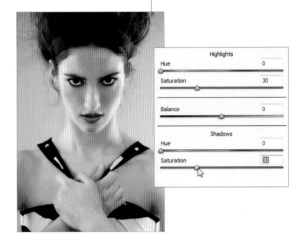

2 Below the Histogram, locate the Split Toning tab and click on it. This section is split into two distinct areas, one governing the Highlights in the image and the other governing the Shadows. Start by setting the Saturation for both of these to around 30%.

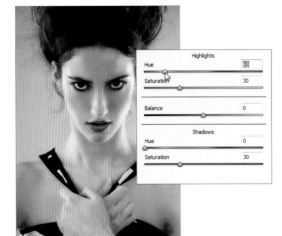

3 At the moment, the color tint for the Highlights and Shadows is the same for both of them. To choose a new color for the Highlight tint, simply grab the Hue slider and drag it. You'll see that the current color is the one directly behind the slider point itself.

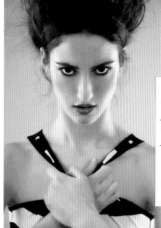

4 Now choose a color for the Shadows tint. Again, move the slider to whichever color you prefer. You need to use a darker color for the shadows and a brighter color for the Highlights. Here we have chosen a bright yellow for the lights and a deep blue for the darks.

8 Split toned images often benefit from the addition of a small vignette effect. To achieve this, choose the Lens Correction tab. Drag the Amount slider to the right to darken the vignette, and adjust its spread with the Midpoint slider. When you're done, click on the Open Image button.

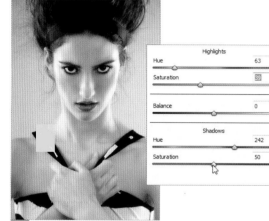

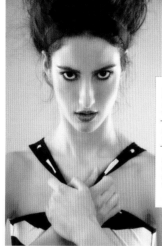

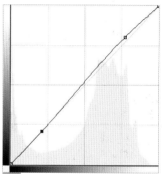

5 Now you can adjust the saturation for each of the tints. The further to the right you drag the Saturation slider, the more saturated and vibrant the colored tint will be. It's generally best to saturate the shadow tint a little more than the highlights.

6 The balance slider is useful for adjusting the predominance of either tint. Dragging the slider to the right will make the highlight color proportionally more visible than the shadows color. Dragging the slider to the left will have the opposite effect.

9 Back in the Photoshop workspace, you'll often find that the finished image benefits from a slight contrast curve being applied to it. Do this via **Image > Adjustments > Curves**. Replicate the shallow "S" curve shown in the screenshot.

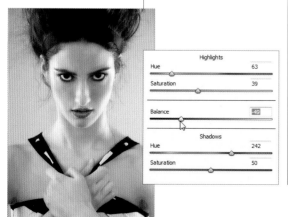

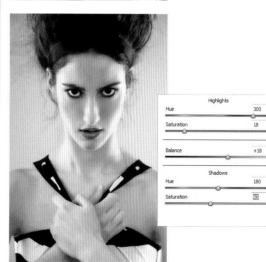

7 As you'll see from these three examples, there's really no limit to the color combinations possible using this method of split toning.

ISOLATING COLOR FOR EXTRA EFFECT

Color is always a powerful force in images, and when it is kept to a minimum and restricted to a single area in an otherwise monochrome image, that power is multiplied. By isolating areas of color we can control the viewer's gaze, directing the eye into and around the image.

A popular effect, and one which can transform seemingly uninspiring shots, this technique is easier to achieve within Photoshop than you might at first imagine. The key here is layer masking, a technique that involves constructing two separate layers, one in color, the other desaturated, then, via a layer mask, hiding certain areas of the Monochrome layer to allow the underlying color to show through. This technique is particularly suited to images of children in brightly colored clothing, and is guaranteed to produce very striking results.

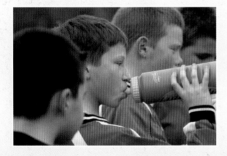

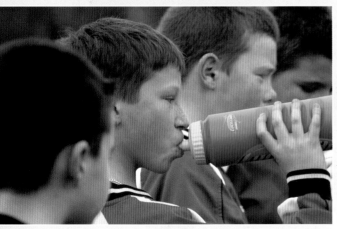

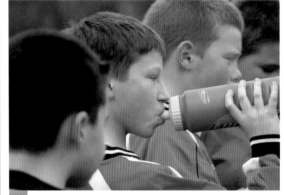

1 First, duplicate the Background layer. To do this, in the Layers palette drag the background thumbnail over the Create A New Layer icon (or hit Ctrl/⌘ + J). Call this layer

Monochrome. Next, convert the duplicate layer to monochrome. You could do this simply by desaturating the layer, but this can produce rather washed-out monochrome images, so use the

Channel Mixer, which results in black-and-white images with more impact. With the Background Copy layer selected, go to **Image > Adjustments > Channel Mixer**.

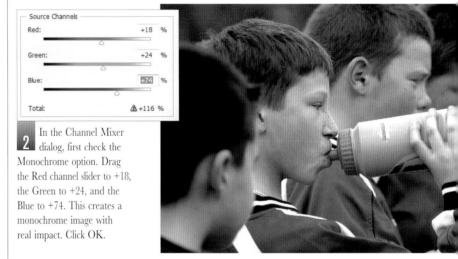

2 In the Channel Mixer dialog, first check the Monochrome option. Drag the Red channel slider to +18, the Green to +24, and the Blue to +74. This creates a monochrome image with real impact. Click OK.

3 Now hide parts of this layer to allow some of the color from the underlying layer to show through the monochrome. Go to **Layer > Layer Mask > Reveal All**. Choose the Brush tool from the Toolbar and select a hard, round brush from the Brush Picker. In the Layers palette, click on the thumbnail for the layer mask. Ensure that black is your Foreground color and begin to paint over the boy's face.

4 Be careful here, if your brush paints black over the image, then you're working on the image layer instead of the mask! Click again on the layer mask attached to the layer, checking for a bold outline around the thumbnail. Continue to paint with black over the face, making sure to keep exactly to the outline of the boy. If you accidentally go over the edges of the face, simply paint back into the image with white to correct this. Zoom well into the image and adjust the brush size with the square bracket keys ([and]) on the keyboard to ensure accuracy.

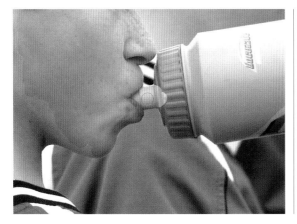

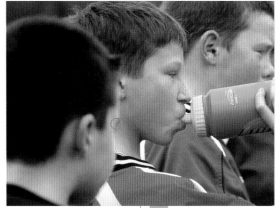

8 As a finishing touch, and still working on the layer mask, choose the Blur tool from the Toolbar. Set the Strength to 100% in the Options bar. Now use this tool over the area between the two boys. As this area is out of focus we need to blur the mask here so that the colored areas do not have a hard edge.

6 Return to the Brush tool and continue to paint black over the rest of the boy's figure to reveal the color from the lower layer. When painting over the hair, zoom well into the image and use a tiny brush to paint over the single stray hairs.

9 Make a final check to make sure you haven't painted outside of the edges anywhere, painting over any spots where you've strayed over with white to correct them.

5 The drinking bottle has a good, straight geometric outline, so you can make a simple selection here instead of trying to follow the shape with a brush. Choose the Polygon Lasso tool from the Toolbar and click on the very edge of the bottle. Drag the selection along the edges, clicking when you need to change direction. Complete the selection by clicking again on your starting point. Fill the selection with black via **Edit > Fill**, choosing Black for Contents. Hit Ctrl/⌘ + D to deselect.

7 You can check the mask on this layer by holding down the Alt key and clicking the layer mask thumbnail to display the mask in isolation. You should have a perfect black silhouette of the boy. If there are any white parts inside the silhouette, paint over them with black now. Opt/Alt-click the mask again to revert to the normal view.

10 Finally, return to the Background layer, and go to **Image > Adjustments > Hue/Saturation**. Increase the Saturation value by dragging the slider to the right a little to give the color an extra boost. Flatten the image via **Layer > Flatten Image** and save it.

CREATIVE LIGHTING

RESTORING BURN OUT

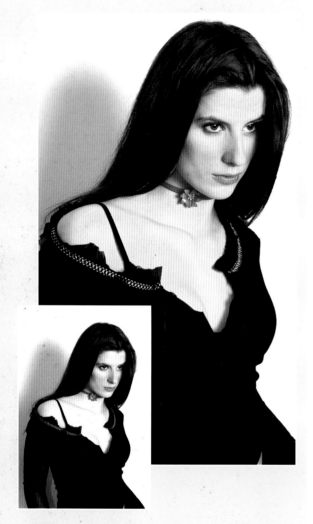

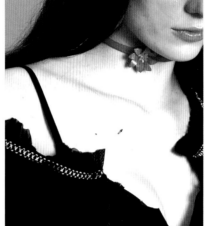

1 This otherwise striking image is spoiled by the burnt-out area around the woman's neck and chest. Zoom into the burnt-out area and then choose the Eyedropper tool from the Toolbar, making sure that Point Sample is selected from the Sample Size box in the Options bar. Click within the burnt-out area (select one of the lighter but not the lightest area) to sample that color. Go to **Select > Color Range**. From the Selection Preview box choose Black Matte.

3 Notice that the Color Range selection has selected every pixel of this color throughout the image, including the burnt-out areas in the face. Add a new layer (Ctrl/⌘ + Shift + N), and then with the Eyedropper tool, sample one of the lightest skin tones (but not from the burnt-out areas). On the new layer, go to **Edit > Fill**, and choose Foreground color for Contents.

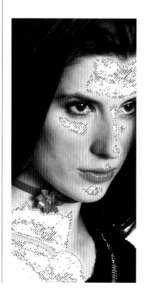

2 Choose Sampled Colors from the Select box. Carefully drag the Fuzziness slider to the right until the area of burn out is visible in the Preview pane. The very lightest parts of the burnt-out areas will show as partially selected (gray), but you'll correct these areas later. For now, just make sure that most of the burnt-out area is showing through the Black Matte. Here I set a Fuzziness value of 62, but this will vary depending on exactly which area you selected. Click OK to generate the selection.

Burnt-out highlights are one of the most difficult of photographic demons to correct. If you have an image in which the overall tone and exposure is too dark, a simple Levels or Curves adjustment can solve this in just a few clicks, but there is no one-stop Photoshop adjustment for blown-out highlights in an otherwise successful image. To deal with this photographic phenomenon, one needs to be a little more inventive. We can actually replace these blown-out areas with sampled colors and combine the filled areas with layer blending modes to preserve what little detail remains visible. The key to this technique is the Color Range command. So—before you trash that burnt-out image—follow the workthrough.

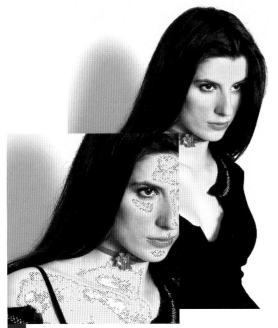

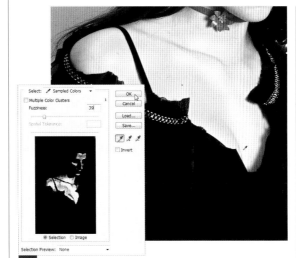

4 Hit Ctrl/⌘ + D to deselect. Set the blending mode for this layer to Multiply. Blur this layer via **Filter >** **Blur > Gaussian Blur**. Use a radius of 14 pixels or so—just enough to blur any hard edges on the filled areas.

6 Click again on the Background layer and add another new layer (Ctrl/⌘ + Shift + N). Click with the Eyedropper tool in the very lightest area of burn out in the image. Return to **Select > Color** **Range**. Move the Fuzziness slider until just these highlight areas show through the Black Matte in the Preview pane. Click OK to make the selection.

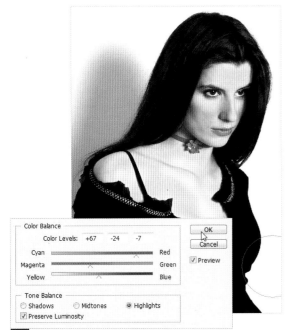

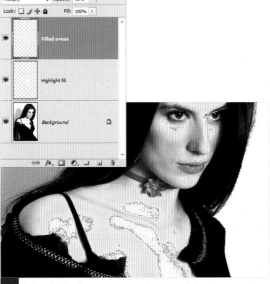

5 You can fine-tune the actual color of the blurred fill via **Image > Adjustments** **> Color Balance**. Select the Highlights radio button and adjust the sliders to modify the color of the fill to match it to the rest of the image. Add a little more red and magenta to the fill to match the surrounding skin. Use the Eraser tool to erase any unwanted fill on the background.

7 Using the Eyedropper tool, click in the very lightest natural skin tone in the image. Again, go to **Edit >** **Fill**, choosing Foreground color for Contents. Hit Ctrl/⌘ + D to deselect. Set the blending mode for this layer to Multiply. Again use Gaussian Blur to blur any hard edges, and **Image > Adjustments >** **Color Balance** if the "new" skin needs to match more closely the surrounding areas. You can adjust the lightness of these highlights by reducing the opacity of this layer. Again, erase any unwanted areas in the background with the Eraser tool.

8 For added realism, click on the first filled layer and go to **Filter > Noise >** **Add Noise**. Select Gaussian for Distribution and use a very small amount—around 1–2%. Finally, flatten the image via **Layer > Flatten Image** and save.

ADDING DIRECTIONAL LIGHTING

To create the effect of light through blinds, you need to call on one of Photoshop's less well-known filters: the Displace filter. The Displace filter can wrap the elements on a layer around the contours of an image. To use it you need to create a Displacement Map. The Displacement Map is a grayscale version of the main image, where all of the lighter tones in the image are interpreted as high contours, and the darker tones as low. You'll create the shadows from the blinds by making a simple filled selection on a layer, and duplicating this a few times. After running the Displace filter, a little deft blurring is used to add some realism to the shadow.

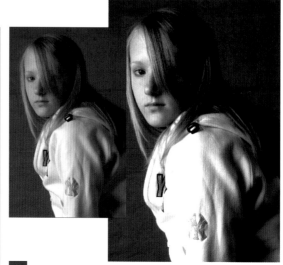

1 For the technique to work—and the shadows to wrap themselves around the subject—you first need to create a monochrome Displacement Map to use with the Displace filter. Open your image and go to **Image > Duplicate**. On this duplicate file, go to **Image >** **Adjustments > Desaturate** (Ctrl/⌘ + Shift + U). You need to increase the contrast in the image so you have strong light and dark tones. Go to **Image > Adjustments > Brightness and Contrast**. With the sliders, set the Brightness to -2, the Contrast to +35. Click OK.

3 Next, create the shadows from the blinds. Add a new layer (Ctrl/⌘ + Shift + N) and choose the Rectangular Marquee tool from the Toolbar. From the Style box in the Options bar, choose Normal. Drag a long, thin selection across the top of the image. Go to **Edit > Fill**, choosing Black for Contents.

2 Go to **Filter > Blur > Gaussian Blur**, entering a Blur Radius of 8 pixels. Save this file for later use. Go to **File > Save As**. Choose a directory to save the file in so you can easily locate it, and name the file Displace. It is very important that the file is saved under a PSD file type so that it can be used with the Displace filter. Choose PSD from the Format box. Once saved, close this file, returning to the original color image.

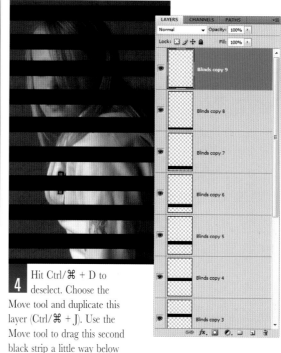

4 Hit Ctrl/⌘ + D to deselect. Choose the Move tool and duplicate this layer (Ctrl/⌘ + J). Use the Move tool to drag this second black strip a little way below the first. Repeat this procedure, duplicating and moving layers, until the whole image is covered with the stripes from top to bottom. You'll probably need to do this eight or nine times.

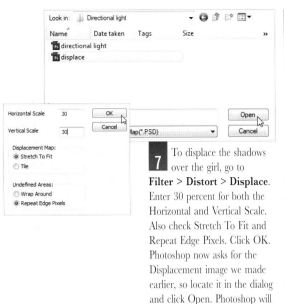

5 Merge all of these layers into one single layer by clicking on the top layer in the stack and going repeatedly to **Layer > Merge Down** (Ctrl/⌘ + E), until you have just a single layer containing all of the black stripes.

7 To displace the shadows over the girl, go to **Filter > Distort > Displace**. Enter 30 percent for both the Horizontal and Vertical Scale. Also check Stretch To Fit and Repeat Edge Pixels. Click OK. Photoshop now asks for the Displacement image we made earlier, so locate it in the dialog and click Open. Photoshop will now displace the Shadow layer, using the grayscale image as a Displacement Map.

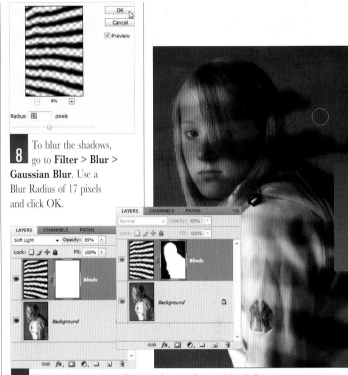

8 To blur the shadows, go to **Filter > Blur > Gaussian Blur**. Use a Blur Radius of 17 pixels and click OK.

9 The shadows on the wall behind the model need to be more blurred, but, first, add a layer mask via **Layer > Layer Mask > Reveal All**. Now choose the Brush tool and select a soft, round brush from the Brush Picker. Select black as your Foreground color and paint around the girl to hide the shadows on the wall.

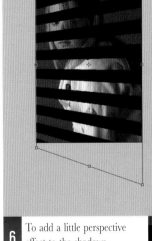

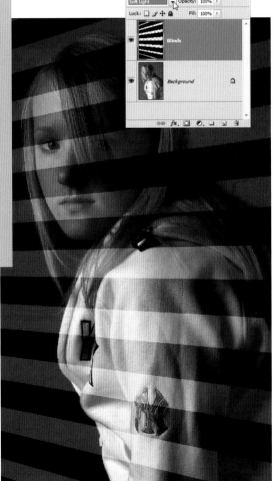

6 To add a little perspective effect to the shadows, zoom out from the image so you have plenty of space around it. Go to **Edit > Transform > Perspective**. Grab the top right-hand handle on the bounding box around the image and drag it upward a little way. Check Commit in the Options bar to make the transformation. Set the blending mode for this layer to Soft Light and reduce Opacity to 75%.

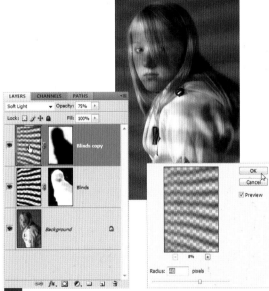

10 Duplicate this layer, complete with layer mask (Ctrl/⌘ + J). Click the layer mask thumbnail on this duplicated layer and go to **Image > Adjustments > Invert** (Ctrl/⌘ + I) to invert the mask. Click on the image layer thumbnail and go to **Filter > Blur > Gaussian Blur**. Use a Blur Radius of 48 pixels. Flatten the image with **Layer > Flatten Image** and save.

CREATING HIGH-KEY PICTURES

A high-key picture is one in which the majority of the tones are light, so that if the midtones were examined they would be found to be higher than the average midtone gray value. A high-key effect lends an image a light, ethereal look, but this doesn't mean that a high-key image lacks detail. Indeed, that's the difference between a high-key and an overexposed image—the former retains detail, the latter loses highlights in the image. Fortunately, if you tackle this digitally with a normally exposed photo, not only is there no damage of having a ruined picture—you can always scrap it and revert back to the original— it also means that the process can be carefully controlled and you can exploit a greater tonal range than by photography alone.

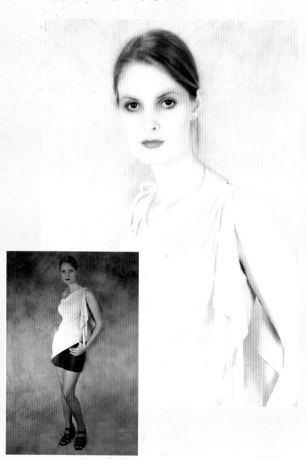

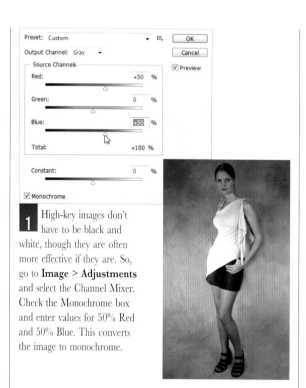

1 High-key images don't have to be black and white, though they are often more effective if they are. So, go to **Image > Adjustments** and select the Channel Mixer. Check the Monochrome box and enter values for 50% Red and 50% Blue. This converts the image to monochrome.

3 Now create a Curves adjustment layer in the same way as you created the Levels adjustment layer. For the curve itself, click on the midpoint and drag up and to the left. This brightens all the tones, but particularly the middle ones.

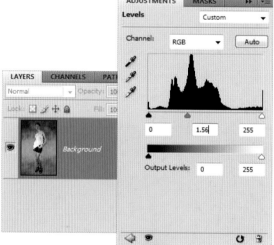

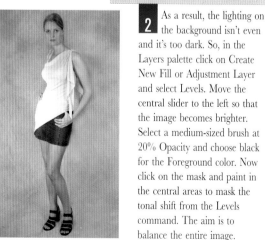

2 As a result, the lighting on the background isn't even and it's too dark. So, in the Layers palette click on Create New Fill or Adjustment Layer and select Levels. Move the central slider to the left so that the image becomes brighter. Select a medium-sized brush at 20% Opacity and choose black for the Foreground color. Now click on the mask and paint in the central areas to mask the tonal shift from the Levels command. The aim is to balance the entire image.

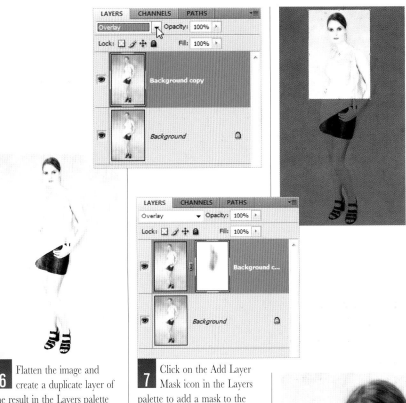

4 Now select the Brush tool again, this time at 5% Opacity, and, with a larger brush, carefully paint on the Levels mask around the inside edges of the figure, so that they are lifted and don't merge with the background. The skin areas should only be painted once, clothing areas can be painted multiple times.

5 Next, change the Opacity to 10%, reduce the brush size and zoom in to paint on the Levels mask—over the hair, the eyes, eyebrows, and lips. Watch that you don't create a "panda" or "dirty mouth" effect. Finally, paint where detail has been lost in the light-colored top as well.

6 Flatten the image and create a duplicate layer of the result in the Layers palette (Ctrl/⌘ + J), and set the blend mode to Overlay. This will create the final high-key look. Be sure to mask the light top worn by the subject using a layer mask and brush as before. For a more extreme, graphic effect, try the Vivid Light blend mode.

7 Click on the Add Layer Mask icon in the Layers palette to add a mask to the top layer. Select the Brush tool and with a 20% Opacity brush, paint over the top of the subject to make her stand out from the background, but without becoming too dark. Merge the layers at this point.

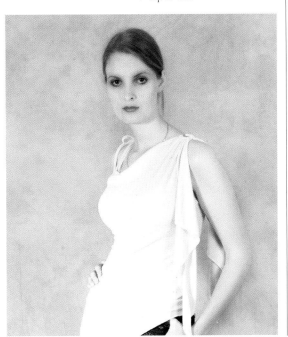

8 To emphasize the subject, select the Crop tool and crop in around the head and torso region. Apply the crop.

9 Following the crop, you need to increase the size of the new image. Go to **Image > Image Size**. Increase the image size to 3000 pixels vertically. This will invariably soften the image as the interpolation process adds an awful lot of new pixels to the image. However, as the style of the image is light and airy (and a portrait), you can get away with the softness without having to sharpen it.

LOW-KEY PORTRAITS

As it suggests, a low-key portrait is the exact opposite of a high-key one—most of the tones in the image are darker than the midtone range, producing shadow and darkness. Again, this is different to underexposing an image—it has a purpose. Rather than to "muddy" skin tones, the overall effect can be dark, mysterious, exotic, or alluring. A low-key effect will work if the subject matter lends itself well to the technique—shooting a happy, smiling face and then subjecting it to a low-key effect might produce a rather sinister result. If that's not what you are after, use either an image that lends itself better to the technique or vice versa.

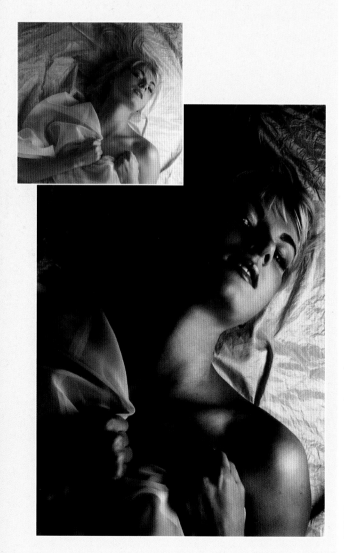

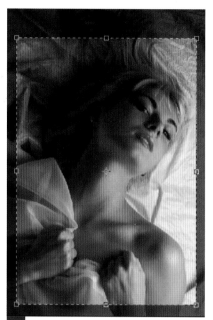

1 The original composition is too loose—there is far too much space at the top and around the subject. The image feels impersonal. The aim is to make the composition tighter, bring out the subject's contemplative mood, and make it much darker and more intimate. First, select the Crop tool and mark a tighter composition around the subject. Apply it.

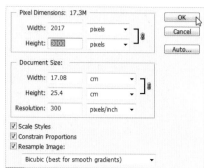

2 The resulting image is a little on the small side now, so interpolation needs to be used to make it bigger. Go to **Image > Size** and boost it up to 3000 pixels high. It is better to do the interpolation at the beginning of the process rather than the end if you are carrying out significant image-processing.

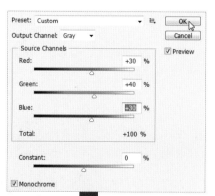

3 Next, convert the image to black and white using the Channel Mixer. Go to **Image > Adjustments** to select it. Check the Monochrome box and enter values of 30% Red, 40% Green, and 30% Blue. The image is beginning to take shape but still needs work.

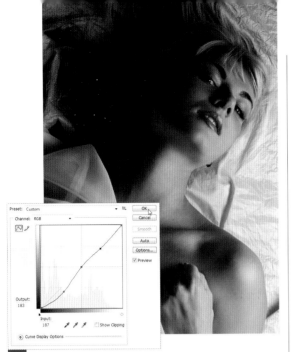

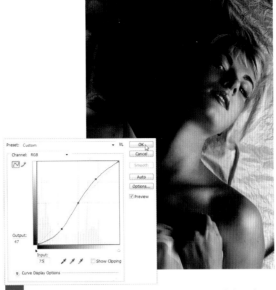

4 Go to **Image > Adjustments > Curves**. Click on the light skin tones of the image with the Eyedropper that appears as you move the cursor over the image. This shows where on the curve the skin tones sit. Click a point on the line to lock them into place. Then set a point halfway down from the midpoint and drag down and to the right to darken the image.

6 Next, apply another Curve function. By this point the background at the top right should be below the midpoint and the skin tones should be above it. Place a control point at the midpoint and then above and below it. Pull the control points to produce the classic S-shape curve that darkens the shadows and lightens the highlights.

7 Select the Burn tool and set the Opacity at 25%. Use it to burn in areas such as the top and bottom right of the picture, which at the moment are too bright.

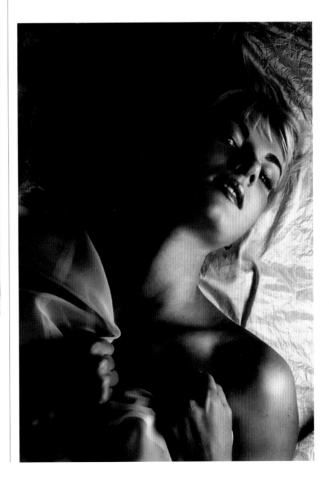

5 In the Layers palette, create a duplicate layer (Ctrl/⌘ + J) and set the blend mode to Multiply, then click on the Add Layer Mask icon at the bottom of the palette. Select the Brush tool and make sure the Foreground color is black and the Background is white. Set the Opacity to 20% and use a large brush—around 200 pixels. Select the mask and paint the areas where you want the skin tones to be lighter—the right side of the face and shoulder area. It may take three or four coats to get the right effect but it is better to do it gradually. Select **Layer > Flatten Image**.

8 Go to **Filter > Texture > Grain**. Set the Grain Type as Regular, the Intensity at 30, which will put texture back into the areas you smoothed out, and set the Contrast at 60. This gives the final contrasty, dark, and moody atmosphere to the image.

DRAMATIC LIGHTING AND SHADOW EFFECTS

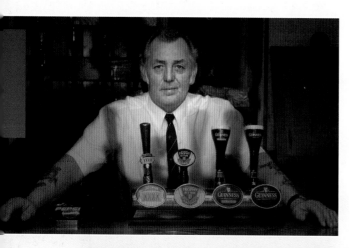

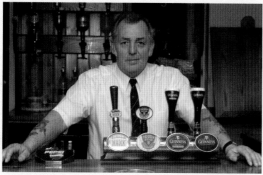

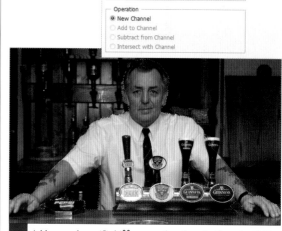

1 Begin by painting a quick mask over the main figure. Hit Q on the keyboard to enter Quick Mask mode and choose the Brush tool. Choose a hard brush from the Brush Picker and ensure that black is your Foreground Color. Paint over the entire figure and the counter, taking care to follow the outlines and shapes carefully. Remember you can quickly change the size of the brush by using the square bracket keys.

3 Add a new layer (Ctrl/⌘ + Shift + N). Depending on how your Quick Mask option is set, you may have the space around the figure selected rather than the figure itself. If this is the case go to **Select > Inverse**. Go to **Edit > Fill** and choose Black for Contents. Hit Ctrl/⌘ + D to deselect.

Where there's light, there's shadow, and that's the phenomenon covered in this section. You'll learn how to create the impression of shadows by painting the appropriately shaped selections in Quick Mask mode. In this mode you paint with a red overlay—similar to the traditional Rubylith process that was once common in printing. When you exit Quick Mask mode, an active selection is generated. By filling this selection with black on a separate layer, and applying a little Gaussian Blur, very realistic shadows can be created. The final burst of light that completes the effect is added using the powerful Lighting Effects filter.

2 If you accidentally paint over the edge of the figure with the mask, simply paint back into the mask with white to correct it, and then continue to paint with black; use the X key to toggle between the colors. When the mask is complete, hit Q to exit Quick Mask and generate a selection. Save this selection via **Select > Save Selection** and name it Figure.

4 Change the blending mode for this layer to Soft Light. Chose the Move tool and drag this shadow layer a little to the left. Go to **Edit > Transfrom > Scale**, hold down the Shift key and drag one of the corner handles to enlarge the shadow. Hit the Commit box in the Options bar.

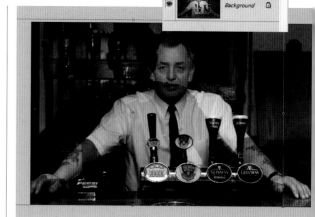

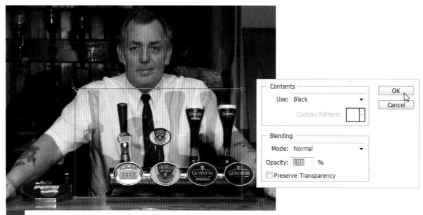

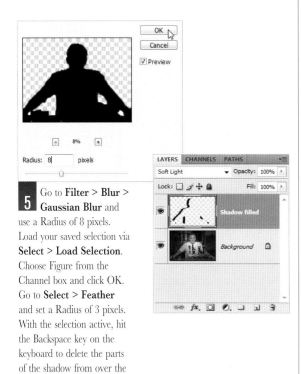

5 Go to **Filter > Blur > Gaussian Blur** and use a Radius of 8 pixels. Load your saved selection via **Select > Load Selection**. Choose Figure from the Channel box and click OK. Go to **Select > Feather** and set a Radius of 3 pixels. With the selection active, hit the Backspace key on the keyboard to delete the parts of the shadow from over the figure and hit Ctrl/⌘ + D to deselect.

7 Fill this selection with Black via **Edit > Fill > Contents**. Hit Ctrl/⌘ + D to deselect. Set the layer blending mode to Soft Light. Again, choose the Move tool and move the shadow a little to the left. Go to **Edit > Transform > Scale**. Drag on the top-left corner handle to increase the size of the shadow. Hit Enter to commit the transformation.

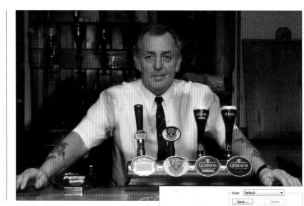

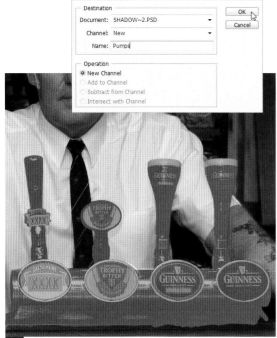

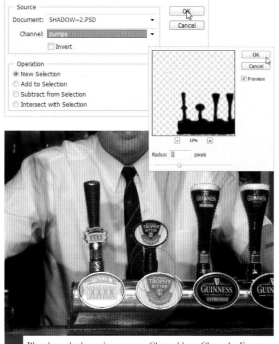

9 To complete the lighting effect, click on the Background layer and go to **Filter > Render > Lighting Effects**. Choose Omni for Light Type and drag the light over the man's head and shoulders. Set the Intensity slider to 18 and the Ambience to 14. Choose White for the Light color swatch. Click OK to apply the lighting. Go to **Layer > Flatten Image** and then save.

6 Repeat much the same process to create the shadows from the beer pumps in the foreground. Add a new layer and choose the Brush tool. Enter Quick Mask mode again (Q), and carefully paint a mask over the pump assembly. When you're done, hit Q to exit Quick Mask. Again, go to **Select > Save Selection**, naming it Pumps.

8 Blur these shadows via **Filter > Blur > Gaussian Blur**, using a Radius of 7 pixels. Reload the Pumps selection via **Select > Load Selection**, choosing Pumps from the Channel box. Chose the Eraser tool and erase the areas of shadow within the selection. Intensify the shadows by duplicating this layer (Ctrl/⌘ + J) and adjusting the opacity of the duplicate layers.

ADDING CANDLELIGHT AND COLOR

The effects of candlelight are notoriously difficult to capture with a camera, presenting all manner of difficulties concerning exposure values and white balance anomalies. However, this needn't prevent you from creating stunning candlelit shots, if you have Photoshop. The source image we're using here isn't one that you'd necessarily think was suited to a candlelight effect, but that's the whole point. With a little judicious image editing, the perfect candlelight effect is only a few clicks away.

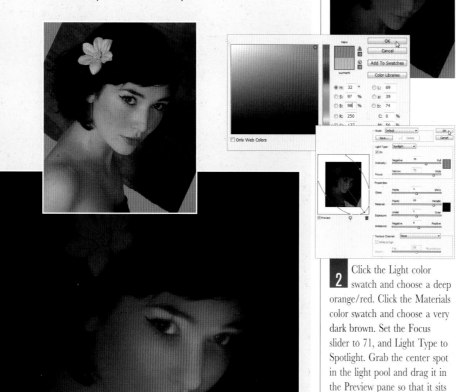

1 First, duplicate the Background layer (Ctrl/⌘ + J). On this duplicate layer go to **Filter > Render > Lighting Effects**.

2 Click the Light color swatch and choose a deep orange/red. Click the Materials color swatch and choose a very dark brown. Set the Focus slider to 71, and Light Type to Spotlight. Grab the center spot in the light pool and drag it in the Preview pane so that it sits to the side of the woman's eye. Grab the handle on the right of the light pool and drag it to the right until the pool encompasses the edge of the image. Use the screen shot to roughly replicate the size of the light pool. Grab one of the handles and rotate the pool so that the light shines from the lower right-hand corner of the image.

3 Go to **Layer > New Fill Layer > Solid Color**. Click OK to the layer dialog and choose a bright red/orange from the Color Picker. Set the blending mode for this layer to Overlay. Now fill the mask for this layer with black via **Edit > Fill > Contents** and then choose Black. This layer will supply the reflected candlelight, after some painting on the associated layer mask.

4 Select the Brush tool and choose a soft brush from the Brush Picker. Reduce the brush Opacity to 25%. Now, with the brush at a fairly large size, paint over parts of the girl's face with white to expose the orange from the Fill layer. We need to achieve a very subtle and gradual lighting effect here. Concentrate the red reflected glow on the front of the woman's face. The more you paint over an area, the stronger the red glow will become.

5 This screenshot shows the associated layer mask in isolation. You can see that very little white needs to be applied to achieve the required amount of glow.

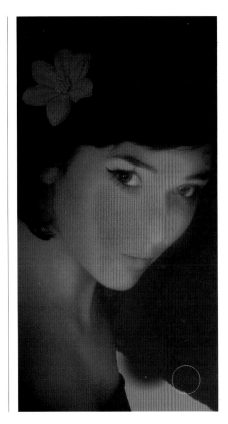

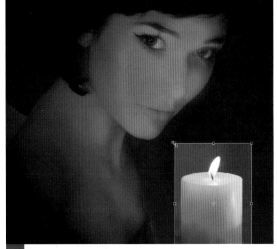

6 Again, go to **Layer > New Fill Layer > Solid Fill**. This time, choose a bright golden yellow from the Color Picker. Fill the mask on this layer with black via **Edit > Fill > Contents** and then choose Black. Set the blending mode for this layer to Color Dodge.

9 Before moving on, click on the Lighting Effects layer and use the Eyedropper tool to sample the darkest color behind the woman. Now use the Brush tool to paint over the two orange areas at bottom right of the picture.

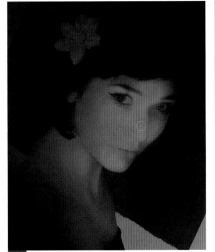

7 With the mask still selected, paint with white over the front of the girl's face. Use the brush at varying opacities to show more and more of the associated yellow-filled layer. This will increase the candlelight effect. Avoid painting over any dark features around the eyes. The point here is to add very subtle highlights to the red/orange glow areas. Again, less is more.

8 Reduce the brush to a very small size, and paint with white into the whites of the woman's eyes to reveal the yellow-filled layer there. This will give the effect of bright highlights and reflections from the candles. Zoom into the eyes, reduce the size of the brush, and paint over the existing catchlights in the eyes.

10 Open the candle image and go to **Select > All** (Ctrl/⌘ + A), followed by **Edit > Copy** (Ctrl/⌘ + C). Return to the main image and go to **Edit > Paste** (Ctrl/⌘ + V) to paste the candle into the image. Adjust the size and position of the candle via **Edit > Transform > Scale**. Choose the Eraser tool and erase around the candle.

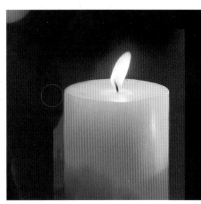

BACKGROUND LIGHTS

When you photograph someone standing in front of a plain background, the results are dependent upon the lighting and the merits of the subject. It's a good rule of thumb to have diffused backgrounds in portraits—except where the subject is interacting with the background obviously—as this concentrates the viewer's attention on the subject. If the background is plain white, however, it adds nothing at all. That's where this tutorial comes in. The idea is to separate the subject from that white background and then use Photoshop's Lighting filters to add a little drama and interest as a backdrop, but without competing with the subject.

1 First, correct the overall exposure of the image, and make any color and contrast adjustments. Next, make any improvements to the portrait that you think are required. Here, I've used the Clone tool to clean up the complexion a little.

3 Go to **Select > Inverse** to invert the selection around the figure. Go to **Select > Modify > Contract** and enter a value of 2 pixels to pull the selection right to the figure. Go to Select again and feather the selection by 1 pixel. Press Ctrl/⌘ + C to copy it and Ctrl/⌘ + V to paste it back as a new layer, minus the background. Rename this Figure layer.

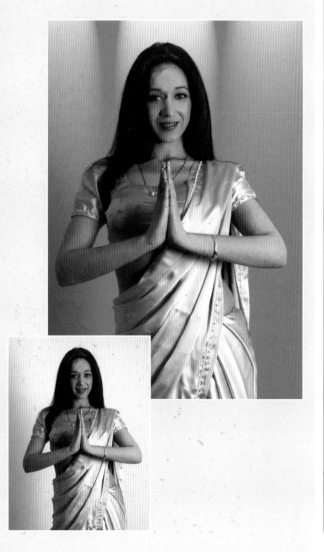

2 Select the Magic Wand tool and set the Tolerance to 20%. Click in the background areas and then hold down the Shift key to add to the selection by clicking in those areas that weren't picked up initially. Do this until you have selected the whole of the white background. Zoom in to check for stray unselected pixels. The area around the hair will not be tight to the head, but do not click any nearer to it at this stage.

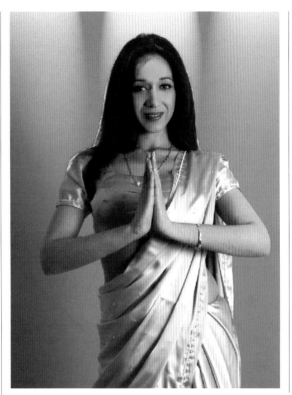

4 Select the Background layer again and go to **Filter > Render > Lighting Effects.** Select the triple spotlight—or in fact any lighting combination that you feel suits your portrait. The idea is to make it dramatic without being overbearing. Reposition the lights so that they are coming down from the top, with the one in the middle slightly stronger than the others.

5 Change the color of the lights so that they have a golden tint to reflect the color of the clothing the subject is wearing. Apply the Lighting filter, which will now work on the background.

6 You will now be able to see the original background through the hair as a white outline. To get the lights to shine through the hair, select the Figure layer and click on the Add Layer Mask icon in the Layers palette.

7 Select a brush at 20% Opacity and make black the Foreground color. Click on the layer mask to select it then paint over the gaps in the hair where you can see the original background. Go around the head, painting along the edge of the hair so that there is a slight halo effect. If you make any mistakes, such as painting over the head, switch to white and paint over it. Once complete, merge the layers and save.

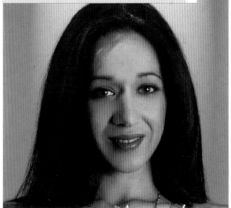

MULTICOLORED LIGHTING

In the photographic studio, using a number of different-colored lights can be very effective and add an extra dimension to otherwise quite bland images. In terms of setting up this kind of shoot in the studio, we'd need to use colored gels over powerful studio flash heads, and carefully judge the positioning of each light source. Thankfully, you don't necessarily need all of this kit and expertise to recreate a similar effect in Photoshop. Thanks to the Lighting Effects filter, we can create and arrange a number of colored "virtual" lights, and create some stunning results!

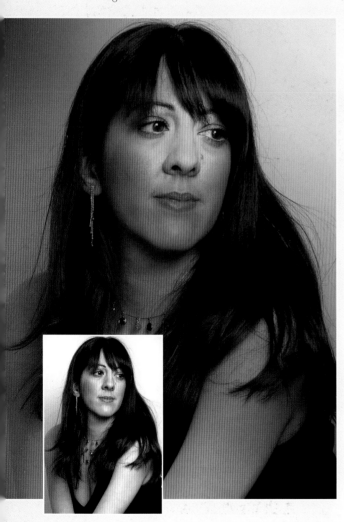

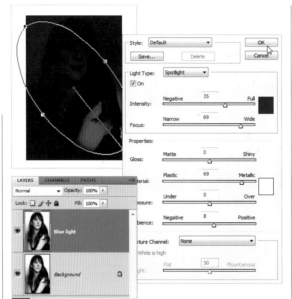

1 Each different-colored light will have its own layer, so first duplicate the Background layer (Ctrl/⌘- + J) and call it Blue light. You're going to add the blue light first, so go to **Filter > Render** > **Lighting Effects**. In the Lighting Effects dialog, choose Spotlight from the Light Type box. Click in the Light color swatch (to the right of this box) and choose a vivid blue color from the Picker.

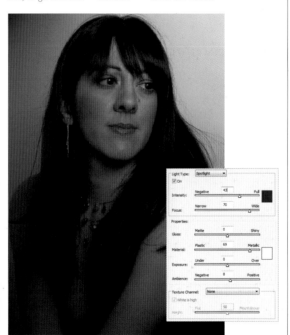

2 The light pool in the Preview pane has handles around it. Grab the handle which is attached to the center light spot with a line and rotate the light pool so that the light falls from top right to bottom left. Drag this handle up and to the left until it almost disappears from view. Grab one of the side handles and drag it out so that the light pool encompasses the whole image. Drag the central spot of the light onto the model's chin. Increase the Intensity slider to 43 and leave all other settings at the defaults. Click OK to apply the lighting.

3 That's placed the blue lighting—now to introduce another color. This time it's a red light source, but first hide the Blue light layer by clicking the visibility eye for this layer. Now add a new layer for the red light by duplicating the Background layer again (Ctrl/⌘ + J). Call this one Red light.

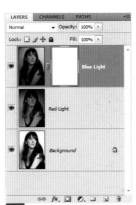

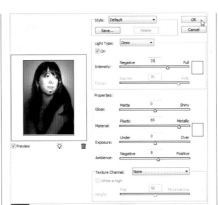

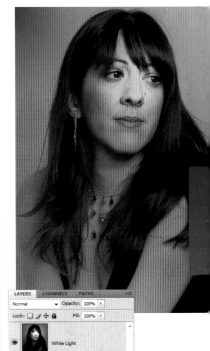

5 Now for a little light blending magic. Click the visibility eye for the Blue light layer again, and click on the layer itself. Go to **Layer > Layer Mask > Reveal All**. By painting on this layer mask with black, we'll hide parts of this layer. Choose the Brush tool and select a large, soft brush from the Brush Picker.

4 Return to **Filter > Render > Lighting Effects**. The setting for the filter will be as you left them for the Blue layer, so first, click in the light color swatch and choose a vivid red. Grab one of the handles and rotate the light pool so the light shines from the lower left to upper right. Position the center spot of the light pool near the bottom left-hand corner of the image. Click OK.

7 Finally, we need to add a spot of white light to concentrate the attention around the eyes and add an accent to the image. Click on the Background layer and duplicate it (Ctrl/⌘ + J). Drag this new duplicated layer to the top of the layer stack. Return to **Filter > Render > Lighting Effects**. This time, choose Omni for the Light Type. Drag the light pool over the woman's eyes. Click on the Light color swatch, choosing White from the Picker. Reduce the Intensity slider to 35 and click OK.

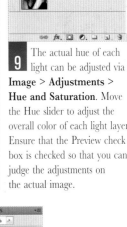

9 The actual hue of each light can be adjusted via **Image > Adjustments > Hue and Saturation**. Move the Hue slider to adjust the overall color of each light layer. Ensure that the Preview check box is checked so that you can judge the adjustments on the actual image.

6 Increase the size of the brush to around 400 pixels and ensure that your Foreground color is Black. Click on the layer mask in the Layers palette and paint over the lower left of the image to expose the Red light layer beneath. Use the brush at a low opacity (set in the Options bar) over the woman's face to achieve a gradual blend between the red and the blue.

8 Change the blending mode for this White light layer to Lighten. Reduce the opacity of this layer to control the intensity of this highlight. Here I've chosen an Opacity of 37% so the light has a subtle but significant effect.

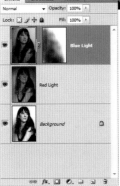

TURNING DAY INTO NIGHT

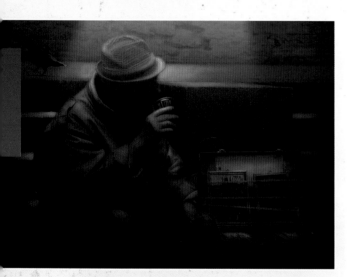

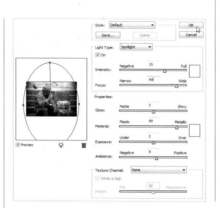

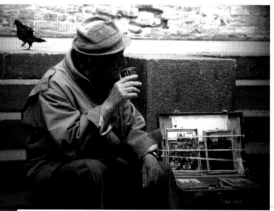

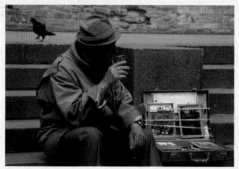

For the novice, taking photographs at night can be a tricky business, involving very slow shutter speeds and somewhat hit-and-miss estimated exposures. While you're busy grappling with that new digital camera, the thought of doing the same in dark conditions can seem a little daunting. However, we can simulate the atmosphere of after-dark images in Photoshop to great effect.

We'll establish the initial ambience with the Lighting Effects filter. The sombre nighttime light levels are supplied by a Hue/Saturation adjustment layer. By painting on to the mask attached to this layer, we can subtly reveal the light and color from the Background layer. Finally, a simple gradient adds that extra touch of illumination.

1 To establish the lighting, go to **Filter > Render > Lighting Effects**. Choose Spotlight for Light Type. Rotate the light pool with the handles so that the light falls from above and stretch the light pool so that it covers the entire image. Choose White from the Light color swatch, and set the Intensity to 35, Focus to 69.

2 To establish the nighttime effect, go to **Layer > New Adjustment Layer > Hue/Saturation** and click OK. Check the Colorize box. Set the sliders as follows: Hue 230, Saturation 47, Lightness -70.

3 For the light beam, add a new layer (Ctrl/⌘ + Shift + N) and call it Light Beam. Choose the Polygon Lasso tool from the Toolbar. Draw a large polygon selection enveloping the figure, quite narrow at the top, wider at the bottom. Choose the Gradient tool and click the Foreground color swatch, choosing a very light yellow. Click in the Gradient Picker in the Options bar and select the Foreground to Transparent swatch. Starting above the top of the image (you'll need to increase the space around the image to do this), drag a gradient down to the bottom of the selection. Hit Ctrl/⌘ + D to deselect.

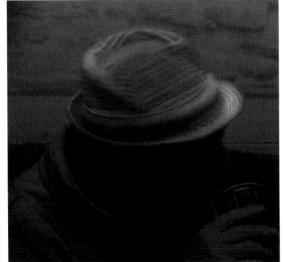

4 Go to **Filter > Blur > Gaussian Blur** and use a Blur Radius of 67 pixels. Set the blending mode for this layer to Luminosity and reduce Opacity to 86%.

6 Bear in mind that the light is falling from above, which will help you to visualize where you need to add the light to the figure. Be very subtle about this. To make a particular area of illumination brighter, simply work over that area again with the brush. The more black you apply to the mask, the more of the underlying spot lit layer will be revealed.

8 Increase the size of the brush and paint with black over the lightest parts of the stone steps to reveal some light there. Paint from the figure toward the outer edges of the image so that the light trails off into the darkest, concentrating the lightest parts below the beam of light.

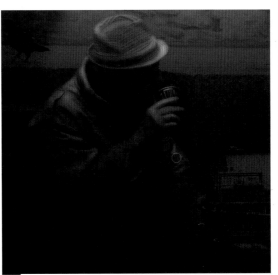

9 Finally, paint a little over the case and its contents, again revealing some light here. As a final touch, click on the original Background layer and go to **Image > Adjustments > Hue/Saturation**. Increase the Saturation slider until you're happy with the depth of color in the lighter parts of the figure. Finally, flatten the image via **Layer > Flatten Image** and save.

5 The Hue/Saturation adjustment layer comes complete with a layer mask, and next you need to paint on this to give the effect of subtle light falling on the figure and the surroundings. Click on the Brush tool, and from the Brush Picker, choose Airbrush Soft Round 45. In the Options bar, reduce the Brush Opacity to 30%, and the Flow to 19%. Click on the adjustment layer and begin to paint with black as the Foreground color over the lighter areas of the subject's hat.

7 Continue to work down the figure, exposing light here and there in the lighter parts of the image, adjusting the size of the brush in the Options bar to suit the size of the highlight you're painting. Use the brush at a very small size to add very small bright accents here and there.

CREATING SILHOUETTES

To shoot silhouettes in the studio requires accurate lighting control, metering, and exposure. There is an easier and far more successful method, and it involves the use of Photoshop. By duplicating one of the separate RGB color channels, and adjusting the levels for this duplicated channel, we can get a real headstart on creating the final silhouette. The ubiquitous Lighting Effects filter supplies the required backlighting, bringing the silhouette to life. Silhouette portraits are a tradition which dates back hundreds of years, and applying the technique to modern digital portraits can still result in stunning portrait images with great intimacy and charm.

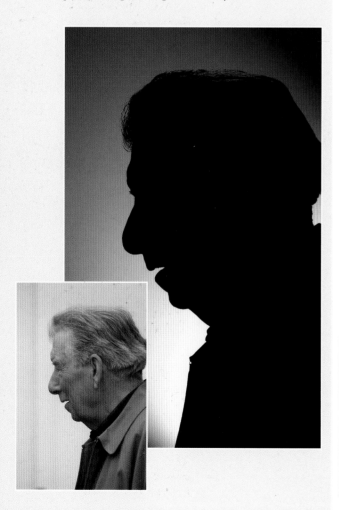

1 Duplicate the Background layer (Ctrl/⌘ + J) and click on the tab for the Channels panel to display the individual color channels.

2 Make a copy of the Blue channel by clicking on that channel in the palette and dragging it to the Create New Channel icon at the base of the Channels palette.

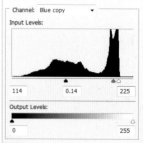

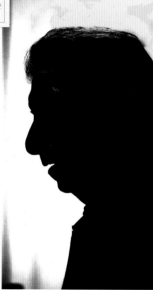

3 You need to radically alter the contrast of this channel to generate the silhouette, so go to **Image > Adjustments > Levels**. Slide the black point marker beneath the histogram over to the right to darken all of the darkest tones in the image. Drag it to the right until you obtain a value of 114 in the Input Level box. Drag the white point marker to the left, achieving an Input Level value of 225. Darken the midtones by entering a value of 0.14 in the central Input Levels box. Click OK to apply the Levels.

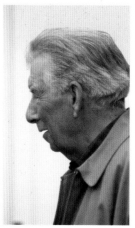

4 You may find that some small areas of white or gray remain within the silhouette. Choose the Brush tool from the Toolbar and select a hard, round brush from the Brush Picker. Hit D on the keyboard to set default Foreground/Background colors and then hit X to swap them. Using black, paint over these remaining areas of white within the silhouette.

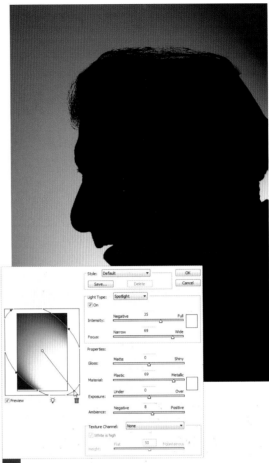

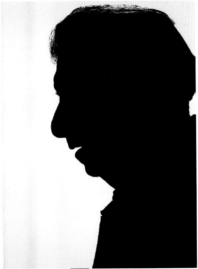

5 Hit X again so that white is the Foreground and paint out any black areas in the background surrounding the silhouette.

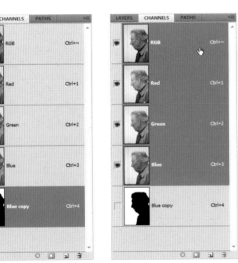

6 To deal with any remaining grays in the background, go again to **Image > Adjustments > Levels**. Drag the white point marker to the left until the gray

disappears. Drag the black point slider a little way to the right to increase the contrast even more. Go to **Select > All** (Ctrl/⌘ + A) and then to **Edit > Copy** (Ctrl/⌘ + C).

7 Click the RGB channel at the top of the channel stack and return to the Layers palette. Go to **Edit > Paste** to paste the copied silhouette. Change the blending mode of this pasted layer to Darken.

8 Click on the background layer and duplicate it (Ctrl/⌘ + J). Choose a light cream color for the Foreground color swatch and go to **Edit > Fill**, choosing Foreground color for Contents.

9 To apply some lighting, go to **Filter > Render > Lighting Effects**. Choose Spotlight for Light Type. In the Preview pane, grab one of the handles around the light pool and drag the pool counterclockwise

so the light falls from bottom right to top left. Drag the light pool handles outward so that it covers the entire image as in the screen shot. Set the Intensity to 35 and the Focus to 69. Click OK to apply.

10 Choose the Blur tool from the Toolbar. Click on the Silhouette layer and set the Blur Strength to 50% in the Options bar. Use this tool around the outline of the profile to soften the edge a little here and there.

PERSONAL IMPROVEMENTS

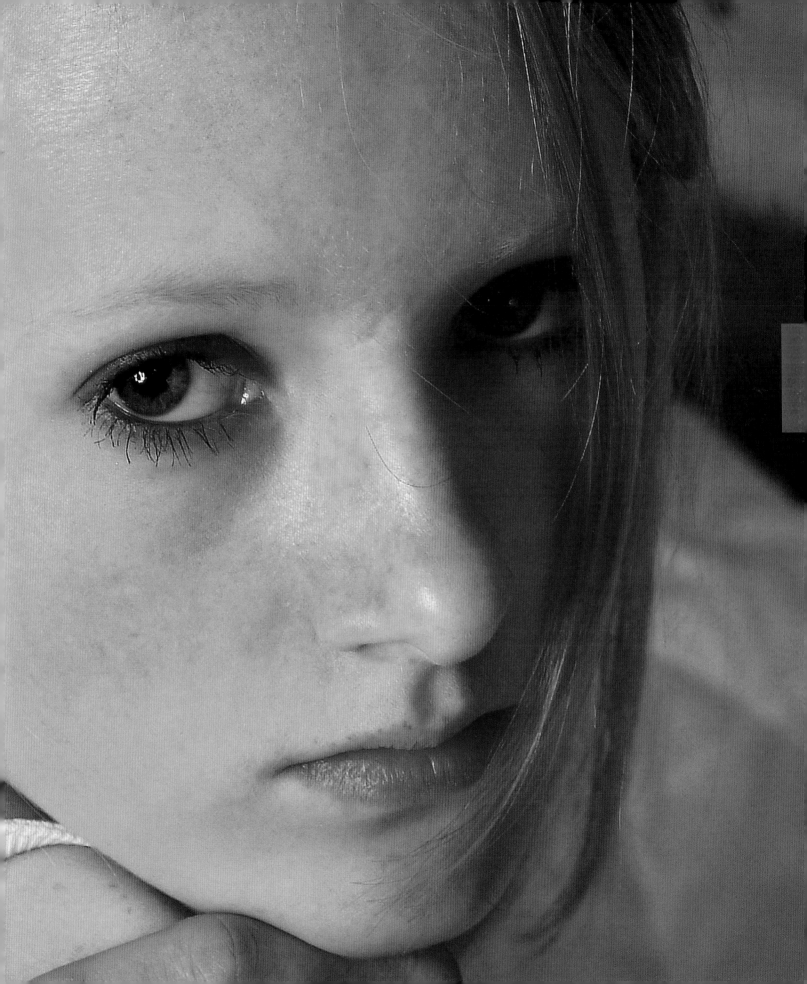

FACIAL BLEMISHES

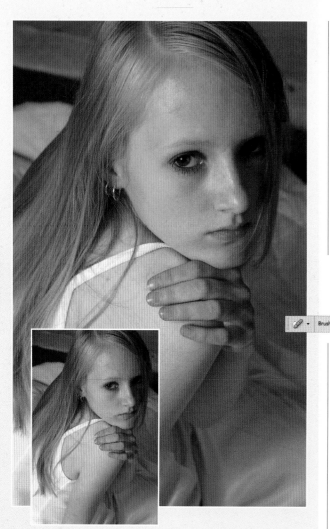

1 The Spot Healing Brush tool, introduced in Photoshop CS2, is simplicity itself when it comes to correcting spots and blemishes. It's your one-stop store for cleaning up a complexion in Photoshop. The tool itself is nested within the Healing tool group in the Toolbar.

E ven the world's greatest models suffer from the occasional spot on an otherwise beautiful complexion. The smallest mark or scratch can be exaggerated by studio lighting, but this needn't relegate the shot to the garbage. This section looks at three methods of removing skin blemishes from a portrait. The Spot Healing Brush, the Healing Brush, and the Patch tool all work in a similar way, but each is especially useful in its own right. This group of Healing tools work by copying or cloning image content from one area to another, but differently to the Clone Stamp tool in that the Healing tools preserve the shading and texture of the area being corrected.

2 It's always best to correct problems on a separate layer, so add a new layer now via **Layer > New > Layer** or by hitting Ctrl/⌘ + Shift + N on the keyboard. Because you are cloning onto a separate layer, make sure that the Sample All Layers option is checked in the Options bar.

3 Zoom into the area and reselect the Spot Healing Brush tool. Increase the size of the brush (via the right-facing square bracket key on the keyboard) so that it is slightly larger than the spot itself, and click directly over the spot. Hey presto—no more spots! It's as simple as that. Generally, you'll find that the Proximity Match option (set in the Options bar) is the most effective, whereby Photoshop matches the clone information with the values and texture from the nearby surrounding pixels, but the Create Texture option is worth a try if the results are not convincing.

4 There are times, however, when you need a little more control over the cloning process, and the source of the cloning sample. In this event, call upon the Healing Brush. Again, it's selected from the portfolio of Healing tools. To try the tool, first delete the previously applied layer by dragging the layer thumbnail into the trash in the Layers palette.

5 The Healing Brush is less automated than the Spot Healing Brush in that you need to choose the area of blemish-free skin, which is used as the cloning source point. Add a new layer (Ctrl/⌘ + Shift + N), select the Healing Brush and make sure that Sample All Layers is checked in the Options bar. Adjust the size of the Healing Brush to suit the size of the offending spot, place the tool near to the blemish (but not overlapping it), and hold down the Alt/⌥ key on the keyboard.

7 Next, conceal the blemish by simply clicking over it with the tool. Remember, when you move to another spot that needs concealing, you must set your source point again by using Alt/⌥ + click on a nearby unmarked area.

9 Lastly, for covering larger blemishes, use the Patch tool. Choose the Patch tool from the Healing tools. The Patch tool works by cloning over a blemish with a copy of an area defined by a drawn selection. Hold down the Spacebar and drag the image so you can see the blemish against the side of the girl's mouth.

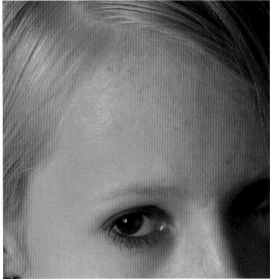

6 With the Alt/⌥ key depressed, you'll see the tool pointer change into a pair of cross-hairs inside a smaller circle. This is the symbol used to indicate that you're about to set a cloning source point. Position this point over a clear area of skin of a similar shade and texture to the area your trying to correct and click the mouse button to set the source point.

8 The Healing Brush has a number of available modes available, some of which can prove useful. So far you've been using the tool in Normal mode, which is the mode you'll use it in most of the time. Replace mode makes the Healing Brush work exactly like the Clone Stamp tool. If you want to just conceal the dark parts of a blemish try using the tool in Lighten mode. Conversely, to conceal only the lightest areas and leave darker areas unaffected, use the tool in Darken mode.

10 First, ensure that the Destination box is checked in the Tool Options bar, instructing Photoshop to copy the selected area to the destination location. Locate an area of clear skin near the blemish, and draw a selection with the Patch tool slightly larger than the blemish itself. Click inside this selection, drag it over the blemish and release the mouse button, dropping the clone area over the blemish. A perfect, seamless match!

With these three Healing tools and just a little time and patience you can create a perfect, flawless complexion.

CHANGING EXPRESSIONS

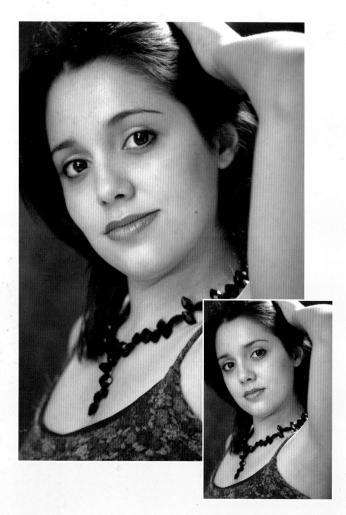

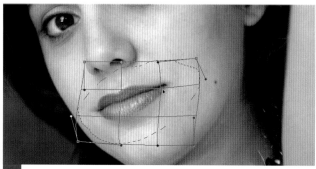

1 Open the start image and choose the Lasso tool. Now drag a selection around the mouth. In the options bar click the Refine Edge button. Click the On White button and increase the Feather value until the selection edge is nice and soft. Click OK. Right-click within the selection and choose Layer Via Copy.

2 On the pasted layer go to **Select > Reselect** followed by **Edit > Transform > Warp**. Now you can use the handles around the Warp map to widen and curve the mouth a little. Very small movements make a big difference here, so just make very fine adjustments here as we don't want a really exaggerated expression.

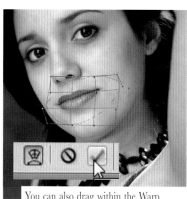

3 You can also drag within the Warp grid itself, again making very small movements. Use the shap of the warp grid in the screenshot as a guide here. Once you're happy with the changes you've made, click the Commit Tick in the Options Bar.

4 Go to the Masks panel and hit the Add Pixel Mask button. Now choose the Brush Tool with a soft brush and paint with Black at low opacity around the mouth to hide any hard edges from the pasted section. When you're happy go to **Layer > Merge Down**.

Facial expressions are very subtle and can change, quite literally in the blink of an eye, especially when you're busy behind the viewfinder of the camera. So what can you do, it your subjects expression on the final shot is not quite the way you want it? Scrap the whole shoot and start again? Not if you're armed with Adobe Photoshop CS4!

Here we're going to look at how you can use the Warp command, and the Liquify filter to make subtle changes to an expression, and save a portrait image that might otherwise be destined for the recycle bin. The key here is subtly; tiny movements and adjustments can make a huge difference, so carefully does it! Both allow you to move pixels around within the image, so you can tweak facial features to your heart's content. Go on, put a smile on her face!

7 Choose the Thaw Mask Tool from the Toolbar. Now use this tool to erase the mask along the outer edge of the cheek line. return to the Forward Warp Tool and use it at around 100 pixels wide to gently pull out the cheek a little.

5 As a safeguard, duplicate the Background Layer (Ctrl/⌘+J), this way, if your editing goes wrong, you'll have the original background layer to return to. On the duplicate layer go to **Filter > Liquify**.

Within the Liquify dialog, choose the Freeze Mask Tool from the Toolbar. Now use the brush at a large size to paint a mask around the mouth so that you don't distort the other parts of the face.

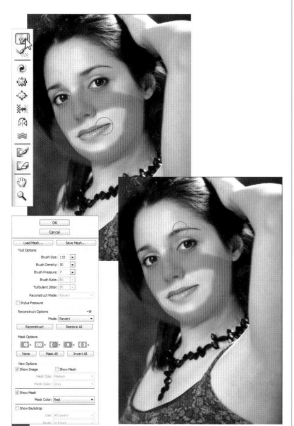

8 You can use the Show Backdrop check box to display an overlay of the original image so that you can judge the changes you've made. Now use the Thaw Mask Tool to erase the rest of the mask. Now you can use the Forward Warp Tool at a very small size to make very minor adjustments to the expression, such as lifting the upper eyelids a little. Make sure to use a very low Brush Pressure setting.

9 If you accidentally drag a little too far with the brush, and make an unnatural shape, simply choose the Reconstruct Tool from the Toolbar and brush over the section to remove the effect. When you're happy with the changes you've made, click OK and Photoshop will return the Liquify result to the layer. back in the Photoshop workspace, flatten the Image via **Layer > Flatten Image**.

6 Choose the Forward Warp Tool from the Toolbar. Set the Brush Size to 118, Density to 50, and Brush Pressure to 7. Now use the tool to gently pull the corner of the

mouth outwards and upwards slightly. Again, be very gentle here, small movements make a big difference! You can also use the brush at this size to nudge the eyebrows up slightly.

Changing Hair and Eye Color

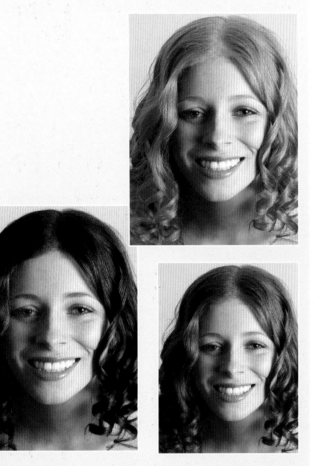

1 Open the original image, and in the Layers palette click on the Create A New Layer icon—it's important that the new layer has a transparent rather than white background. Name the new layer Eye layer and set its blend mode to Color.

3 Set the brush size at around 20 pixels—this is all dependent upon the size of the eye in the picture. Set it so that it is smaller than the eye. Now paint over the colored part of the eye. If you make a mistake, switch over to the Eraser and remove the coloring.

2 Begin by selecting a new color for the eyes. Click on the Foreground color box to bring up the Color Picker. Bear in mind that the result will be lighter and brighter than the color you pick so err on the side of caution and choose a darker color. Zoom in to 200% so that you can see the eye close up. Select the Brush tool and set Opacity to 30%.

4 Complete both eyes, then zoom out so that you can see the effect at Normal size. Reduce the opacity of the eye layer so that the effect looks convincing. For this image, the Opacity was 37%.

A radical change of hair color often reflects a transition between young and old—or from old to older! When you're young, experimenting with bleaching and dyeing processes can produce characterful—or disastrous—results, but is an essential part of teenage rebellion. Later, of course, most of us are desperate to fight the uphill battle to keep our natural hair color by counteracting the onset of gray and the associated signs of aging, but not always in ways that suit us. Well, even if we can't get the color right in real life, how fortunate that you can play with new hair (and eye) colors to your heart's content in Photoshop—and always have the power to change it back in an instant if you don't like it.

7 Ensure you paint the eyebrows as well as the hair so they match, but reduce the brush Opacity to 20%. If you find the color isn't quite what you want, go to **Image > Adjustments > Hue/ Saturation**. Experiment with the Hue/Saturation sliders until you find the right shade and color.

5 Click on the Background layer and select the Sponge tool—it's under the Dodge tool. Ensure the Mode is Desaturate and set the Flow at 50% and paint over the hair, right up to the edges. Then go over it again to completely remove the color.

9 Next, where the background shows through the hair, where the hair fringes the face, or at the parting in the scalp, paint on the mask to reduce the effect. The aim is to restore the background and any skin color that has been changed.

6 Create another new layer in the Layers palette and call it Hair layer. Set the blend mode to Soft Light. Decide on the new hair color you'd like. Set the Opacity of the Brush tool at 100% and paint the middle section. Now reduce the Opacity to 20% and paint up to the edges of the hair. While the Soft Light mode will give a more accurate color, it also means that the paint will show up if you paint on the background. When you think you're done, briefly switch the blend mode to Normal to check the bits you've missed.

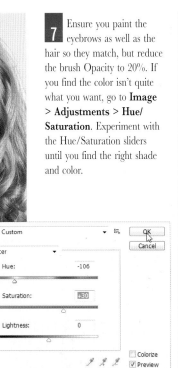

8 With the Hair layer selected, click on the Add Layer Mask icon in the Layers palette. Select the Brush tool and ensure black is the Foreground color. Set the brush Opacity at 20%. Select the mask itself. Zoom in to 100%.

10 If you find that you have let too much of the original hair color back through, switch paint color to white and block it out again by painting on the layer mask. You will need to reduce the brush size to around 10 pixels to pick out loose hairs. Finally, zoom out and check the overall effect, making any necessary adjustments to layer color or opacity. If for example, you change the Lightness value of the hair, you can make it dark or very pale as an alternative. Finally, flatten to finish.

HUMAN CANVAS

Tattoos can look great, but they are quite painful, and permanent. Not if they're Photoshopped, however, where everything starts with the painless Brush tool—or any other that you choose. Use it to create a black and white design.

Once you have your black and white design, there lots of techniques you can use in CS4 to apply the tattoo to your model flawlessly, and we'll cover them all below. The new Color Range feature within the Masks panel makes creating an accurate mask around the lines an absolute breeze, and the simple use of Solid Color layers takes care of the coloring. Layer Blending modes blend the tattoo with the existing tones within the models body.

Of course, to be convincing, the design needs to follow the contours. We can achieve this by using both the Warp command and the Liquify filter, to accurately mould the design around the contors. Painless tattoos, the CS4 way!

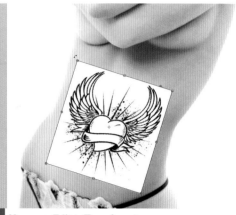

1 Open your figure image. Now open your tattoo design. On the Tattoo design, go to **Select > All**, followed by **Edit > Copy**. Back with the figure image, zoom in to the target area where you want to position the tattoo and go to **Edit > Paste**.

3 Now go to **Edit > Transform > Rotate**. Position your pointer just outside one of the corner handles and drag to rotate the tattoo to a suitable angle. Again, hit the Enter key or click the commit tick in the Options Bar to commit the transformation.

2 Go to **Edit > Transform > Scale**. Hold down the Shift key and grab one of the corner handles around the Bounding Box. Now pull on this handle to size the tattoo to fit the body. Hit the Commit tick in the Options bar to commit the transformation.

4 Now add a little noise to this layer via **Filter > Noise > Add Noise**. Choose Gaussian and Monochromatic and use an Amount of around 14%. Make sure your Foreground color is Black and, in the Masks panel, hit the Add Pixel Mask button. Again in the Masks panel hit the Color Range button.

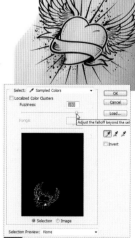

5 Use a Fuzziness value of around 180, or move the slider until no white if visible within the tattoo and click OK. Set the Blending Mode for this layer to Multiply.

11 Go to **Edit > Transform > Warp**. Drag within the mesh to make the tattoo look more natural, flowing the contours of the body. Hit the Commit tick in the Options Bar when you're done.

6 Go to **Layer > New Fill Layer > Solid Color**. Choose whatever color you like from the color picker and click OK. In the Layer palette, set the Blending Mode for this layer to Lighten. So the color shows only over the lines of the tattoo, go to **Layer > Create Clipping Mask**.

7 You can reveal the original black in places by simply painting on to the layer mask attached to the color fill layer with black. Now right-click the layer mask attached to the tattoo layer and choose Apply Layer Mask.

8 To add the colors to the tattoo, choose the Magic Wand Tool and choose the Add To Selection button in the Options Bar. Set the Tolerance to a very low value. Click within the shapes you want to be colored to select them, then click on the Background Layer and go to **Layer > New Fill layer > Solid Color**. Choose your color from the Color Picker and click OK.

9 Set the Blending Mode for this layer to Multiply and reduce the Opacity to around 50%, then right-click this layer and choose Rasterize Layer. Go to **Filter > Noise > Add Noise**. Use an Amount of 4, Gaussian and Monochromatic. Add the other colors using the same procedure.

10 Hold down the Ctrl/⌘ key on the keyboard and click all of the layers above the Background Layer to highlight them. Now go to **Layer > Merge Layers**. Change the Blending Mode for the merged layer to Multiply.

12 Now go to **Filter > Liquify** and check Show Backdrop. Choose the Forward Warp tool and use it at a large size to further mould the tattoo to the form. You can also choose the Bloat Tool and use this at a very large size to bloat parts of the tattoo over the other contours of the body with single clicks.

13 Finally, add a layer mask to this layer via **Layer > Layer Mask > Reveal All**. With the Brush tool, paint with Black to hide any parts of the tattoo that stray over the edges of the body. When you're happy, flatten the image via **Layer > Flatten Image**.

TURNING BACK THE CLOCK

Admit it—you'd love to be younger, wouldn't you? It's fair to say that almost everyone over the age of 35 would love to shave off a few years (and maybe a few wrinkles and gray hairs, too). Alas, without a plastic surgeon and a healthy bank balance, most of us have to be content with looking our age. Until now, that is! With the help of Photoshop you can roll back the years—and even add a youthful head of hair. The biggest weapons for such a project are the Healing Brush and Clone Stamp tool. We can even smooth away a little flesh via the Liquify command. In no time at all, you'll be ten or twenty years younger—in your portraits, at least.

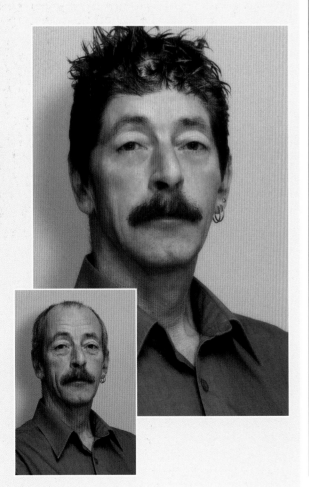

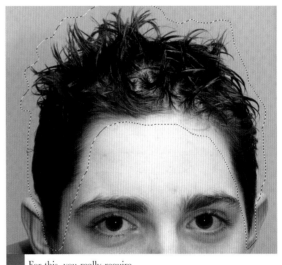

1 For this, you really require an image of a balding man. Nothing takes away the years like adding a good head of hair. Open up your hair source shot. Choose the Lasso tool and make a rough selection around the hair. Go to **Edit > Copy**. Close the file, returning to your main image. Go to **Edit > Paste** to paste the hair onto a separate layer.

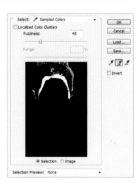

2 To fit the hair to the head, go to **Edit > Transform > Scale**. Drag the handles around the bounding box to size the hair to the head. By dragging inside the box you can position the hair. Hit Enter to commit.

3 Temporarily hide the Background layer by clicking its visibility eye in the Layers palette. Choose the Eyedropper tool from the Toolbar and click in the skin still visible on the Hair layer. Go to **Select > Color Range**. Choose Black Matte from Selection Preview and drag the Fuzziness slider to a value of 50. Click OK to make the selection. Choose the Eraser tool and erase the unwanted skin within the selection. Hit Ctrl/⌘ + D to deselect.

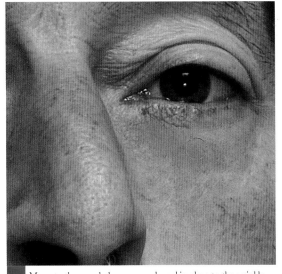

8 By Alt/⌥+clicking on clear areas of skin on the cheek you can clone out the small, broken veins.

4 With the Eyedropper tool, click in a part of the background behind the hair. Go again to **Select > Color Range** and use a Fuzziness of between 70–80. Click OK. Use the Eraser tool to erase this unwanted background. Hit Ctrl/⌘ + D to deselect. Click the visibility eye for the background to make this layer visible. Use the Eraser tool at a very small size and at low opacity (set in the Options bar) to erase any remaining areas of skin or background on this layer.

6 Move to the area below the eyes and begin to clone out the wrinkles over the eye bags. Remember to set your Healing Brush source point regularly by Alt/⌥-clicking with the tool on a section of

clear skin close to the wrinkle you are cloning out. Use the brush at a size which just covers the wrinkle you're healing, modifying the size of the tool with the square bracket keys on the keyboard.

5 Add a new layer for cloning out the wrinkles. Choose the Healing Brush from the Toolbar and click in the Brush Picker. Set the Hardness slider to 20%. Ensure that Aligned and Sample All Layers are checked in the Options bar. Zoom into the forehead. To set the source point for the Healing

Brush, hold down the Alt/⌥ key on the keyboard and click just below one of the frown lines on the forehead, making sure the brush outline is not touching the wrinkle itself but an unwrinkled area of skin. Release the Alt/⌥ key and begin to click along the wrinkle to clone the smooth skin over it.

7 Continue to clone out the wrinkles beneath the other eye using the same method. You can always source another wrinkle-free area of skin from another part of the face, but remember as you move across the image as you are cloning out wrinkles you may need to regularly reset your source point.

9 For the folds of skin above the eyes, change to the Clone Stamp tool as you only want to partially conceal them rather than obliterate them completely. In the Options bar, set the Opacity for the Clone Stamp tool to 40%, making sure that Aligned and Sample All Layers are checked. Again, this tool works in the same way as the Healing Brush, so Alt/⌥+click just next to one of the skin folds to set the source point, and then click directly over the fold to partially hide it.

TURNING BACK THE CLOCK

12 To disguise the gray hairs in the moustache choose the Brush tool and add a new layer (Ctrl/⌘ + Shift + N). Choose a soft brush from the Brush Picker, and select a mid-brown for the Foreground color. Set the blending mode to Darken, and with a small brush set to 50% Opacity in the Options bar, paint over each of the gray hairs.

13 Just how many of the smaller wrinkles you clone out with the Healing Brush is up to you. This is a technique which relies on patience as much as anything else. Use the same technique with the healing brush for these small wrinkles as we've used above, selecting a source point from a smooth section of skin and cloning this over the imperfection.

11 To disguise this crease even further, but still not obliterate it completely, click again on your cloning layer. Choose the Clone Stamp tool again, Alt/⌥ + click within the cheek area to set a cloning source point and carefully clone over the crease with a fairly large brush.

10 There is a crease on the left of the cheek and jaw, but rather than completely conceal this, just make it a little less obvious, so that you keep some contours in the face. Click on the original Background layer and select the Dodge tool from the Toolbar, and in the Options bar set the Range to Shadows and the Strength to 10%. Using the tool at a suitable size (alter this via the square bracket keys on the keyboard), gradually work over the crease to lighten it.

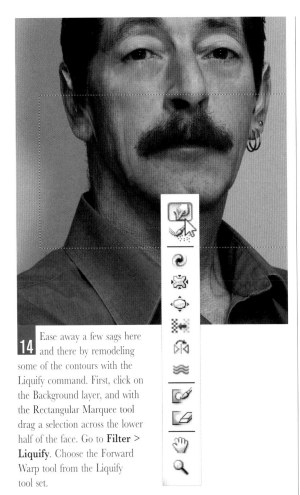

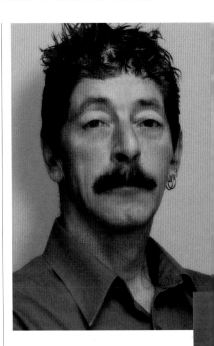

14 Ease away a few sags here and there by remodeling some of the contours with the Liquify command. First, click on the Background layer, and with the Rectangular Marquee tool drag a selection across the lower half of the face. Go to **Filter > Liquify**. Choose the Forward Warp tool from the Liquify tool set.

16 Finally, once you're satisfied with the overall effect, it's time for some careful cleaning up and attention to detail. Check around the hairline. Where the hair meets the ears, use the Eraser tool with a very small brush at low opacity (set in the Options bar) to erase any unwanted parts and achieve an accurate join with the existing features and skin.

18 When you're happy with the result, flatten the image via **Layer > Flatten Image**. To soften the whole image a little, duplicate this Background layer (Ctrl/⌘ + J) and go to **Filter > Blur > Gaussian Blur**. Use a Radius of 14 pixels and click OK. Reduce the opacity of this layer. Here, we want the opacity low enough to soften the skin a little, but still keep the darker feature and hair fairly sharp. A 25% Opacity is about right.

15 Reduce the Brush Size to 88 pixels. Position the brush next to an area of sagging skin and gently push these in toward the face to flatten them. Be subtle here—very small adjustments make a big difference. Click OK to apply the Liquify adjustments.

17 You may find that you need to choose the Clone Stamp tool again and use it to clone out any stray gray hairs over the ears and the sides of the face. Use the tool at a very small size in exactly the same way as you did in the earlier steps to achieve a perfect finish.

ADVANCING THE YEARS

As we grow older, many of us strive to cheat the aging process for as long as possible, sometimes even spending a small fortune in pursuit of everlasting youth. It's difficult, then, to imagine that any of us would want to speed up this process, but that's exactly what we're going to do here—at least digitally. To create the effects of age convincingly, you're going to subtly combine two images, preserving the facial features from one and sourcing the aged skin and complexion from the other. The key to the success of this effect is the careful use of layer masking—allowing you to partially reveal parts of a layer, seamlessly blending wrinkles with the existing features. A simple desaturated layer supplies the essential graying hair to complete the effect.

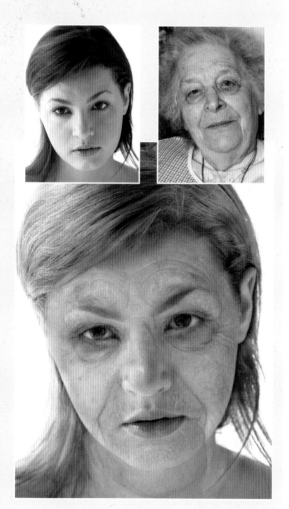

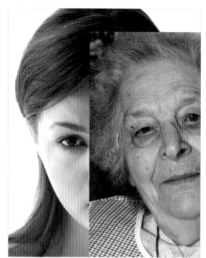

1 Open your source image. You need to overlay older skin onto the image, so after sourcing a suitable image of an elderly woman, open this second (or Wrinkles) image and go to **Select > All** (Ctrl/⌘ + A), and then to **Edit > Copy** (Ctrl/⌘ + C). Close this image, returning to the young face and go to **Edit > Paste** (Ctrl/⌘ + V). To help position the two heads, reduce the Opacity of the Wrinkles layer to 50%. Go to **Edit > Transform > Rotate** and rotate the Wrinkles layer to the eyes of both heads are level. Hit Enter to commit the rotation.

2 To scale the Wrinkles layer, go to **Edit > Transform > Scale**. Shift and drag the corner handles on the bounding box to size the head to fit the underlying one. Just ensure that the main wrinkles in the face, bags beneath the eyes, mouth, and nose match up. Check Commit in the Option bar when you're happy with the positioning.

3 Return the Opacity of the Wrinkles layer to 100%. Hide this layer with a layer mask, via **Layer > Layer Mask > Hide All**. You'll notice that the new layer mask attached to this layer is filled with black. You're going to paint onto this mask with white as the Foreground color to expose some of the wrinkles. Choose the Brush tool. Click in the Brush Picker and choose a soft brush. Set the Opacity of the brush to 25% in the Options bar.

4 Make sure you're working on the layer mask by clicking on it in the Layers palette. Select white for the Foreground color and begin to paint around the eyes and forehead. Remember you can use the square brackets keys ([and]) to quickly alter the size of the brush. Because we're using the brush at low opacity you will need to paint over the same areas a number of times to make selected wrinkles more obvious.

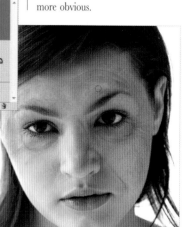

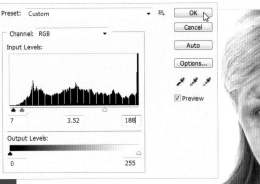

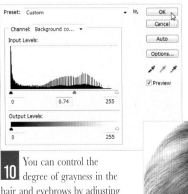

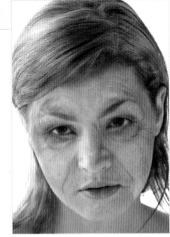

5 Continue to paint over the rest of the large areas of the face, avoiding the lips. Don't overdo this stage—we're just attempting to generally change the majority of the skin texture. Keep the wrinkles visible, but subtle, by not painting too heavily on any one area.

6 Open the Wrinkles image again and choose the Rectangular Marquee tool. Make a selection around the right eye. Go to **Edit > Copy** (Ctrl/⌘ + C). Return to the main image and go to **Edit > Paste** (Ctrl/⌘ + V). Go to **Edit > Transform > Distort**. Use the handles on the bounding box to size this eye so that it matches the underlying one, positioning it accurately. You may find it easier to match the eyes if you reduce the Opacity of the pasted eye while positioning it. Once you're happy return the Opacity to 100%.

7 Got to **Layer > Layer Mask > Hide All**. Paint with your brush onto the mask with white to expose just the eyelids, top and bottom, from this layer. Be careful not to expose the pupil from this layer, and ensure that you blend the lids in with the face by using the brush at very low opacity at the edges.

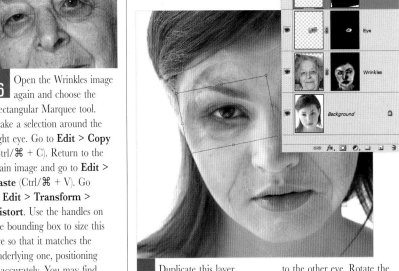

8 Duplicate this layer (Ctrl/⌘ + J) and go to **Edit > Transform > Flip Horizontal**. Go to **Edit > Transform > Rotate** and drag this eyelid copy layer over to the other eye. Rotate the eyelids to match the position of the eye by placing the mouse pointer over the corner of the bounding box and dragging. Hit Enter.

9 Click on the Background layer and duplicate it (Ctrl/⌘ + J). Go to **Image > Adjustments > Desaturate** (Ctrl/⌘ + Shift + U). Then select **Image > Adjustments > Levels**. In the Input Levels boxes enter the following from left to right 7, 3.52, and 188. Click OK. Hide this layer with a mask via **Layer > Layer Mask > Hide All**. Return to the Brush tool and paint carefully over the hair with white on the layer mask. Paint over the eyebrows at low opacity.

10 You can control the degree of grayness in the hair and eyebrows by adjusting the levels on this layer mask. Make sure you're working on the mask itself (by checking for a solid outline around its icon in the Layers palette), and go to **Image > Adjustments > Levels**. By dragging the midpoint slider to the right, you can reduce the visibility of the gray hair for a more subtle effect.

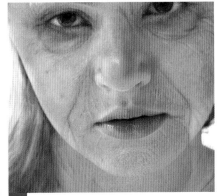

11 When you're happy with the degree of ageing, flatten the image via **Layer > Flatten Image**. For the final touches, choose the Sponge tool, set it to Desaturate in the Options bar, and use this over the lips to remove some of the color. Correct any patches in the skin with the Healing Brush tool.

LENS AND BACKGROUND EFFECTS

IMPROVING HOLIDAY PHOTOS

When you're busy having fun on holiday, photographs are generally snapshots—transient moments captured on the spur of the moment, with little consideration given to lighting, depth of field, and composition. However, it's surprising just how much the snap can be improved upon in Photoshop. In this project, you'll introduce some depth of field to throw the background elements out of focus, add a flattering soft-diffusion effect, create a border with a layer mask, and add some text. This is a great way to extend the holiday mood once you get home and preserve those cherished moments with a little more flair.

1 First you need to perform a little judicious cropping on the image to improve the composition and focus attention on the subject. Choose the Crop tool and drag a crop around the image. Adjust the handles around the crop box so that the child is central in the image. Hit Enter to commit the crop.

4 When you've completed the mask, hit Q on the keyboard to exit Quick Mask mode. Now save this selection by going to **Select > Save Selection**, naming it Blur Mask. Duplicate the Background layer via **Layer > Duplicate Layer**. Hit Ctrl/⌘ + D to deselect and go to **Filter > Blur > Lens Blur**.

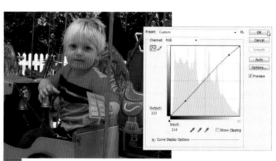

2 Next, boost the contrast a little. Go to **Image > Adjustments > Curves** and make a very slight S-shape in the curve by adding two points (by clicking on the line) and dragging them in opposite directions. Click OK to apply the adjustment.

3 To throw the background elements out of focus, create a selection to use with the Lens Blur filter. Choose the Brush tool and select a hard brush from the Brush Picker. Enter Q to activate Quick Mask mode. Now, with black as your Foreground color, paint a quick mask over the main foreground figure. Take care to accurately paint over all parts that you wish to remain in focus in the final image.

5 In the Lens Blur dialog, choose Blur Mask from the Depth Map box. Set the Blur Focal distance to 22. Set the Radius slider to 32. For Specular Highlights, set the Brightness to 2, and Threshold to 60. Set the Noise amount to 17 and choose Uniform and check Monochrome. Click OK to apply the blur.

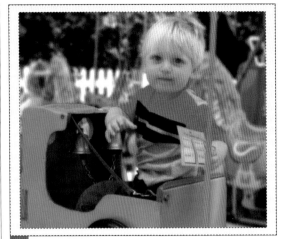

6 Now add a subtle soft focus diffusion to the image. First, flatten the layers in the image via **Layer > Flatten Image**, then duplicate the flattened Background layer (Ctrl/⌘ + J). Go to **Filter >** **Blur > Gaussian Blur** and use a Blur Radius of 9 pixels. To soften this layer very slightly, while retaining some fine detail, reduce the Blur layer Opacity to 40%.

8 To create the border, click on the main image and add a layer mask via **Layer > Layer Mask > Reveal All**. Choose the Rectangular Marquee tool and drag a selection a little way inside the edge of the image. Go to **Select > Inverse** (Ctrl/⌘ + Shift + I), and fill this inverted selection with black via **Edit > Fill**. Hit Ctrl/⌘ + D to deselect.

10 Finally, add some text to the image. Choose the Horizontal Type tool from the Toolbar and click at the bottom of the image. Type your line of text and then click and drag over the text to highlight it. Choose a suitable font face, size, and color from the Options bar. Hit Enter to commit the type.

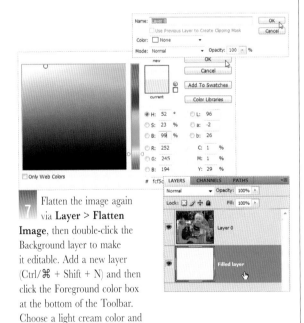

7 Flatten the image again via **Layer > Flatten Image**, then double-click the Background layer to make it editable. Add a new layer (Ctrl/⌘ + Shift + N) and then click the Foreground color box at the bottom of the Toolbar. Choose a light cream color and go to **Edit > Fill**, choosing Foreground color for Contents. Drag this layer below the image layer in the Layers palette.

9 Next, break up the edge of the border a little. Ensure that you're still working on the layer mask by clicking its thumbnail in the Layers palette. Go to **Filter > Brush Strokes > Sprayed Strokes**. Use a Stroke Length of 8, and a Spray Radius of 23. Click OK to apply the filter to the layer mask, then go to **Layer > Flatten Image** to flatten the image.

11 To add some extra decoration to the text, go to **Window > Styles**, and choose a style from the swatches in the Styles palette. When you're happy with the style flatten the image (**Layer > Flatten Image**) and save.

INSTANT STUDIO BACKGROUND

While we would all like to be able to afford to have our portraits shot in an expensive studio for that professional look, it just simply isn't possible for most of us. But fortunately we have Photoshop to help us emulate the studio look without going to the expense. All you need is a plain background when shooting your original portrait. The color isn't important as long as it contrasts with the subject. For subjects with dark hair and bright clothes, a white background is best, but for those with fair hair a dark background is preferable.

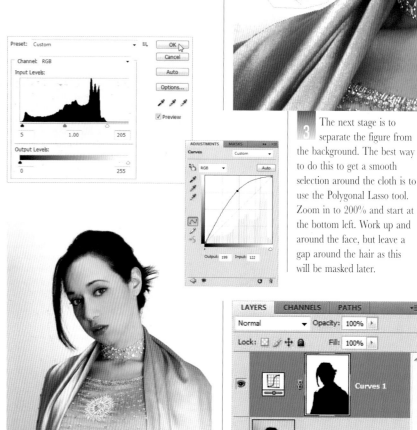

3 The next stage is to separate the figure from the background. The best way to do this to get a smooth selection around the cloth is to use the Polygonal Lasso tool. Zoom in to 200% and start at the bottom left. Work up and around the face, but leave a gap around the hair as this will be masked later.

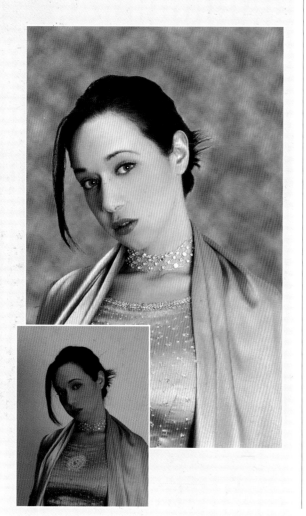

1 The subject in this portrait is standing against a white wall. The original picture was underexposed, which is why the wall looks gray and the subject a little too dark. The first task is to sort out the Levels and expand the tonal range. Moving the white slider to the left lightens the subject and the walls, returning them to their original color. However, for a brighter wall, create a Curves adjustment layer in the Layers palette and use the curve to brighten the image.

2 Select the Brush tool at 100% Black to paint on the layer mask, blocking out the effect of the Curves adjustment, to make sure the wall remains the only affected area. However, the subject is still too dark, so select the Eraser tool, set Opacity to 25% and erase over the face, neck, and a little of the dress in the mask. This reduces the mask in those areas, enabling the brightening effect of the Curve through. Go to **Layer > Merge Visible** to merge the layers at this point.

4 Go to **Select > Modify > Contract** and enter a value of 2 pixels to contract the selection. Then go to Select again and feather it by 1 pixel.

Press Ctrl/⌘ + C to copy and Ctrl/⌘ + V to paste as a new layer. Rename this layer Subject layer.

6 Click on the Subject layer, which you'll see has a white halo around it. Click on the Add Layer Mask icon in the Layers palette and select the Brush tool. Choose black as the Foreground color and white as the Background. Set the brush Opacity to 100% and brush in toward the head.

5 The Subject layer sits on the top, so click on the Background layer. Select a color for the studio background that you want. If you leave the Background color as white, the backdrop will be quite light, whereas if you select black it will have the opposite effect. A smarter option is to select two shades of the same color using the Foreground/Background boxes at the bottom of the Toolbar (here, I've chosen purples) that will merge together, making the backdrop less intrusive. Go to **Filter > Render** and select Clouds to fill the background.

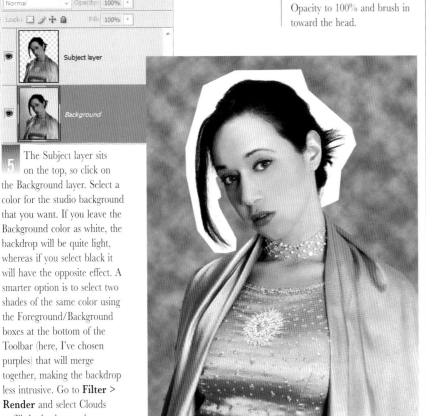

7 When you get close up, change to 60% Opacity, and brush up to the hair. To tackle the gaps in the hair, reduce the Opacity to 20% and make the brush size no larger than 10 pixels. Paint into the gaps in the streaks of hair—just enough so that you can see the purple background rather than a white one.

8 When complete, examine the mask and effect. If you think the hair looks too straggly use the Soften brush on the edges. Otherwise, flatten the layers and save.

CROPPING FOR EFFECT

1 Open your source image and choose the Crop tool from the Toolbar. Click and drag a crop around the subjects' heads. Don't worry too much at this stage about the accuracy of the crop area, you can adjust this more accurately once a crop area has been set.

On first sight, many images might seem to be complete failures in terms of composition and impact, and yet many of these images can be saved from the trash can and transformed into truly memorable pictures by a little judicious cropping in Photoshop. The Crop tool itself is often seen as pretty much of an "also-ran" in terms of the toolset in Photoshop, but, when used with imagination and care, it can save the day when it comes to creating pictures that work.

One of the real strengths of the tool is that you can experiment with your crop area to your heart's content before actually committing yourself. So here we'll look at extracting a portrait that really works from a seemingly messy and cluttered snapshot.

2 To make the crop area clearer, you can change the color of the overlay for the cropped area. Click in the Color swatch in the Options bar and choose a more contrasting color for the crop shield. Bright red is good for easily distinguishing the crop area.

3 Adjust the crop area more accurately by dragging on the individual handles around the crop box. Clip the top and sides of the heads, where appropriate, to concentrate attention on the faces.

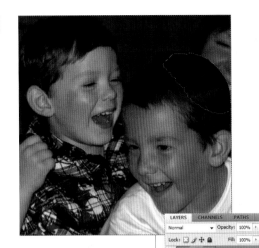

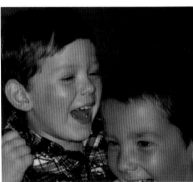

4 Once you're happy with the crop, either check Commit in the Options bar or hit the Enter key.

5 While the cropped image is a big improvement on the original, as is so often the case you still need to do a little cleaning up here and there. Take care to clone out the remaining parts of other figures behind the boys. Enter Quick Mask Mode by hitting Q on the keyboard. Now choose the Brush tool and select a small, hard brush from the Brush Picker.

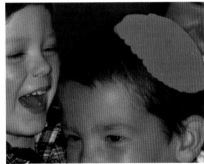

6 Hit F5 to display the Brush Properties dialog and click in the Brush Tip Shape category. Set the Hardness slider to 70%. Use this brush, with black as your Foreground color, to paint over the back of the subject's head to separate it from the figure behind. Take your time with this, making sure to paint over the stray hairs and keep to the outline. You may need to adjust the size of the brush, using the square bracket keys on the keyboard.

7 When you're done with the Quick Mask, hit Q again to generate the selection. Add a new layer for the cloning (Ctrl/⌘ + Shift + N). Select the Clone Stamp tool from the Toolbar. Check Aligned and Sample All Layers in the Options bar.

8 With the selection still active, and working on the new layer, position the mouse pointer on a section of background above the subject's head. Hold down the Alt/⌥ key and click to set the cloning source point. Begin to click over the figure's face, with your brush size fairly large. You may find you need to choose your source point again periodically when you get too close to the heads.

9 To finish off, zoom in to the top of the subject's head and deselect (Ctrl/⌘ + D). Use the Clone Stamp tool at a very small size to clone out any tiny parts of unwanted areas still visible between the edge of the hair and the background.

BODY ABSTRACT

Nowadays, the old adage that the camera never lies is actually pretty far from the truth. In this exercise, you'll start with an obvious body shot, and create a singularly abstract image with a little simple cropping and the use of a blending mode. The result is a very graphic, abstract image, and yet one that still retains all the subtle contours and tonal nuances of the human form. This is an opportunity to use the largely ignored Crop tool with a little more imagination than usual. You'll make a couple of adjustments to the tool itself to make the crop area more effective, and even use the tool to *add* some canvas area rather than take it away!

Choose the Crop tool from the Toolbar. Click and drag a crop box anywhere within the image. By default, Photoshop renders the crop shield in black at 75% Opacity, but this can be a bit distracting and make it difficult to compose your crop. To change this, click in the Shield color swatch in the Options bar and select a mid-gray. Increase the shield Opacity to 100%. This will make your cropped area more obvious and easier to define.

You can alter the size and shape of the crop by dragging on the handles around the bounding box. Remember, what you're looking for here is an abstract final image. You can find the best area to achieve this end simply by dragging your crop box around the image. Click and drag within the box to do this.

The area you settle on for the crop is a matter of personal choice. Fine-tune the actual size of the crop with the handles around the box and hit the Enter key on the keyboard to make the crop.

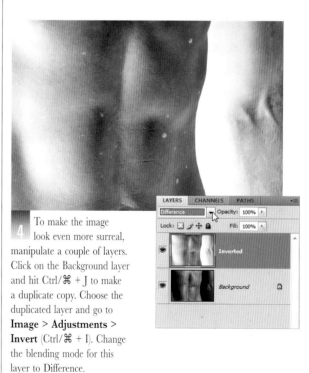

To make the image look even more surreal, manipulate a couple of layers. Click on the Background layer and hit Ctrl/⌘ + J to make a duplicate copy. Choose the duplicated layer and go to **Image > Adjustments > Invert** (Ctrl/⌘ + I). Change the blending mode for this layer to Difference.

5 Apart from simple cropping, the Crop tool can be used as a really quick and efficient way to extend the canvas size, which can be incredibly useful for creating borders. Click the Background color swatch and choose a color for your border.

7 Add a drop shadow to the image via **Layer > Layer Style > Drop Shadow**. In the Drop Shadow dialog choose 45 for Distance and 92 for Size. Click OK to apply the Layer Style.

6 Choose the Crop tool again and drag inside the entire image. Now drag the central handles on each side of the box outside the image boundaries. Make sure that the border is equal on the left and right side, with a little less depth at the top and about double the depth at the bottom. Hit Enter to apply the crop. The empty border surrounding the image will be filled with your background color.

8 To add the second border to the image, hold down the Ctrl/⌘ key on the keyboard and click the image thumbnail for the Difference mode layer to generate a selection from its transparency. Go to **Edit > Stroke**, choose 35 pixels for the Stroke Width and Inside for Location. Click in the Stroke color swatch and choose White. Click OK to apply and Ctrl/⌘ + D to deselect. Because of the blending mode applied to this layer, this border will not appear fully opaque, but will interact with the Background layer.

DEPTH OF FIELD

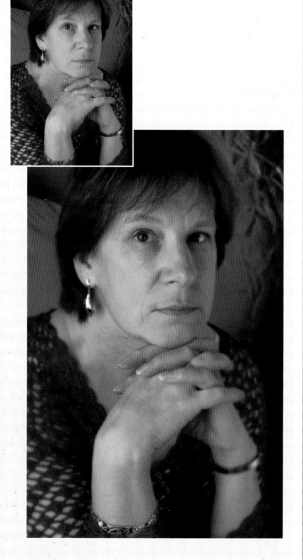

Controlling depth of field in-camera can be a tricky business, especially for amateur photographers. The elements within an image that are in focus, and those that are out of focus, can be affected by many variables, including the focal length of the lens and the aperture selected when shooting the image. A far more reliable method of controlling depth of field—after the shutter has clicked—is to use Photoshop's powerful Lens Blur filter. This filter is your one-stop shop when it comes to accurately controlling depth of field.

1 First, duplicate the Background layer by dragging it to the Create A New Layer icon in the Layers palette (or hit Ctrl/⌘ + J). It's always sensible to do this so you have an unaltered layer to return to should you need to. You need to create a Depth Map to use with the Lens Blur filter, so hit D on the keyboard to revert to the default black/white Foreground and Background colors. Hit X on the keyboard to swap these so that white is Foreground.

2 Click on the Quick Mask icon at the bottom of the Toolbar (Q), then choose the Gradient tool. Click in the Gradient Picker in the Options bar and choose Foreground to Background from the swatches.

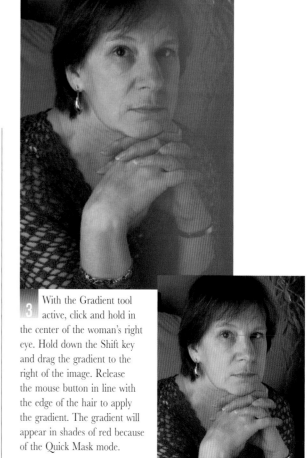

3 With the Gradient tool active, click and hold in the center of the woman's right eye. Hold down the Shift key and drag the gradient to the right of the image. Release the mouse button in line with the edge of the hair to apply the gradient. The gradient will appear in shades of red because of the Quick Mask mode.

4 Hit D to swap your colors again and choose the Brush tool. Select a soft brush from the Brush Picker and paint over the woman's right-hand shoulder and arm, so that these areas will be thrown out of focus too.

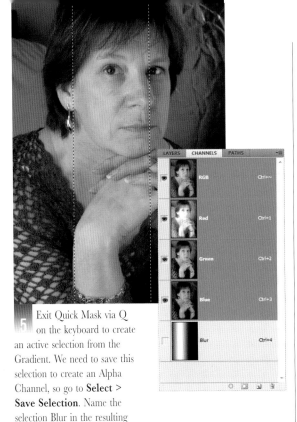

5 Exit Quick Mask via Q on the keyboard to create an active selection from the Gradient. We need to save this selection to create an Alpha Channel, so go to **Select > Save Selection**. Name the selection Blur in the resulting dialog box and hit OK. This new Alpha Channel will now be visible in the Channels palette.

7 The Iris Shape mimics the actual shape of the aperture in a camera, so leave this set to the default Hexagon. The actual degree of blur is controlled with the Radius slider. You can adjust this to whatever value you wish, but the best results come from using just a modest amount. Here, I set the Radius to 43 for a moderate blur.

9 For extra realism, add a tiny amount of Noise to the blurring with the Noise slider. A value of just 1 or 2 will do here. Choose Uniform for Distribution and check Monochrome. Finally, click OK to apply the filter to the image. This filter can often take quite a while to apply, so be patient.

6 Now for the Blur. Hit Ctrl/⌘ + D to deselect and go to **Filter > Blur > Lens Blur**. From the Depth Map Source box, choose Blur (the Alpha channel you've just made). You want to restrict the "in-focus" areas to just the white parts of the gradient we made, so drag the Blur Focal Distance slider up to the maximum of 255.

8 For the Specular Highlights (areas where out-of-focus highlights "bloom" in the lens), choose your desired level of intensity with the Brightness slider. Reduce the Threshold setting very gradually, just by one point at a time, to control the amount of these highlights.

10 You can fine-tune the intensity of the effect by adjusting the opacity of the lens blurred layer in the Layers palette. Finally, flatten the image via **Layer > Flatten Image** before saving.

DIFFUSE EFFECTS

In the Layers palette, duplicate the Background layer (Ctrl/⌘ + J) and call this Working layer. Zoom in and select the Clone tool. Set the size to around 10 pixels and the blend mode to Lighten. Set the Opacity to 50%. The idea is to soften the effect of wrinkles, not to remove them completely at this stage. Sample from below each wrinkle next to the eye and make one or two passes.

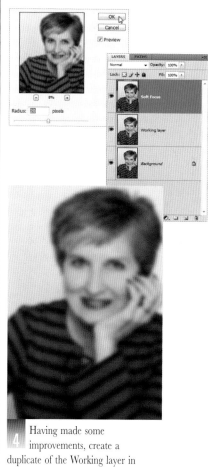

To improve the eyes, select a much larger, feathered brush, set the blend mode to Normal and the Opacity to 20%. Sample from below the eyes and make a sweep across the baggy eye area, taking care not to paint into the eye or to produce a repeated pattern. Make a couple of brushes around the chin and cheek areas to soften them.

Different types of portrait require different kinds of effect. Some portraits need to be pin-sharp, while others require a shallow depth of field to block out the background and focus attention on the subject. For some portraits an overall soft, diffused effect is appropriate. Obviously, you have to be a little judicious with this effect, but used subtly—with some lines and age effects reduced and removed—it produces a fresher, brighter result.

Keep the same settings and work in and around the eye, and where there are skin blemishes. Move down to the lines around the mouth. When you reach the mole, change the blend mode back to Normal and paint over it a couple of times to remove it completely. Go to the other side of the face and tackle the wrinkles there.

Having made some improvements, create a duplicate of the Working layer in the Layers palette and call it "Soft focus." Now, go to **Filter > Blur > Gaussian Blur** and enter a value of 20 pixels. Apply it.

Create a duplicate of the Soft focus layer and call it Blur layer. Run the Gaussian Blur filter on the Blur layer and enter a value of 2 pixels to soften the edges.

Set the background color to white then go to **Filter > Distort > Diffuse Glow**. Set the Graininess to 0, the Glow Amount to 1, and the Clear Amount to 15. This gives the face a subtle, healthy-looking glow.

Set the blend mode of the Soft focus layer to Overlay then make the Background layer invisible. Now go to **Layer > Merge Visible**. This combines the two edited layers, making the image softer but with richer colors.

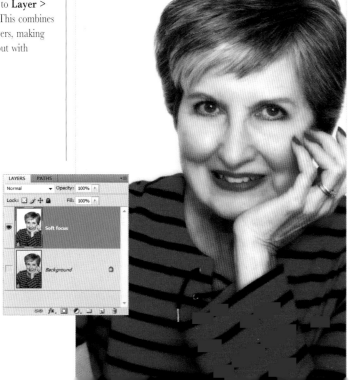

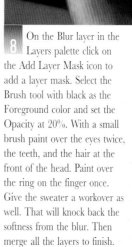

On the Blur layer in the Layers palette click on the Add Layer Mask icon to add a layer mask. Select the Brush tool with black as the Foreground color and set the Opacity at 20%. With a small brush paint over the eyes twice, the teeth, and the hair at the front of the head. Paint over the ring on the finger once. Give the sweater a workover as well. That will knock back the softness from the blur. Then merge all the layers to finish.

VIGNETTES

Of the various definitions of "vignette," the one that is most relevant here, and which has become widely known, is a small portrait, normally kept in a locket. This concept was extended to include a printing technique on the paper itself, whereby what is known today as an edge effect was used to encircle the subject in the image, removing the traditional rectangular shape of the frame and focusing more attention on the subject. Digitally, this is easy to do, and a variety of effects can be used to produce a modern or more classical finish.

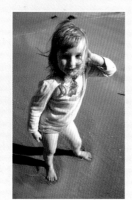

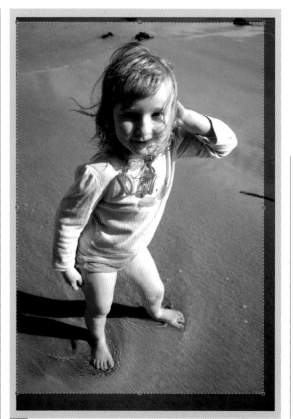

1 The first consideration is the placement of your subject in the portrait. Is she or he centered well enough so that the vignette effect won't interfere? In this original, the subject is slightly off-center, so you must first use the Crop tool to trim the picture so that the subject is central in the image.

2 In the Layers palette create a new blank layer by clicking the Create A New Layer icon. Use the Paint Bucket tool and fill the new layer with white. Name it the White layer.

3 Reduce the layer Opacity to 75% so that you can see what you are doing.

4 Select the Elliptical Marquee tool and drag from the top left to the bottom right of the picture. If the selection is too small, simply click outside it and try again.

If the selection is the right size but in slightly the wrong position, click and drag from inside the selection to move it into position.

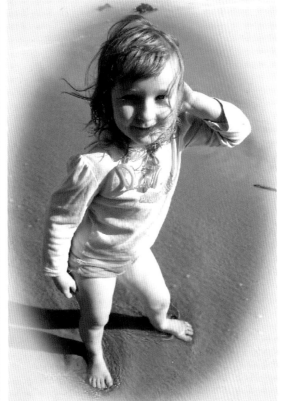

7 Remove the selection and merge the layers. Next, consider a more traditional alternative. Go to **Image > Adjustments > Desaturate** (Ctrl/⌘ + Shift + U).

Ordinarily, you would use the Channel Mixer for black-and-white images, but sepia-toned portraits suit a desaturated effect, rather than heavy contrast.

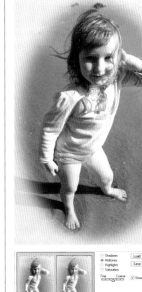

8 Go to **Image > Adjustments > Variations** and add a dash of yellow and red to the image until you achieve a suitably sepia finish. You should now have a more traditional-looking vignette.

Feather Radius: 75 pixels

OK

Cancel

5 Go to **Select > Feather** and enter a value of 75 pixels.

6 Next, go to **Edit > Clear** to remove the middle of the White layer and reveal the subject beneath. At this point you have the option of leaving the layer opacity as it is to produce that subtle background effect or selecting 100% Opacity to remove the exterior entirely.

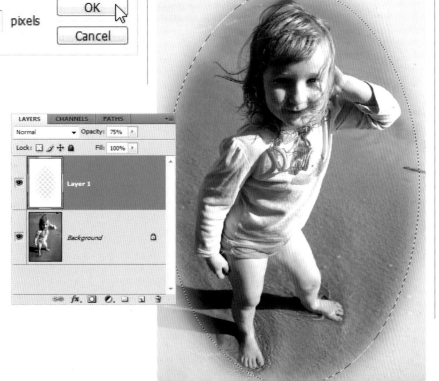

SUPER WIDE-ANGLES

In terms of portrait photography, it's perceived wisdom that wide-angle lenses are not suited to shooting portraits—they exaggerate perspective, and, as a consequence, distort features and limbs. However, the deliberate use of super-wide angle lenses can produce some very quirky portraits. In this exercise you'll simulate this wide-angle effect in Photoshop. Photoshop CS2 introduced a new command that is ideally suited to this effect: the Warp command allows you to stretch and distort an image live on screen.

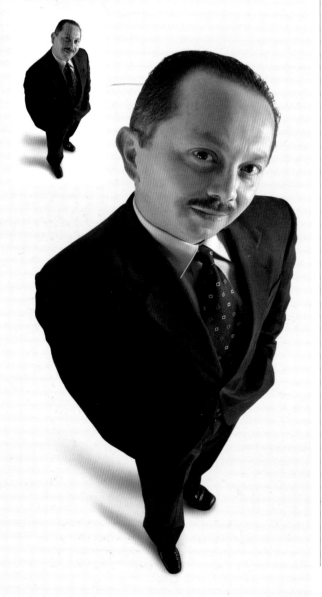

1 For this effect, use the Warp command. Duplicate the Background layer (Ctrl/⌘ + J) and choose the Rectangular Marquee tool from the Toolbar. Make a selection around the head and then Ctrl/⌘-click within the selection, choosing Layer Via Copy from the sub-menu to paste a copy of the head onto a separate layer.

3 Now you have more space to work with, choose the Move tool and drag the head down the canvas a little. Time for the warp. Go to **Edit > Transform > Warp**. Grab one of the inner dot handles at the top of the Warp box and drag it upward. Repeat with the other inner dot handle at the top.

2 On the Head layer, go to **Edit > Transform > Distort**. Pull each of the top corner handles outward and upward a little to increase the size of the upper half of the head. Hit Enter to commit the transformation.

4 Drag each of the corresponding dots at the bottom of the box downward.

5 Drag the dots on each side of the box outward. At this point you'll begin to see the spherical distortion appearing in the face.

6 Drag each of the four grid intersections within the box out toward the corners a little. Hit Enter when you're happy with the shape of the head to apply the transformation.

7 With the Move tool, move the head back in to the correct position, using the collar and tie as guides. Click on the Background Copy layer and return to **Edit > Transform > Warp**. This time, drag the upper outer corners of the box outward to broaden the shoulders.

8 Drag the bottom corner handles inward and upward to shorten the perspective on the figure and to narrow the lower half of the body. Finally, drag the two lower direction handles inward a little. Hit the Enter key to commit the transformation.

9 In the Layers palette select the Head layer and then holding down the Shift key select the Background Copy layer, so that both are selected. Return to the main image and use the Move tool to drag both the head and body down the canvas.

10 Click on the head layer and use the Eraser tool to erase any unwanted parts of the collar on this layer to blend the head in with the collar on the layer beneath.

11 Click on the original Background layer and go to **Edit > Fill**, choosing White for Contents. Flatten the image via **Layer > Flatten Image**. Finally, correct any misaligned outline by painting over it with white using the Brush tool.

MIRROR IMAGE

Apparently, the most beautiful faces are those that are very close to being symmetrical. Sadly, for the majority of us, a little lopsidedness is a reality. However, as the tutorials in this book demonstrate, with Photoshop in your digital armory, anything is possible. In this project, you're going to construct a symmetrical image of a face by duplicating and flipping one half of the image itself. Ultimately, this technique will help you to create some very unusual and striking portraits, which have an intriguing and effective twist.

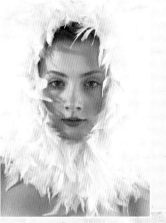

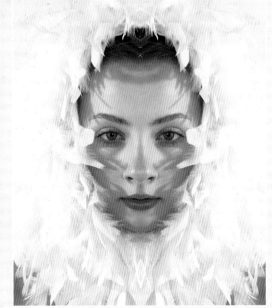

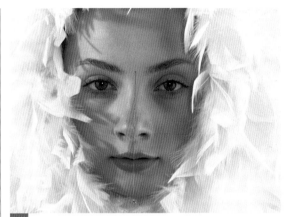

1 To create the symmetrical face, you first need to make sure that the face itself is perfectly plumb within the canvas. Click and hold on the Eyedropper tool and choose the Measure tool from the fly-out. Zoom into the image and click and hold with the tool on the center point between the eyebrows. Drag the tool downward, intersecting the central point of the mouth, and release the mouse button at the chin.

2 There's a quick way of rotating the canvas so that the measure line is perfectly upright. Go to **Image > Rotate Canvas > Arbitrary**. Photoshop will automatically enter the required rotation amount based on the line you've drawn, so simply click OK to rotate the canvas.

3 Next, position a guide to accurately select exactly one half of the face. Display the Rulers via **View > Rulers**. Click in the left-hand ruler and drag a guide across the face, releasing the mouse button when the guide is perfectly central between the features.

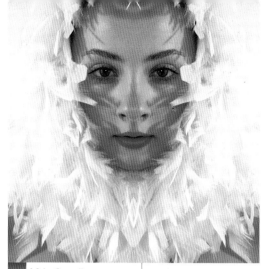

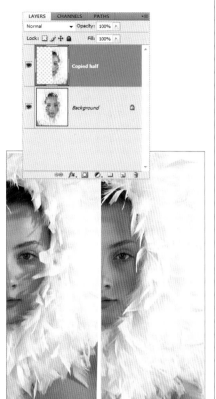

7 Make fine adjustments with the arrow keys, making sure that the two halves match up perfectly with no hard, dividing lines between them.

4 Next, make the selection to copy. Choose the Rectangular Marquee tool and set the Style to Normal in the Options bar. Go to **View > Snap** so that the selection will snap exactly to the guide. Starting in the top-left corner, drag the selection over the entire left half of the image.

5 With the selection active, go to **Edit > Copy** (Ctrl/⌘ + C). Go to **Edit > Paste** (Ctrl/⌘ + V) to paste a copy of the left half of the image onto a separate layer. To flip this layer go to **Edit > Transform > Flip Horizontal**.

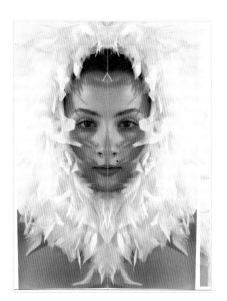

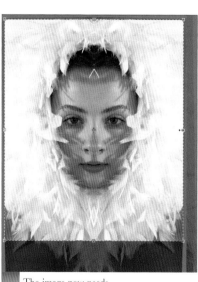

6 Click on the Move tool and use the right-pointing arrow key on the keyboard to gradually move this pasted half across the image so that its left edge lines up with the guide running down the center of the image. When the layer is roughly in position, go to **View > Clear Guides**.

8 The image now needs cropping. Choose the Crop tool from the Toolbar, and drag a crop around the image, discarding any blank areas and the chest area. Check Commit in the Options bar to apply the crop.

9 In this image, there's an unsightly inverted V shape that has been made by copying one half of the image. You'll often find with this technique that there are anomalies such as this, but they are easily dealt with. Add a new layer to the image (Ctrl/⌘ + Shift + N) and choose the Healing Brush from the Toolbar. Choose a soft brush from the Brush Picker and Alt/⌥-click directly to the side of this V. Now carefully click over the white V itself to conceal it. You may find it helpful to change the mode of the Healing Brush to Replace in the Options bar. As soon as you're happy, select **Layer > Flatten Image** and save.

MOODY PORTRAIT

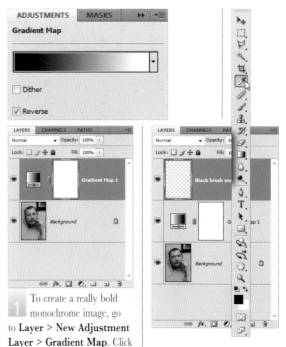

1 To create a really bold monochrome image, go to **Layer > New Adjustment Layer > Gradient Map**. Click OK. In the resulting Gradient Map dialog, click on the arrow and choose the Black/White swatch—it's third from left. Click OK.

2 Add a new layer (Ctrl/⌘ + Shift + N), call this Black Brushwork, and choose the Eyedropper tool from the Toolbar. Click with the tool in the darkest tone in the hair. Select the Brush tool and choose a soft brush from the Brush Picker. Now paint out the unwanted background around the head and shoulders. Use the brush at a lower opacity (set in the Options bar) near the outline of the head itself to achieve a good blend between the head and the background.

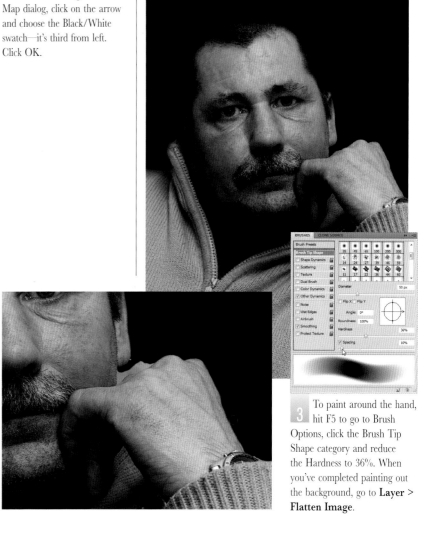

3 To paint around the hand, hit F5 to go to Brush Options, click the Brush Tip Shape category and reduce the Hardness to 36%. When you've completed painting out the background, go to **Layer > Flatten Image**.

Black-and-white portraits can be wonderfully atmospheric and convey powerful emotion. Add a touch of grain to this recipe, together with a measure of dramatic lighting, and the finished image can be very arresting indeed.

To create such an image from a fairly run-of-the-mill snapshot, you need to make some careful adjustments to the tones in the image. Rather than use the Dodge and Burn tools for modifying these tones, we'll use a layer filled with 50% Gray, with its layer blending mode set to Overlay. By painting onto this layer with black and white, we can selectively lighten and darken the tones in the image. We'll go on to add the required grain using one of Photoshop's stock filters.

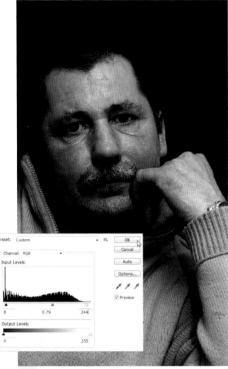

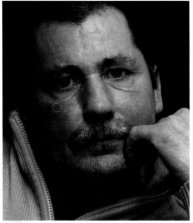

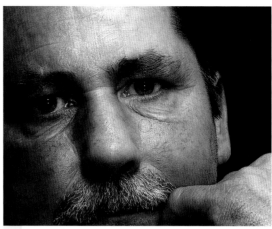

6 Choose the Brush tool and select a soft brush from the Brush Picker. Hit D on the keyboard to revert to default black/ white Foreground/Background colors. Make sure you have the 50% Gray layer selected in the Layers palette. Using this brush at 15% Opacity (set in the Options bar), and with black as Foreground, paint over the mid- to dark tones in the face. Because of the special nature of this layer set to Overlay mode, your painting will gradually darken these tones.

8 Hit X so that you're now painting with white. This time, still working on the 50% Gray layer, paint over the lighter tones in the image. Because you're painting with white this will lighten these tones. Again, modify these tones little by little, working over the same areas again to lighten them even more.

4 On the flattened image, go to **Image > Adjustments > Levels**. Enter the following value into the Input Levels boxes from left to right 8, 0.79, and 244.

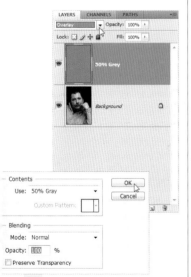

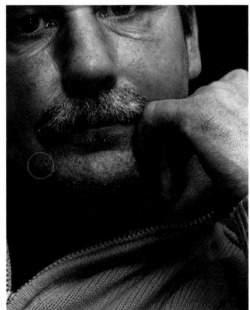

5 Next, adjust the tones in the image. Add a new layer (Ctrl/⌘ + Shift + N) and go to **Edit > Fill**. In the Fill dialog, choose 50% Gray from the Contents drop-down. In the Layers palette, set the blending mode to Overlay.

7 Remember, you are selectively darkening the existing mid- and dark tones in the image. Use the brush at a suitable size for the particular area, and slowly build up the tones by working repeatedly over certain areas. Continue to paint with this brush over the darker midtones throughout the image, dramatically darkening them.

9 Flatten the image via **Layer > Flatten Image**. Duplicate the resultant Background layer (Ctrl/⌘ + J). Go to **Filter > Texture > Grain**. In the Grain dialog, choose Sprinkles for Grain Type. Set the Intensity to 47, and Contrast to 54. Set this Grain layer to Soft Light in the Layers palette. Once again flatten the image and save.

HALFTONE BLACK AND WHITE

In commercial terms, the most effective and economical way to print grayscale images is halftone printing. But there is more to halftone printing than simply producing a newspaper at minimal cost. The process itself uses a screen to render the original image as a collection of black dots at various sizes to render the tones of gray optically. The results of this process, taken to the extreme, can be used to create very striking images, with powerful graphic impact. Fortunately, Photoshop has a Halftone filter of its own, which you can use to create the effect, and it's worth looking more closely at the options and variables that this filter contains. Halftone is the way to create modern, graphic portraits with real impact.

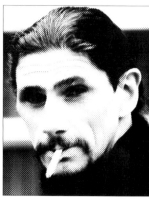

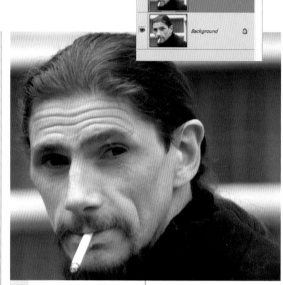

1 To begin the halftone conversion, we desaturate the image first. Duplicate the Background layer (Ctrl/⌘ + J). Next, go to **Image > Adjustments > Desaturate** (Ctrl/⌘ + Shift + U).

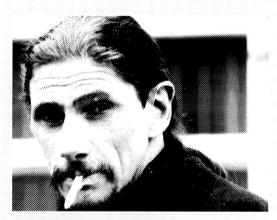

| Brightness: | 6 |
| Contrast: | 35 |

OK
Cancel
☑ Preview
☐ Use Legacy

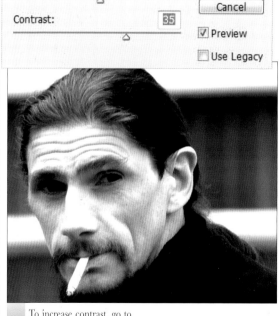

2 To increase contrast, go to **Image > Adjustments > Brightness and Contrast**. Drag the Brightness slider to +6 and the Contrast to +35.

OK
Cancel

Halftone Pattern
Size 5
Contrast []
Pattern Type: Dot

3 We'll use a Photoshop filter for the halftone effect, but first, duplicate this layer (Ctrl/⌘ + J). Next, go to **Filter > Sketch > Halftone Pattern**. We'll begin with the classic halftone dot pattern. In the Halftone Pattern dialog, choose Dot for Pattern Type. The Size slider controls the size of the individual dots. Set the Size to 5 to preserve some degree of detail in the image.

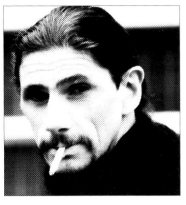

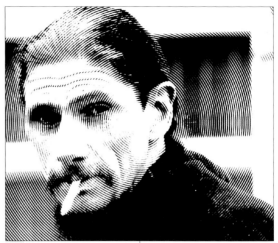

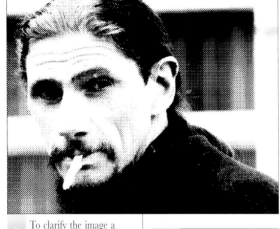

4 The Contrast slider controls the amount of mid grays visible in the halftone image—go for a mid-range value of 30. Experiment with this slider for the best effect. Click OK to apply the filter.

5 To clarify the image a little, go to **Image > Adjustments > Threshold**. Drag the slider to a value of 117. Dragging the slider to the left will add more white areas to the image, whereas dragging to the right will add more black.

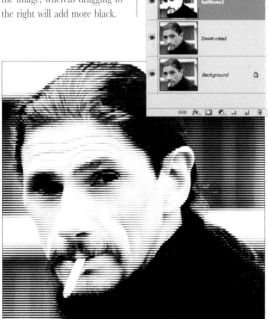

6 To experiment with the other halftone options, hide this layer by clicking the visibility eye in the Layer palette margin. Click on the desaturated layer and duplicate it (Ctrl/⌘ + J). Return to **Filter > Sketch > Halftone Pattern**. This time, choose Line from the Pattern Type box. Reduce the Size to 4 and increase Contrast to 32. OK the filter dialog and change the blending mode to Hard Light.

7 Choose Circle for the Pattern Type and use **Image > Adjustments > Threshold** at the same settings as above. Set the blend mode to Linear Light so that the halftone layer interacts with the desaturated layer.

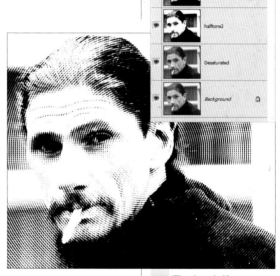

8 The three halftone patterns can be combined by switching on each layer with its visibility eye in the Layers palette. Set the blending mode for the top layer to Lighten, the middle layer to Color Burn, and the lowest halftone layer to Normal. I've reduced the Opacity of this layer to 50%.

MELLOW MONOCHROME

As a counterpoint to the gritty styling of classic black-and-white photography, why not try your hand at a soft, mellow approach. This kind of light, airy photo hints at summer sunshine, so to create this effect, seek out a similar kind of shot to convert. It also allows you to make use of photos that are otherwise languishing in the "never mind" pile because they are slightly overexposed. That's no bad thing here as it adds to the tranquil feel.

2 Set the values in the Channel Mixer to Red: 20, Green: 40, and Blue: 40.

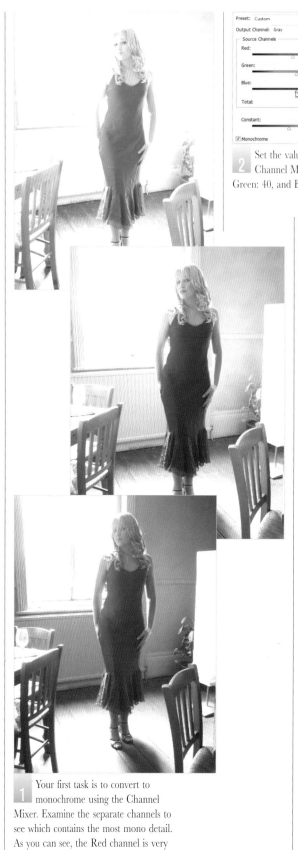

1 Your first task is to convert to monochrome using the Channel Mixer. Examine the separate channels to see which contains the most mono detail. As you can see, the Red channel is very light, and most detail is in the Blue and Green channels.

3 Create a duplicate layer in the Layers palette by dragging the thumbnail onto the Create A New Layer icon (or hit Ctrl/⌘ + J) and name it Curves layer. Go to **Image > Adjustments > Curves**. As you move the cursor over the image, it automatically changes to an Eyedropper. Move the Eyedropper to a point near the top of the woman's dress and note on the Curves line where it registers. Create a control point on the line by clicking it—this will hold the darkness in the dress. Now adjust the Curve to lighten the rest of the image.

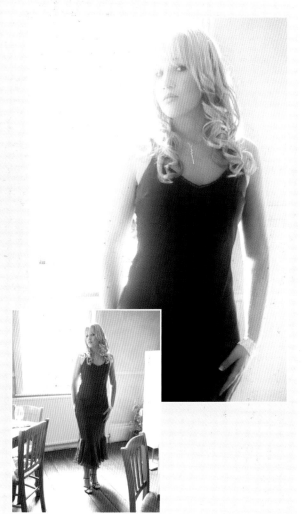

4 In the Layers palette, duplicate the Curves layer as you did in step 3, and call this new one Soft layer.

5 Select **Filter > Blur > Gaussian Blur** and use it on the Soft layer with a value of 50 pixels. This is enough to turn the picture into the vaguest of outlines, but more importantly, it spreads the tones ready to combine a little later in the process.

6 Set the blend mode of the Soft layer to Overlay and click on the Add Layer Mask icon.

7 Select a large, feathered brush and choose black as the Foreground color. Set the Opacity to 20% and select the mask on the Soft layer. Carefully paint over details

like the frame of the window, including the central strut in the window that has vanished, the top of the table to the left, and just around the subject's head and left shoulder.

8 The next stage is to select the Crop tool and tighten up the composition. How far you want to do this is largely dependent upon how sharp you want the image as it will need to be interpolated up again afterwards. Apply the crop.

9 Go to **Layers > Flatten Image** to flatten the layers then go to **Image > Image Size** and enter a value of 3000 vertical pixels, checking the Constrain Proportions check box. Click OK to enlarge the image and then save to finish.

ADDING GRAIN AND TEXTURE EFFECTS

In film-based photography, the film itself, and the prints made from the film, have a structure or grain which is often visible in the finished image. This grain can be especially evident in films with a high ISO. Although photographers will often go to great lengths to minimize the effect of this grain, exploiting this granular quality can add impact and drama to an image. So, why not replicate this effect in Photoshop using a digital image? You can further enhance this tactile quality by adding various texture effects—a surefire way to turn a basic monochrome image into something a little more unique.

1 The first thing to do is use Photoshop's standard Add Noise filter, but use it on the mask supplied with a Levels adjustment layer. This will give you a far greater degree of control over the appearance and intensity of the grain effect in the final image. Go to **Layer > New Adjustment Layer > Levels**. For the time being, simply click OK on both subsequent dialog boxes without making any adjustments. Alternatively you can click on the Create New Fill Or Adjustment Layer at the bottom of the Layers palette and select Levels.

2 In the Layers palette, click on the layer mask attached to the Levels adjustment layer. We need to fill this layer with black to start with, so go to **Edit > Fill**, choosing Black for Contents.

3 Now add some Noise to the layer mask. First, hit D on the keyboard to revert to default Foreground and Background colors. Go to **Filter > Noise > Add Noise**. The amount of noise you choose depends on how pronounced you'd like the effect to be. A good starting point is around 120%. Select Uniform for Distribution.

4 To make the Film Grain effect visible, double-click the Levels adjustment layer thumbnail in the Layers palette to bring up the Levels dialog. Grab the midtone pointer below the histogram and slowly drag it to the right. As you drag the pointer you'll begin to see the film grain effect begin to appear. The further to the right you drag the pointer, the more intense the grain effect will become.

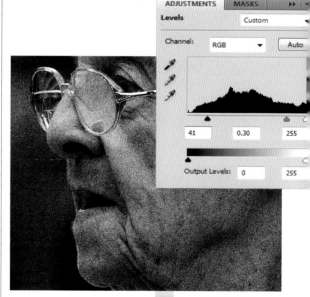

5 By moving the black point slider to the right just a little, you can further intensify the grain.

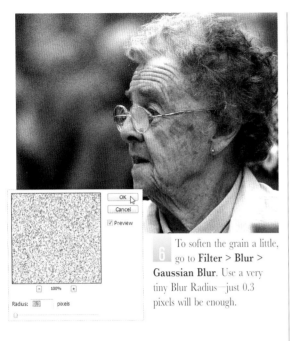

To soften the grain a little, go to **Filter > Blur > Gaussian Blur**. Use a very tiny Blur Radius—just 0.3 pixels will be enough.

In addition to adding grain to the image, we can also add a myriad of other texture effects. How about a shot of some wood texture? Open the wood image. Use **Select > All** (Ctrl/⌘ + A), and then **Edit > Copy** (Ctrl/⌘ + C). Close the file. (The copied texture is now on the clipboard.)

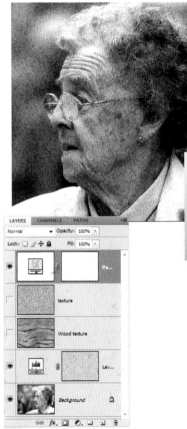

Photoshop also has many of its own textures and patterns. Hide the two texture layers you've just added by clicking their visibility eyes in the Layers palette and go to **Layer > New Fill Layer > Pattern**. Click in the Pattern swatch, hit the small, right-pointing arrow and choose the Texture Fill pattern set. Choose a pattern from the swatches, for example: Burlap. Increase the scale of the texture to suit the image and click OK.

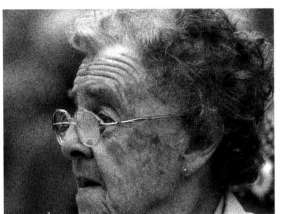

You can further exaggerate the grain effect by duplicating this Levels layer and setting the duplicate layer's blending mode to Darken. Control the intensity of this added grain with the Opacity slider for this layer.

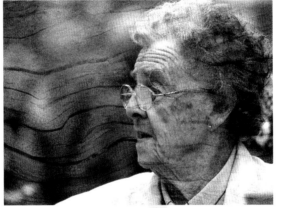

Return to the main image, and go to **Edit > Paste** (Ctrl/⌘ + V) to paste the texture shot onto a separate layer. Go to **Image > Adjustments > Desaturate** (Ctrl/⌘ + Shift + U). Change the blending mode for this layer to Soft Light. If you need to resize the texture image, click on the Move tool and ensure the Show Transform Controls box is checked. You can now grab the corner boxes to drag the image to the correct size. Click OK when you're happy. You can use the Eraser tool at low opacity to partially erase any parts of the texture that obscure the important parts of the image.

Change the blending mode for this pattern layer to Soft Light, and reduce the opacity of the layer a little. You can choose a different texture simply by double-clicking this Pattern layer.

DIFFUSE GLOW EFFECTS

There is an effect buried away in Photoshop's Filter menu, which, surprisingly, is very much underused and all too often completely overlooked. Perhaps this is because it doesn't nestle comfortably in the much abused Artistic Effects group of filters, but skulks within the Filter > Distort selection. Here we'll use the filter on a monochrome image, to create a light-filled, glowing graphic image. This is an excellent way to really crank up the impact of relatively flat black and white images. There's much more to using Diffuse Glow than simply clicking OK to the filter at its default values, and as you'll see, with a little imagination we can create mono images with hidden depths courtesy of Diffuse Glow.

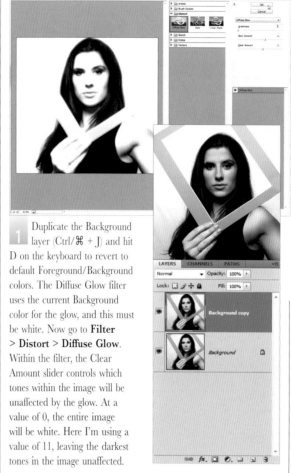

1 Duplicate the Background layer (Ctrl/⌘ + J) and hit D on the keyboard to revert to default Foreground/Background colors. The Diffuse Glow filter uses the current Background color for the glow, and this must be white. Now go to **Filter > Distort > Diffuse Glow**. Within the filter, the Clear Amount slider controls which tones within the image will be unaffected by the glow. At a value of 0, the entire image will be white. Here I'm using a value of 11, leaving the darkest tones in the image unaffected.

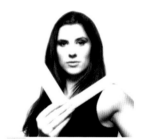

3 You can choose either a very smooth glow, by using a vary low Graininess setting, or introduce more and more grain to the glow itself by increasing the value via the slider. Here we're using a Graininess value of to introduce some nice texture into the image. When you're happy with the settings click OK to apply the Diffuse Glow.

2 The Amount slider controls the Amount or Intensity of the glow itself. At low values the glow is barely noticeable, and at the maximum value obscures too much of the image. Here, use a moderate Amount of 9 so that most of the important details remain visible.

4 You can control the Intensity of this Diffuse Glow layer by adjust the layer Opacity in the Layers palette. The effect itself can be taken to the extreme by reapplying the filter again to this layer using the same settings.

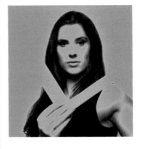

6 As mentioned in step 1, we've been using this effect on a monochrome image, but that's not to say we can't experiment! Go to **Image > Mode > RGB** so we have some color information to use, and click on the Background color swatch. Choose a Bright Yellow from the Color Picker.

7 Now return to **Filter > Distort > Diffuse Glow**. You'll notice this time that the glow is yellow, as this is the current Background Color. Try these settings: Graininess 2, Glow Amount 8, Clear Amount 16.

5 Some weird and wonderful effects can be achieved with a little experimentation. Here I've duplicated the Diffuse Glow layer, inverted it via **Image > Adjustments > Invert** and set this duplicate layer to Difference layer blending mode.

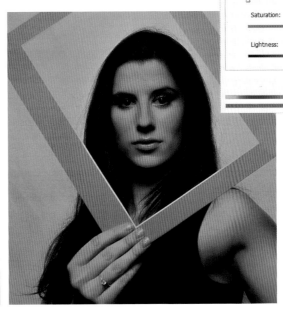

8 Click on the original Background Layer and go to **Image > Adjustments > Hue/Saturation**. Check the Colorize box. Drag the Hue to 0, and the Saturation to 71. Click on the upper yellow glow layer and set the blending mode to Multiply. Who ever said that diffuse glow was black and white?

USING THE BLACK AND WHITE COMMAND

In Photoshop, creating stunning black and white images used to be a rather hit-and-miss affair, but that's no longer the case thanks to the wonderfully powerful new Black and White command. Prior to the introduction of this command, you either had to settle for straightforward desaturation for your black and white images, or get involved with some fairly weird science via the Channel Mixer command, where you could risk making a real mess of the original image.

The Black and White command not only gives you much more control, and a much greater margin of error when converting your portraits to Black and White, but even gives you a choice of out-of-the-box black and white presets that can be very useful indeed. Of course, as ever, you're best to use this command via an Adjustment Layer, as you'll see in the following walkthrough. So, if you love monochrome, try the new Black and White command for the ultimate Black and White portraits.

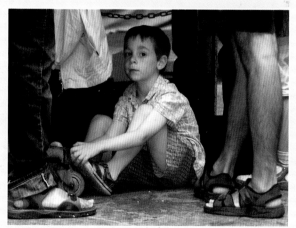

1 Here you can see the dramatically different effects the various presets have on this image. Using the presets can be a good starting point!

High Contrast Blue

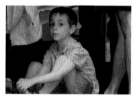
Blue

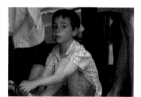
High Contrast Red

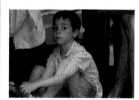
Max black

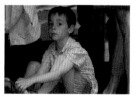
Darker

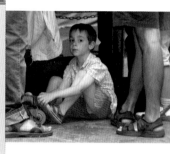

2 If one of the presets works for your image, you can simply leave it at that, or you can use them as a starting point for your Black and White conversion. Another way to begin is by hitting the Auto button, and Photoshop will apply the settings that it thinks are most suitable for the image.

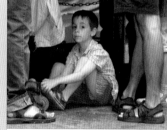

3 It's important to appreciate that each color slider governs the tone, in black and white terms, or the particular color range it governs, so, for instance, the Reds slider will make flesh tones darker if you reduce its value (dragging to the left), or lighter by increasing its value (dragging to the right. Here we've lightened the flesh tones by setting the Red slider value to around 95.

4 We want the focus here to remain on the child, so we'll darken the blue jeans in the foreground by dragging the Blues slider to the left. You can do the same with the Cyans slider to darken the lighter parts of the jeans a little.

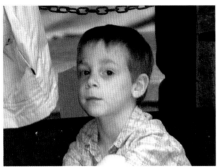

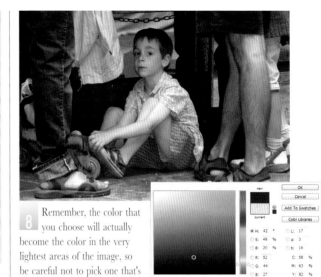

5 The best way to work with the sliders within this adjustment is by using a little trial and error. Very small adjustments can make a big difference and you need to be careful not to introduce too much noise by dragging the sliders too far. In this step too much Yellows creates unsightly noise and skin texture in the child's face, and gives him a ghost-like appearance. Move the Yellow slider back, nearer to 50.

6 If there is a particular area of the image you want to lighten or darken, but are unsure as to which slider will affect it, then click on the slider scrubber button in the top left of the Adjustments panel.

With this tool active, you an now drag to the left or right within an area of the image, and the slider which govern those particular colors will move accordingly. Drag left to darken and right to lighten.

8 Remember, the color that you choose will actually become the color in the very lightest areas of the image, so be careful not to pick one that's too highly saturated. This effect needs to be subtle. The nearer to the bottom (darkest areas) of the color picker you choose your color from, the more subtle your tint will be.

9 When you're happy with the overall feel and contrast of your image, go to **Layer > Flatten image**. You can now selectively lighten and darken specific areas by using the Dodge and Burn tools. The Dodge Tool is very useful for lightening the highlights in the image; simply choose the tool and set the Range to Highlights in the Tool Options Bar. Set the Exposure to 8% and ensure that protect Tones is checked. Now simply brush over highlights in the image to lighten them.

7 If you'd like to add a subtle color tint to the image, simply check the Tint box. You can now click within the color swatch to choose a tint color and tone of your choice.

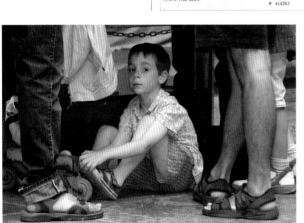

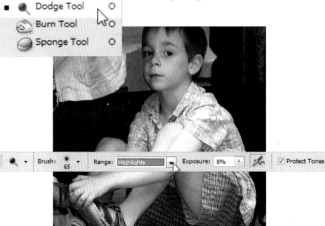

GRAPHIC BLACK AND WHITE

When we call an image "black and white," what we're actually referring to is an image that is grayscale or monochrome—essentially, an image made up of various shades of gray. For a really graphic look, however, we can push monochrome to the extreme so that it is virtually pure black and white. One of the most useful Photoshop commands for this type of effect is Posterize. The Posterize command reduces a grayscale image to its essential and extreme tones. The finishing touch for extreme tonality is generated by adjusting the blending properties of the posterized layer.

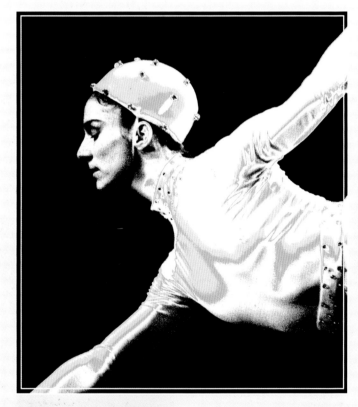

1 Open the start image and increase the contrast. Duplicate the Background layer (Ctrl/⌘ + J) and go to **Image > Adjustments > Brightness/Contrast**. Drag the Brightness slider to +27, Contrast to +36. Click OK.

2 For a black-and-white image, go to **Image > Adjustments > Desaturate** (Ctrl/⌘ + Shift + U).

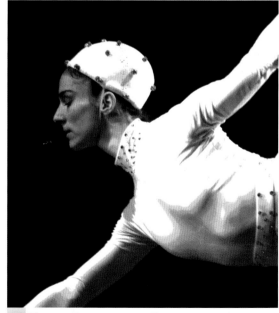

3 Now go to **Image > Adjustments > Posterize**, and enter 11 in the Levels box and check Preview. Experiment with different values to see which you prefer, but a value of 11 works well for this image. Click OK to apply.

5 For added effect, alter the transparency blending properties for this layer. Double-click the image thumbnail for the layer to bring up the Layer Style dialog. Beneath the underlying layer gradient strip, grab the white pointer and drag it to the left, settling on a value of around 213. Now go to **Layer > Merge Down**.

4 Duplicate this layer (Ctrl/⌘ + J) and select **Image > Adjustments > Threshold**. Drag the slider under the Histogram to the left until the features in the face and a few of the shadows on the torso are picked out by black areas. Here a value of 101 has been used. Set the blending mode for this layer to Overlay and reduce the opacity a little.

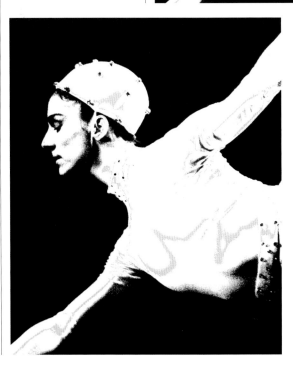

6 Add a final new layer for the border (Ctrl/⌘ + Shift + N). Choose the Rectangular Marquee tool from the Toolbar. Now, starting from the top-left corner, drag a selection around the whole image, just a little inside the outer edge.

7 Ensure that the Foreground color is white by hitting D to reset the Foreground/Background colors and then X to reverse them. To create the border, go to **Edit > Stroke**. Enter a Stroke Width of 10 pixels and choose Inside for Location. Hit OK, and then Ctrl/⌘ + D to deselect. Finally, flatten the image via **Layer > Flatten Image**.

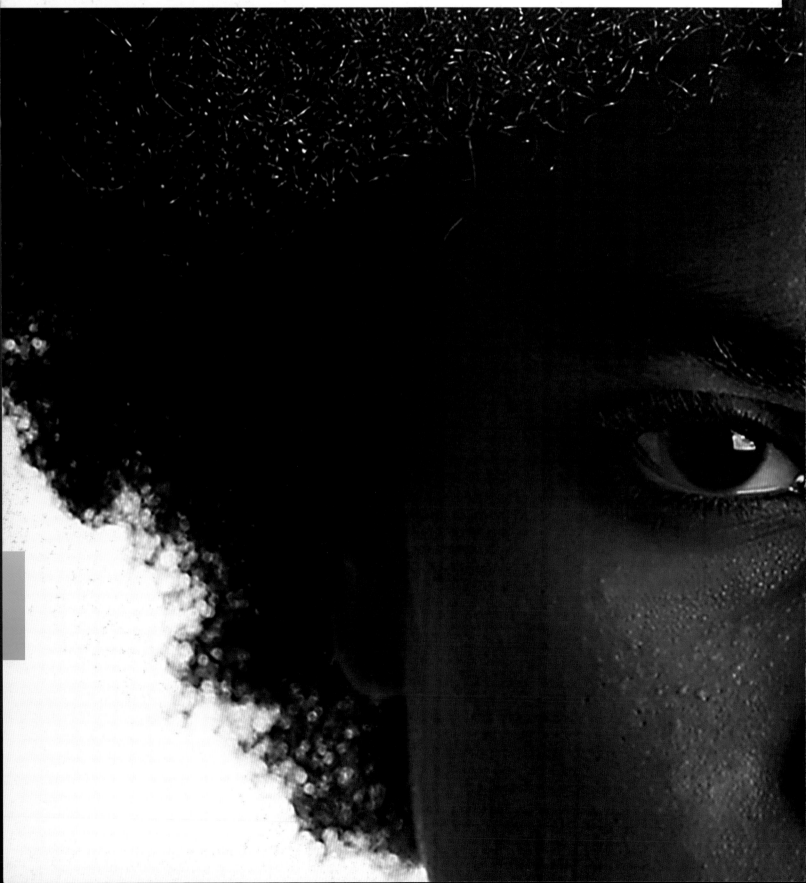

AGING PHOTOGRAPHS

A s a general rule, Photoshop is used to make images cleaner, better, and more perfect. However, in this exercise we're going to indulge in a little reverse engineering. There is a wealth of information out there on how to make old images look like new with digital-imaging techniques, but surprisingly little on doing the opposite. This is a great way to create unique and charming images, and the finished "antique" photographs are certain to delight the family. You'll apply the obligatory sepia tone first and then move on to age the image even more with some careful use of layer masks. We'll even finish off the image with a convincing crease and a few scratches.

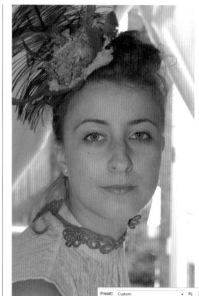

1 First, apply a subtle sepia tone to the start image. Duplicate the Background layer (Ctrl/⌘ + J) and call it Sepia layer. Go to **Image > Adjustments > Hue/Saturation**. Check the Colorize box in the dialog and drag the Hue slider to a value of 43. Set the Saturation to 23, and the Lightness to +9.

2 Tweak the levels to reduce the contrast. Go to **Image > Adjustments > Levels**. Enter the following values in the Input Levels boxes from left to right 18, 1.48, and 235.

3 Add a new layer (Ctrl/⌘ + Shift + N) for the border, and go to **Select > All**. Click the Foreground color swatch and choose a light cream color from the Picker. Now go to **Edit > Stroke**. Enter 45 for Stroke Width and choose Inside for Location, and click OK. Hit Ctrl/⌘ + D to deselect.

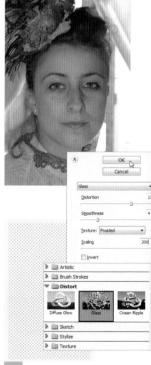

4 To age the border, go to **Filter > Distort > Glass**. Choose Frosted for Texture, Distortion 13, Smoothness 4, 200% for Scale.

5 We destroy some parts of the image, but first we need a filled layer to act as paper. Click on the original Background layer and add a new layer (Ctrl/⌘ + Shift + N). Go to **Edit > Fill**, choosing Foreground color for Contents.

7 You'll need to add a little foxing to the image to age it further. Click on the top layer in the stack and add a new layer (Ctrl/⌘ + Shift + N). Hit D on the keyboard to reset your Foreground/Background colors and go to **Filter > Render > Clouds**. Go to **Filter > Render > Difference Clouds**. Set the blending mode for this layer to Difference and the Opacity to 20%. Choose the Eraser and erase some parts of this layer from over the woman's face.

9 Go to **Filter > Render > Difference Clouds**. Go to **Image > Adjustments > Levels**. In the Input Levels boxes, enter the following values from left to right: 0, 2.62, and 51. Change the blending mode for this layer to Color Burn, the Opacity to 38%.

6 Add a layer mask to the Sepia layer via **Layer > Layer Mask > Reveal All**. Choose the Brush tool and Brush Picker. Click the small right-pointing arrow and choose Reset Brushes. From the brush thumbnails select Rough Round Bristle. Click on the layer mask in the Layers palette and ensure that your Foreground color is black. Paint over one or two of the corners of the image with the brush at a large size to reveal the paper on the layer beneath. Still working on the layer mask with black, reduce the brush to about 7 pixels and scribble over parts of the image to suggest small scratches.

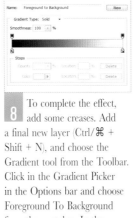

8 To complete the effect, add some creases. Add a final new layer (Ctrl/⌘ + Shift + N), and choose the Gradient tool from the Toolbar. Click in the Gradient Picker in the Options bar and choose Foreground To Background from the swatches. In the Options bar choose Linear Gradient. Click and hold the tool against the bottom of the woman's nose and drag it down and to the left. Release the mouse button to apply.

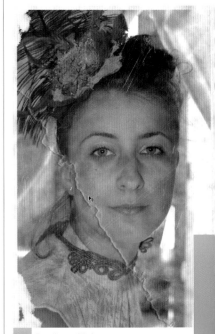

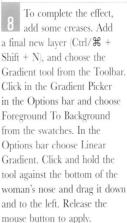

10 Duplicate this layer (Ctrl/⌘ + J) and go to **Image > Adjustments > Invert**. Set the layer blending mode to Screen and set the Opacity to 57%. Choose the Move tool and move this layer a little to the right and slightly upward. As a final touch, duplicate the first crease layer and move it to the top right of the image with the Move tool.

EARLY HOLLYWOOD

When film production moved from New York to Hollywood in the early part of the twentieth century, it heralded the era of the star portrait. For the first time, studios shot publicity stills of their star actors. Early photographic style was very basic: the film stock was generally thin and lacked contrast, while the cameras were not very sharp, invariably producing soft results. Up until the start of the 1920s, lighting arrangements consisted of huge studio tungsten lamps pouring light and heat down onto the poor subject, who had to sit or stand very still for long exposures. A light specifically for hair was usually employed, but due to the limitations of the film, it tended to burn out the highlights. Toward the mid- to late 1920s, more sophisticated poses and lighting arrangements became more widely used.

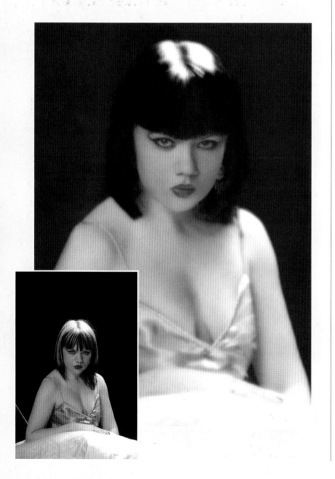

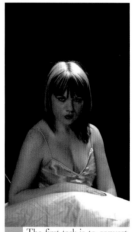

1 The first task is to convert to monochrome and then to balance the subject's hair coloring. Go to **Image > Adjustments > Channel Mixer**. Enter values of Red 20%, Green 40%, and Blue 40%. The idea is to separate the lip color from the skin color in terms of monochrome. As both are red hues, they would normally appear to be quite light in the Channel Mixer, hence the use of a low Red value so they don't. Red colors in old black-and-white photographic film were rendered as very deep shades.

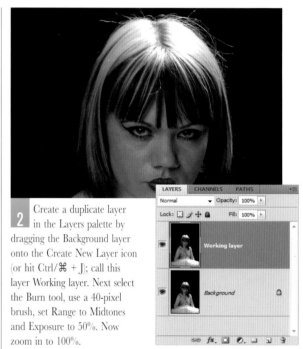

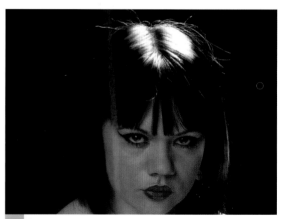

2 Create a duplicate layer in the Layers palette by dragging the Background layer onto the Create New Layer icon (or hit Ctrl/⌘ + J); call this layer Working layer. Next select the Burn tool, use a 40-pixel brush, set Range to Midtones and Exposure to 50%. Now zoom in to 100%.

3 Start brushing the hair, concentrating on the blonde highlights, but also giving the brown hair a brush as well. The key point to this is that it should look relatively even and that you should avoid painting onto either the skin or the background. If you do, press Ctrl/⌘ + Z to undo, select a smaller brush, and redo that area. For the ends of the hair, lower the Exposure to 35% and use a smaller brush.

4 A signature style of the period was Cupid's-bow lips. While this should ideally be created at the photographic stage, it is also possible to make it look more authentic in Photoshop. Select the Clone Stamp tool and set the brush size at around 20 pixels. Set the Hardness at 60%, select the blend mode as Lighten and the Opacity at 80%. Sample from an area to the side of the lips and reshape them, being careful not to go over the actual line of the mouth.

5 At this point clean up any blemishes by using the Clone Stamp tool at 20% Opacity with a Normal blend mode.

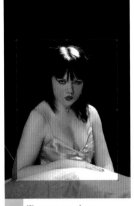

6 To crop out the extraneous space in this picture and to tighten the composition, select the Crop tool and crop into the portrait. Flatten the image at this point as well, select **Layer > Flatten Image**.

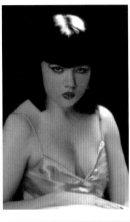

7 Because this next step is very labor-intensive, create a duplicate layer (Ctrl/⌘ + J). Call the new layer Working layer. Use this to emulate the style of Louise Brooks with a short bob and straight fringe. Tackle the hair length with the Clone tool at 20% Opacity, blending in, then using the Darken blend mode to add edges to the trimmed hair. For the fringe, use the Darken blend mode at 100% Opacity with a Hardness of 30% to fill in the gaps. Remove loose hairs around the top of the head.

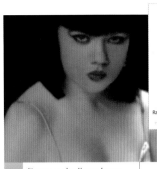

8 Create a duplicate layer of the working layer and call it Diffuse layer. Run the Gaussian Blur filter on this layer using a setting of 4 pixels.

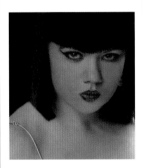

9 With the diffuse layer still active, click on the Add Layer Mask icon in the Layers palette. Pick the Brush tool with a large brush and no Hardness, set the Foreground color to Black and the Opacity to 50%. Paint in the center of the face as the point of focus and include a sweep from burnt-out hair to chin. This area will be more in focus, but not sharp, leaving the rest of the picture much softer.

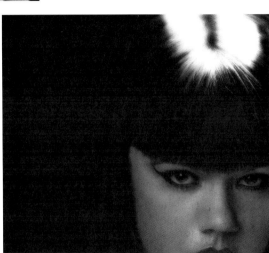

10 Go to **Layer > Flatten Image** to flatten all the layers. Next, select **Filters > Distort > Diffuse Glow**. Early lenses were uncoated so that any bright spots tended to produce halo or brightness effects. This can be duplicated with the Diffuse Glow filter. Enter values of 3 for Graininess, but note that for photographs of the late 1920s the grain would be minimal—thus set 3 for the Glow Amount and 10 for the Clear Amount. This is so that the face is also lightened.

11 As earlier Hollywood photos tended to have a sepia effect, go to **Image > Adjustments > Variations** and add a Yellow and Red component, then click on the Lighter tab as well. As the image was cropped earlier, you may want to interpolate the image back up to a bigger size. Although this will make the image slighty softer, it won't matter too much with this style of image. Go to **Image > Image Size**, increase the height to 3000 pixels, and save.

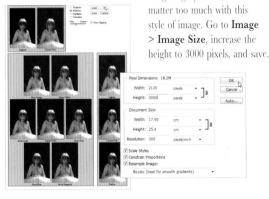

CLASSIC HOLLYWOOD

The 1930s represented the peak of Hollywood star portrait photography. The equipment, though still large and cumbersome, was a significant leap ahead of what had previously been available. The signature lighting of the 1930s became known as "loop" lighting. This is created by placing the key light at 45 degrees up and to the left or right of the subject, creating a downward-angled shadow from the nose. All lighting in those days was produced by large tungsten lamps. To get the same kind of shadow effects, you can use flash, but without diffusion from a brolly or softbox—unheard of in modern portraiture. While flash doesn't provide you with the instant feedback in terms of shadows that tungsten does, with digital you can at least check the results after shooting to make sure the lights have done their job properly.

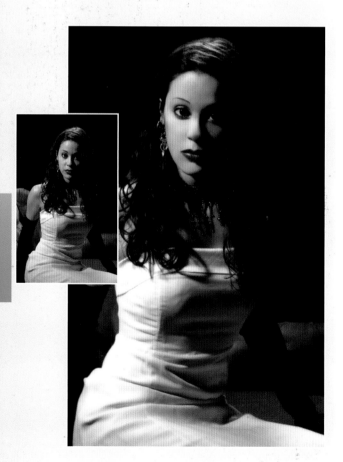

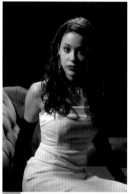

1 Film stock was less reactive to reds in the 1930s than in the 1920s, and it had a lot more contrast. First, convert the picture to monochrome with the Channel Mixer using settings of Red 30%, Green 60%, and Blue 10%. The Green channel contains the best definition of tones and will produce darker red lips on the subject. The Red channel adds highlights while the Blue channel inserts shadows.

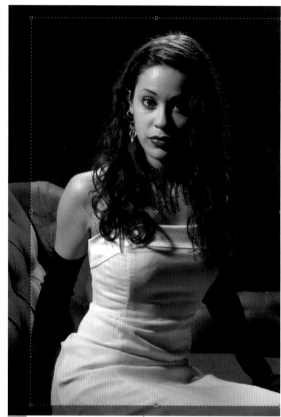

2 The subject is seated a little off-center, so use the Crop tool to bring her back into position.

3 Use the Clone Stamp tool at 20% Opacity and Normal blend mode to clean up any pimples or blemishes.

4 While the eyebrows are already thin, this can be enhanced for added authenticity. Take the Clone Stamp tool again with the Opacity set at 20% and the blend mode at Normal, but add a Hardness of 40%. From underneath (but not right next to) the eyebrow, select a cloning source, then thin the eyebrows.

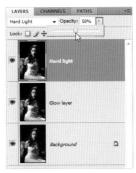

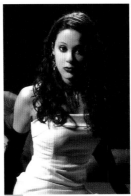

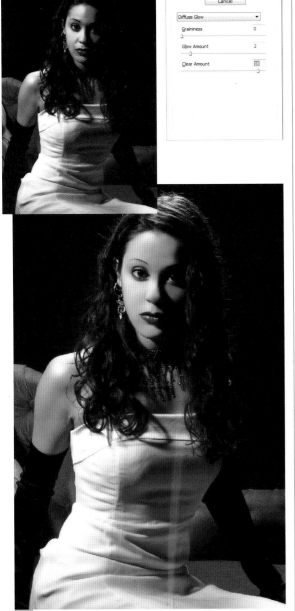

5 Create a duplicate layer, rename it Glow layer, and then run the Diffuse Glow filter. Film stock of the time suffered from halation, just like 1920s film—so white areas tended to have a glow. Enter values of Graininess 0, Glow 2, and Clear 18.

6 Create a duplicate of the Glow layer and set the blend mode to Hard Light. Reduce the Opacity to 50%. This gives the image more contrast. Merge all the layers at this point if you are happy with your progress.

7 Go to the Layers palette again and create a duplicate of the background layer we have just created. Call this the Diffuse layer. Despite having narrow apertures, cameras of the time had much longer focal lengths and as a result produced much less depth of field. Apply a Gaussian Blur of 3 pixels to the layer.

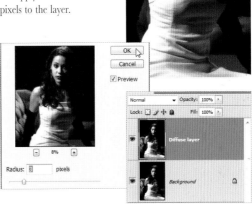

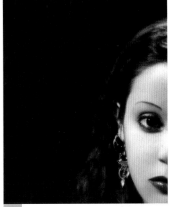

8 With the Diffuse glow layer active, click on the Add Layer Mask icon in the Layers palette. Select a medium-sized brush and set black as the Foreground color. Ensure the mask on the layer is selected, set the Opacity of the Brush to 35% and the Hardness to 50%. Make two passes over the subject, except for the arms. Flatten the image.

9 Finally, select the Clone Stamp tool and choose a large brush. Set the blend mode to Darken and the Opacity to 100%. Zoom in and clone off any loose hairs that have been illuminated by the hair light. Don't forget to save the image when the work is complete.

FILM NOIR

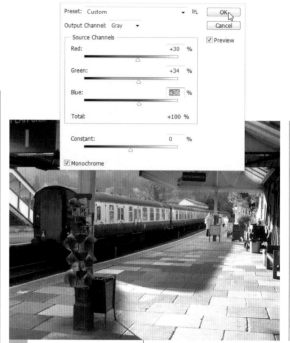

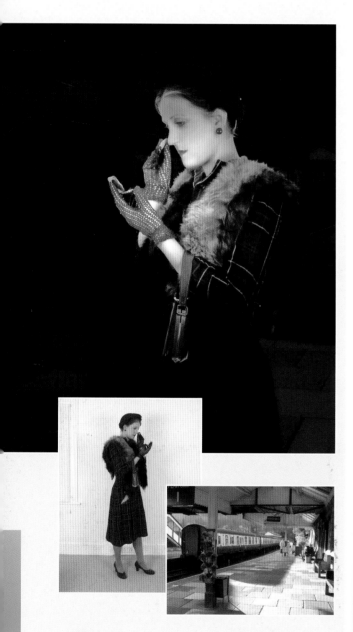

1 This train station at Llangollen in Wales is perfect for a film-noir makeover. However, as it stands, the train station is in color and has tourists all over it. The first thing is to convert to monochrome with the Channel Mixer. Values of Red 30%, Green 34%, and Blue 36% offer the best mix.

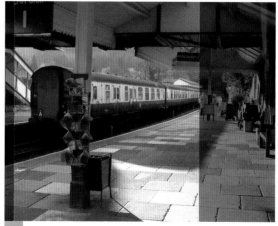

The great film noir movies of the 1940s featured dramatic lighting with lots of contrast, populated by shady, downbeat guys, and glamorous, double-crossing femme fatales. You can recreate some of that film-noir feel digitally, by using sharp, moody lighting. Either position lights at either side of the subject so that the face has shadows thrown across it, or place the main light below head level so that it throws scary shadows upward.

2 Get rid of most of the bright, sunlit areas by cropping the picture, thus eliminating the bystanders as well. Use the Crop tool and change the orientation from landscape to portrait by losing the right-hand side of the image.

3 This was only a 3-megapixel image to start with, so now it's woefully small. It must be interpolated up to the same size as the portrait with which it is going to be composited. If the station were the focus of attention this wouldn't be possible as it would be too soft—but, as a background in the moonlight, you can get away with it. Use **Image > Image Size** to take it up to 3200 vertical pixels.

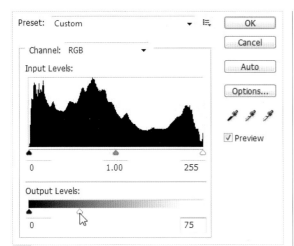

4 To convert the sunny day to a moonlit night, go to the Levels adjustment. Move the white marker of the Output level back toward the left. This adjustment removes the bright white tones altogether, making them gray. In this way the border between light and dark ones becomes less distinct, as befits a weak light source such as moonlight.

6 This figure is now likely to be too small so use Image Resolution to change it to 2800 pixels vertically, which should make it a good size for adding to the other picture.

7 To make the image stand out more and make it easier for cutting out go to Levels. Move the left-hand (black) triangle of the input in so that it is at the start of the data on the histogram. This will stretch out the tones and use more darker ones. At the other end, move the right-control (white) diamond so that it is in the middle of the peak on the right. Click on OK.

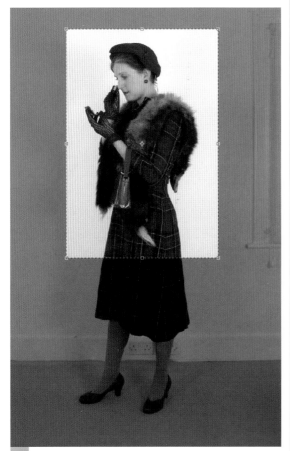

5 Open the image of the woman. First of all she's pointing the wrong way, so go to **Image > Rotate Canvas > Flip Canvas Horizontal**.

Then, use the Crop tool to select just the top half so that the figure will be right in the foreground of the composite.

FILM NOIR

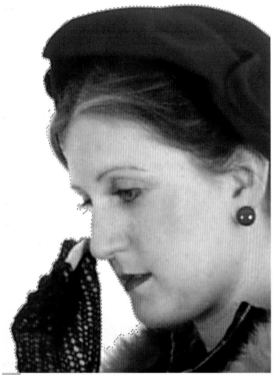

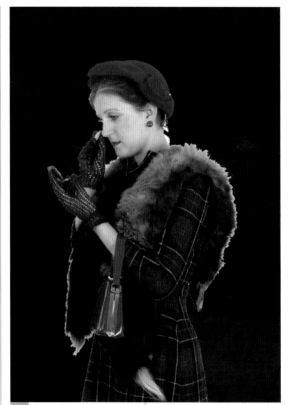

10 Switch to the platform picture and press Ctrl/⌘ + V to paste as a new layer. Use the Move tool to position the figure just right of center and align with the bottom of the picture.

8 Select the Magic Wand and set the Tolerance at 20%. Click on the white background, hold down the left Shift key to add to the selection. Zoom in to ensure there are no stray pixels. The selection won't be tight against the fur, but that's unavoidable at this point. Don't click on it or you will lose more detail in this area. Go to **Select > Inverse** so that the figure is selected.

9 Now go to **Select > Modify > Contract** and enter a value of 2 pixels to pull the selection right up against the figure. Go to **Select > Feather** and enter a value of 1 pixel. Press Ctrl/⌘ + C to copy the figure to the clipboard.

11 Use the **Filter > Render > Lighting Effects** filter. Select an Omni light so that it looks like a spotlight. Set the center around the hands and increase the Intensity to about 65%. Set the Ambience to -16% to throw the rest of the picture into darkness.

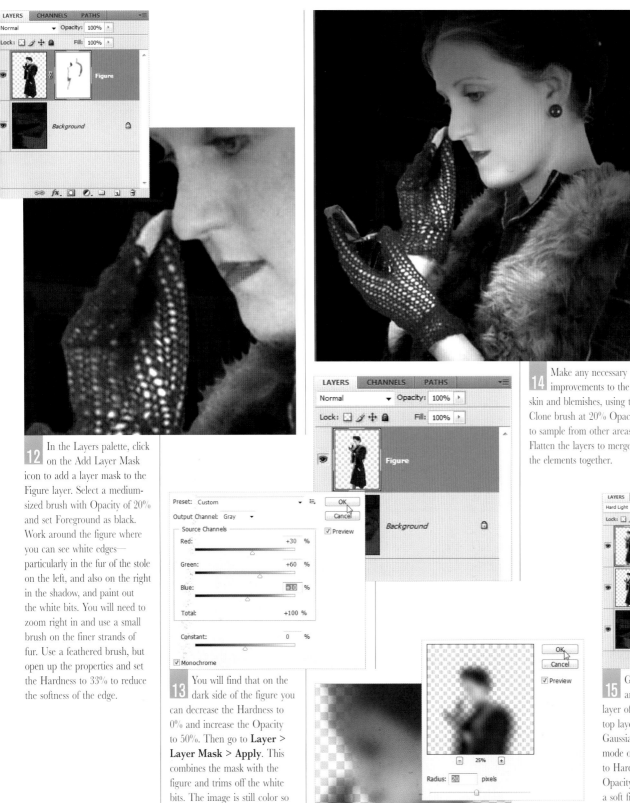

12 In the Layers palette, click on the Add Layer Mask icon to add a layer mask to the Figure layer. Select a medium-sized brush with Opacity of 20% and set Foreground as black. Work around the figure where you can see white edges—particularly in the fur of the stole on the left, and also on the right in the shadow, and paint out the white bits. You will need to zoom right in and use a small brush on the finer strands of fur. Use a feathered brush, but open up the properties and set the Hardness to 33% to reduce the softness of the edge.

13 You will find that on the dark side of the figure you can decrease the Hardness to 0% and increase the Opacity to 50%. Then go to **Layer > Layer Mask > Apply**. This combines the mask with the figure and trims off the white bits. The image is still color so go to **Image > Adjustments** and select Channel Mixer. Enter values of Red 30%, Green 60%, and Blue 10%. Check the Monochrome box.

14 Make any necessary improvements to the skin and blemishes, using the Clone brush at 20% Opacity to sample from other areas. Flatten the layers to merge the elements together.

15 Go to the Layers palette and make a duplicate layer of the result. Click on the top layer and apply a 20-pixel Gaussian blur. Set the blend mode of this blurred layer to Hard Light. Reduce the Opacity to 60%. This produces a soft finish. Crop the image a little, merge the layers again, and save.

WARHOL PRINTS

The screen prints by Andy Warhol remain some of the most iconic images of the 20th Century, and here we're going to take a look at how we can reproduce this effect in Photoshop CS4, without a drop of printing ink being spilt!

The new Quick Selection tool makes isolating the figure from the background very easy, achievable with just a few mouse clicks.

Of course, Warhol wouldn't be Warhol without the bright, garish colors that were so much a signature of his work. We'll add these with a few simple solid color layers, taking advantage of the layer masks supplied with these.

Once you've completed the image, you can create versions using different color combinations simply by double-clicking the color fill layers and choosing a new color for each. Save each file under a new name and flatten them. You can then paste all of the flattened images side by side in a new document. So, if Pop Art is your thing, time travel back to 1960's New York and find you way with Warhol!

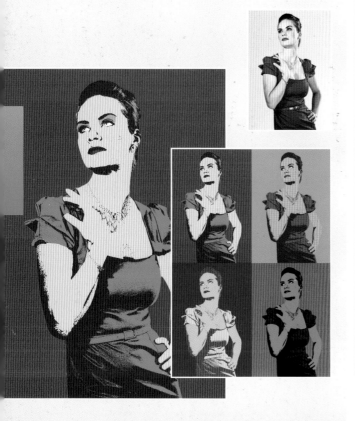

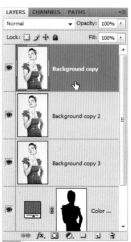

1 Open the start image and choose the Quick Selection tool. In the Options Bar, check Auto Enhance, and make sure the New Selection button is active. Increase the size of the tool to around 60 pixels in the Options Bar then sweep the brush around the outside of the figure. If you find your selection went a little far, switch to Subtract from Selection, reduce the brush size to around 20 pixels, and carefully brush within the model's arm.

4 Right-click the Background layer, choosing Duplicate Layer. Do this twice more so you have three duplicate layers. Grab these duplicate layers in the Layers palette and drop them above the color fill layer.

2 Now choose the Add To Selection button in the Options Bar and sweep the tool within the space between the models arm and body to include this in the selection.

3 Now hit the Refine Edge button in the Options bar. Choose the On Black thumbnail within the dialog and set both the Contrast and Smooth to 12.

Click OK, then go to **Layer > New Fill Layer > Solid Color**. Click OK to the first dialog and then choose a bright red from the color picker.

If parts of the outline need cleaning up, choose the Brush Tool with a hard brush, click on the layer mask, and paint with black to correct the outline.

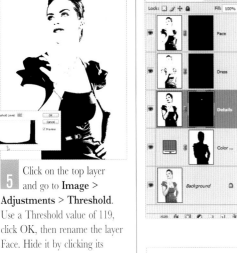

5 Click on the top layer and go to **Image > Adjustments > Threshold**. Use a Threshold value of 119, click OK, then rename the layer Face. Hide it by clicking its visibility eye in the Layers palette.

6 Click on the duplicate layer beneath and return to **Image > Adjustments > Threshold**. This time, choose a Threshold value of 69 and click OK. Rename this layer Dress and hide it. Similarly on the bottom duplicate layer, use a Threshold adjustment of 185. Name this layer Details.

7 Now un-hide the two layers above. Click on the top layer in the stack, then click on the tab for the Masks panel, hold down the Alt/⌥ key, and click the Add A Pixel Mask button to add a black mask. Repeat this for the other two layers.

8 Click on the Background layer and go to **Layer > New Fill Layer > Solid Color**. Choose a flesh tone from the Color Picker.

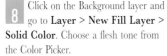

9 Click the layer mask on the top layer and change the layer's Blending Mode to Darken. Choose the Brush tool with a hard brush. Ensure that your Foreground color is White. Now paint over the models head to reveal the black details from that layer.

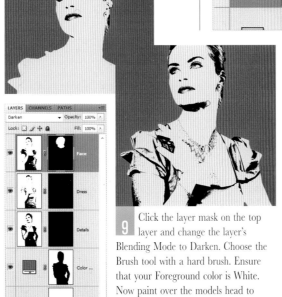

10 Click on the mask for the Dress layer. Change the Blending Mode to Darken, then paint with White over the figure from the neck down. Do the same on the Details layer, using a small brush to paint over the jaw line, nose, and ear. You can paint with a small brush over other areas to reveal detail too.

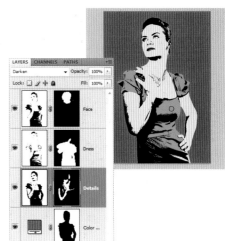

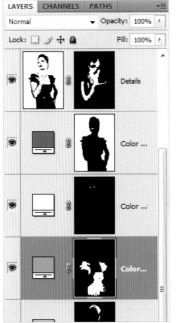

11 To add colors to the finished print, simply click on the flesh filled solid color layer and add another solid color layer (**Layer > New Fill Layer > Solid Color**). Choose your color from the picker, then click on the new fill layer's mask and invert it using the Masks panel. Now simply paint the mask with white to reveal the color where you want it in the image. Repeat this for each color you want to add. After painting, you can easily change the colors to create anther version by double-clicking each solid fill layer and choosing a new color from the color picker.

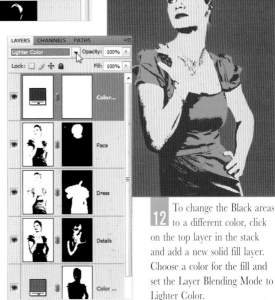

12 To change the Black areas to a different color, click on the top layer in the stack and add a new solid fill layer. Choose a color for the fill and set the Layer Blending Mode to Lighter Color.

SHOOT LIKE BAILEY

For students of photography today it's hard to appreciate the influence of David Bailey and his peers in the 1960s, but without doubt, Bailey changed the face of portrait photography. His black-and-white portraits made use of distinctive stylistic elements—dramatic lighting and intense composition, which often included cropping off the top of the head. This approach was unknown before Bailey. John Swannell, in the preface to *I'm Still Standing*, called Bailey the most important fashion portrait photographer of the century. If you want to shoot like David Bailey, try to get it right first time, but if you have some portrait shots you'd like to use to emulate his style, this is the place to start.

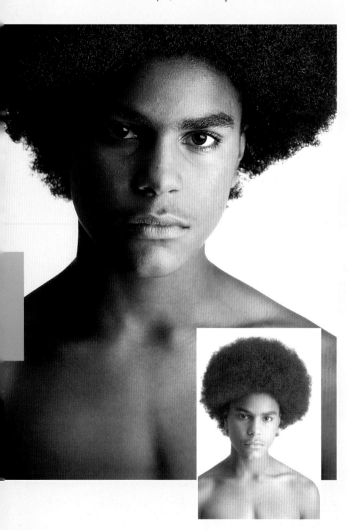

1 If your image isn't already monochrome, that's the first thing to do. In the original we have a full head of hair and two, or perhaps three lights, all set to the right. The key light is the large softbox but there are spotlights to add illumination to the torso, and to the top of the hair. Create a duplicate layer in the Layers palette by dragging the thumbnail onto the Create A New Layer icon (or hit Ctrl/⌘ + J) and call it Working layer. Zoom in to the model's eye on the right.

2 The light sources have created too many catchlights in the eye so select the Clone brush and set the blend mode to Normal. Usually this would be Darken, but there is actually a dark ring around the light. Set the Opacity to 100% and use a brush small enough to paint with, without running over the white of the eye. Clone from a similar area and paint out the two other visible catchlights, leaving just the softbox.

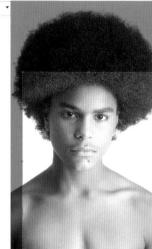

3 Select the Crop tool and use it to mark in right down to just above where the hair starts. Crop from left and right to keep the aspect ratio so that the subject is nearer the left side than the right—the subject would not usually be right in the center of the photo. This will cost you resolution so go to **Image > Image Size** and push it back up to 3000 pixels vertically.

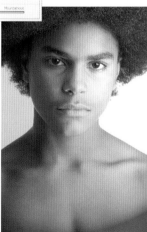

4 The lighting is roughly in the right place for this effect, so let's enhance it. Go to **Filter > Render > Lighting Effects** and select Spotlight. Create an oval shape for the light by dragging on the control points on the circumference of the light graphic. Arrange the angle so that it is pointing from the top right down to the left. This mirrors the actual light used. Set the Focus at 100 and the Intensity at 20. Set the Ambience at 24. This offers us shadow detail on the far side of the face.

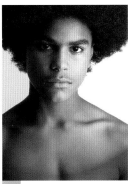

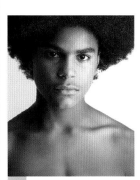

5 Set the blend mode of the Working layer to Multiply; this will give us the deeper shadows required. Now click on the Background layer and duplicate it (Ctrl/⌘ + J). This

should appear in the center. Turn off the visibility to the original Background layer, go to Layer and select Merge Visible. Rename the newly merged layers Working layer.

6 Next, in the Layers palette click on the Add Layer Mask icon to add a mask to the Working layer. Select the Brush tool and black as Foreground color. Select a large, feathered brush. Set the Opacity to 10% and the blend mode to Normal.

Click on the mask and where the edge of the lighting effect is apparent on the right of the torso, use the brush to blend it much more smoothly into the darker area. Only paint in the dark area, do not go over the edge into the lighter area.

7 With the Working layer mask thumbnail still selected, go to **Filter > Blur > Gaussian Blur** and enter a value of 10 pixels. This will smooth out the mask and make it look much more natural.

8 Select the Magic Wand and set the Tolerance at 20%. Click in the area of the background to the left of the neck. Hold down the Shift key to add to the selection and click into the gaps in the hair. If you inadvertently select the hair, press Ctrl/⌘ + Z to step back. Go to **Select > Feather** and feather the selection by 3 pixels.

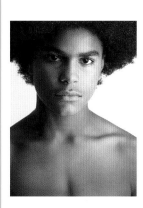

9 Select the Brush tool, set the Opacity at 20% and black as the Foreground color, then click on the mask and paint onto it to brighten the background. Paint over it three or four times. Go to Layer and select Flatten Image.

10 In the Layers palette click on the Create A New Adjustment Layer icon at the bottom of the Layers palette and select Curves. Place three control points on the curve line, moving the bottom one a little

down and to the right and the top one up and left, leaving the middle one alone. This deepens the shadows and brightens the highlights, but the light on the face is too bright.

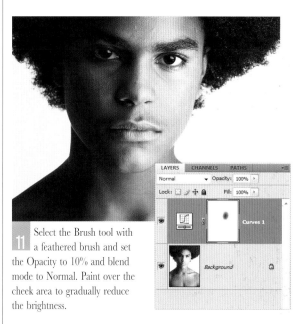

11 Select the Brush tool with a feathered brush and set the Opacity to 10% and blend mode to Normal. Paint over the cheek area to gradually reduce the brightness.

12 Flatten the image again. Finally, go to **Filter > Sharpen > Unsharp Mask**. Bailey photos are characteristically pin-sharp so enter values of Amount 70%, Radius 3, and Threshold 3. Save to finish.

Newtonesque

Helmut Newton, who died in 2003, was a controversial fashion and portrait photographer. Many consider his work to have been innovative and ahead of its time, while others debate what is perceived to be the misogynistic nature of his images. Certainly, he was interested in exploring gender roles and sexual identity. Some of his images find immaculately dressed women juxtaposed incongruously against industrial backdrops. His portraits of powerful male figures invariably pander to ego, mirroring a vision of how they see themselves, while simultaneously exposing their vanity. While predominantly using black and white, Newton also ventured, with success, into the world of color, creating coordinated, complementary schemes. The subjects of these images are fantastically glamorous and have an air of mystery.

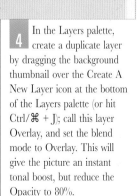

1 Begin by ensuring the model is blemish-free. Use the Clone Stamp tool at 20% Opacity in Normal blend mode to smooth out lines and blemishes.

2 Zoom right in so you can see what you are doing—between 100% and 200% should do the trick.

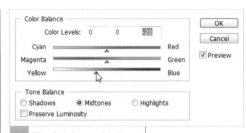

3 The flash has rendered the subject very white and plain, but has pushed up the color of the dress. Go to **Image > Adjustments** and select Color Balance. Shift the Yellow/Blue slider toward Yellow by 20%.

4 In the Layers palette, create a duplicate layer by dragging the background thumbnail over the Create A New Layer icon at the bottom of the Layers palette (or hit Ctrl/⌘ + J); call this layer Overlay, and set the blend mode to Overlay. This will give the picture an instant tonal boost, but reduce the Opacity to 80%.

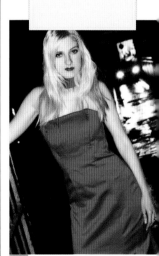

5 Go to Filter and select **Distort > Diffuse Glow**. Enter values of Grain 0, Glow 2, and Clear Amount 12. This will give a white, glossy glow to the subject. If used on a Normal blend mode layer the effect would be much more ethereal.

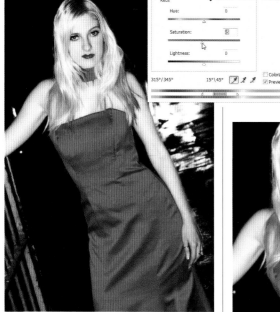

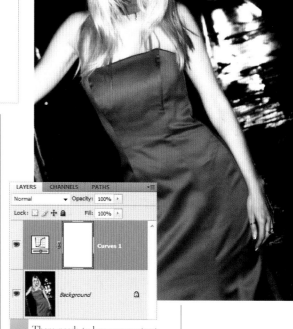

6 Go to **Layer > Flatten Image** then select **Image > Adjustments > Hue/Saturation**. The red color of the dress is a little too bright. In the Hue/Saturation box select reds then use the sampler to click on the dress. Reduce the Saturation by 5%.

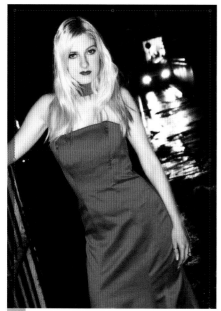

7 Use the Crop tool to get rid of the small section of dead space above the subject's head, then go to **Image > Image Size** to restore the pixel dimensions. I set this to 3100 width from the post-cropped 2800. That's fine for a color photo and can be saved at this stage, but for a black-and-white Newton look, let's convert to monochrome.

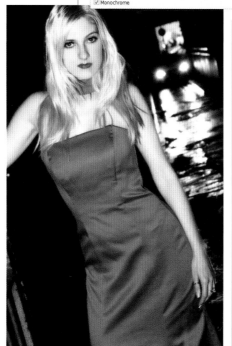

8 Go to **Image > Adjustments** and select Channel Mixer. Check the Monochrome box. Enter values of Red 42%, Green 18%, and Blue 40%. This separates the dress color from the skin tones and provides a good monochrome conversion.

9 There needs to be more contrast, without losing highlight detail. In the Layers palette click on the New Adjustment Layer icon and select Curves. Enter three points on the curve line, at 25%, 50%, and 75% points. Move the bottom control point down and right to darken the shadows and the top point up and left to brighten the highlights.

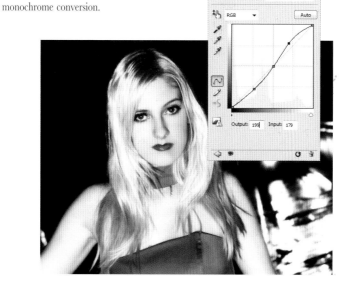

10 Zoom in so you can see the face and hair clearly. Select the Brush tool and set the Foreground to black. Pick a feathered brush, size about 90 pixels, Opacity 20%, and Normal blend mode. Select the layer mask of the adjustment layer in the Layers palette. Paint on the face and hair, where the highlights have been lost, to restore them. Just do enough to bring back the detail—we want a nice, white finish. When finished, go to **Layer > Flatten Image**, and then save.

1980s New York Look

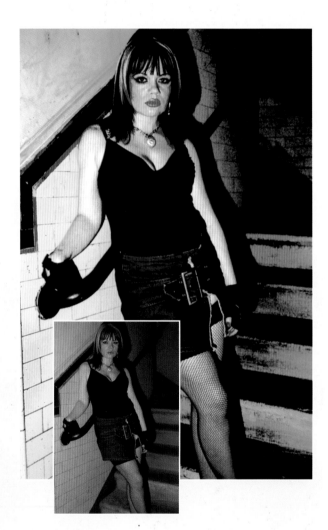

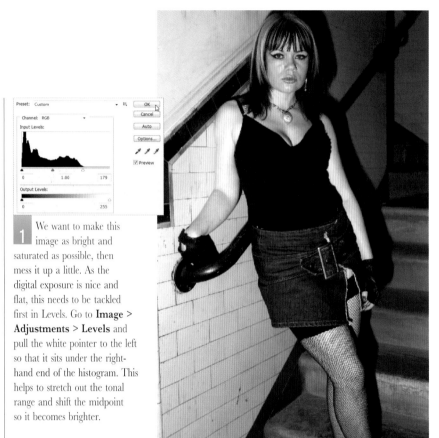

We want to make this image as bright and saturated as possible, then mess it up a little. As the digital exposure is nice and flat, this needs to be tackled first in Levels. Go to **Image > Adjustments > Levels** and pull the white pointer to the left so that it sits under the right-hand end of the histogram. This helps to stretch out the tonal range and shift the midpoint so it becomes brighter.

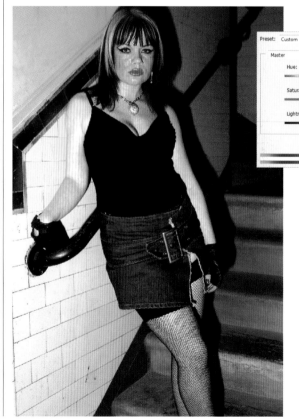

Select **Image > Adjustments > Hue/ Saturation** and push the Saturation right up by 60%. This will lend everything a gaudier color and also give the subject an unpleasant, red-faced complexion.

Forget all the rules about portrait photography for this exercise. In fact, the cheaper the camera you can shoot it with, the more authentic it will look. Nan Goldin shot to fame in the 1980s by photographing her friends and lovers from the underclass of New York City. Goldin made use of color casts, poor focus, heavy saturation, and cheap Polaroid prints, combined with brutal photographic honesty to produce a memorable—if not technically sophisticated—body of work. To get that kind of streetwise, narcotic look, your subjects should pose in the most slouchy, natural way possible. Look for areas of color mixed in with urban grime as backdrops and fire away.

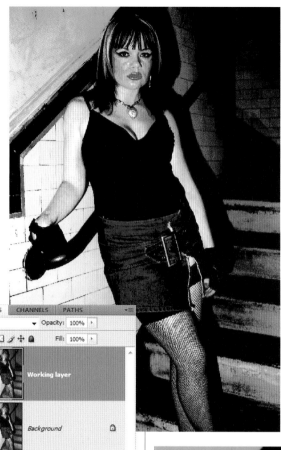

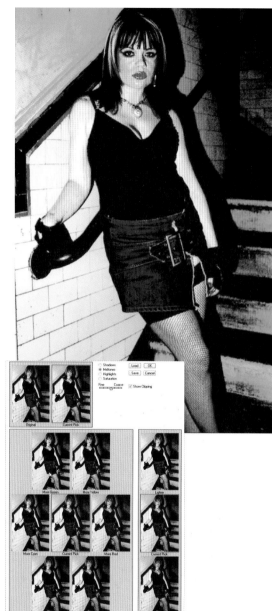

4 Go to **Layer > Flatten Image**, then create a new, duplicate layer in the Layers palette (Ctrl/⌘ + J). Go to **Filters > Blur > Gaussian Blur** and enter a value of 2 pixels, to ensure the picture doesn't look too sharp.

3 Create a duplicate layer (Ctrl/⌘ + J), and in the Layers palette rename it Working layer. Go to **Filter > Sharpen > Unsharp Mask** and enter the maximum values for Amount (500%) and Radius (250 pixels). Leave the Threshold at 3 levels. Click OK to apply. In the Layers palette change the Working layer blend mode to Color Burn. This will give the darker areas lots of shadow detail and produce a more claustrophic effect.

5 Select the Smudge tool and set the mode to Darken, the Strength to 10%. Zoom in on the eyes and carefully smudge the eyeliner and mascara, without affecting the shape of the eyes. Once again, flatten the image.

6 Create a new duplicate layer, then go to **Image > Adjustments > Variations**. Let's add a color cast to the image to give it that "shot on cheap film" look. Add Yellow and Green, either as a single dose, or more if the original picture doesn't have much of either color. This one already does, so one of each component is enough.

7 The overall effect has taken out too much of the florid facial tones, so reduce the Color cast layer Opacity to 80%. Now flatten the image and save your slice of the 1980s New York underground scene.

Swannell Style

John Swannell has been photographing celebrities his whole career. Actors, corporate heavyweights, writers, comedians, royalty, and even other photographers have all come under his scrutiny. A Swannell picture invariably captures the essence of the subject, but there are recurring stylistic tricks that identify his work. For a start, his work is mainly black and white, and compositions are often shot against windows for a contre-jour effect, balanced by the use of spot flash. There are also wacky poses and off-center compositions and the liberal use of masking devices—whether they be barn doors or other attachments fitted to the flash. By masking off areas, Swannell concentrates the attention on the face and other illuminated aspects of the photo. Certainly, in studio shots the background is invariably lit separately. Some of the flash effects border on the harsh shadow styling of classic Hollywood more than the diffuse effects of modern softboxes.

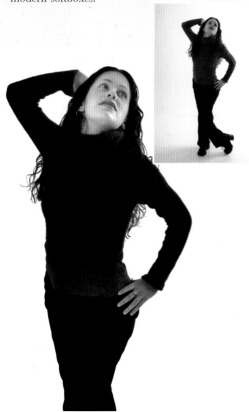

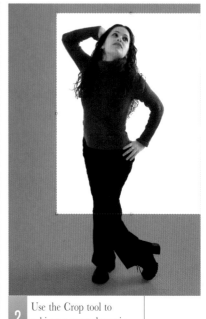

2 Use the Crop tool to achieve a more dynamic, off-center composition.

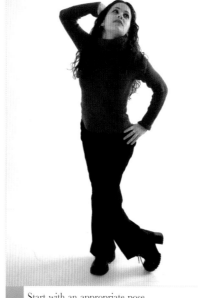

1 Start with an appropriate pose. While the automatic white balance has introduced a yellow-green cast on the left-hand side, this can be eliminated by converting the image to monochrome. Go to **Image > Adjustments > Channel Mixer**. The Red and Green channels provide the best separation of black-and-white tones in this image, so enter Red 76%, Green 34%, and Blue 0%.

3 Cropping the image has reduced the resolution so you require interpolation to get it back up to a workable size. Go to **Image > Image Size** and increase the height to 3000 pixels.

4 Next, apply a "blocking" effect by introducing doors or pieces of card in front of the flash. Begin by creating a duplicate layer in the Layers palette by dragging the background thumbnail on to the Create A New Layer icon at the bottom of the Layers palette (or hit Ctrl/⌘ + J). Call this layer Shadow effects.

5 Go to **Filter > Render > Lighting Effects**. Select the Omni lighting type and move the light position over the face of the subject. Set the strength at 40 and reduce the Ambience to -33, which will darken the rest of the image.

7 This produces the telltale shadow effect, but it has also affected the background, which in Swannell's studio shots tends to be lit separately. So, in the Layers palette, ensuring that the Shadow effects layer is selected, click on the Add Layer Mask icon.

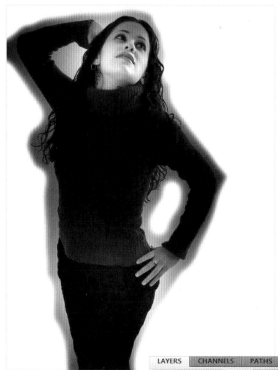

8 Select the Brush tool with a 100% Opacity and a Hardness of 20%. Select black as the Foreground color, along with the mask itself, then paint on the background areas to remove the shadow effect. Leave the areas immediately around the subject.

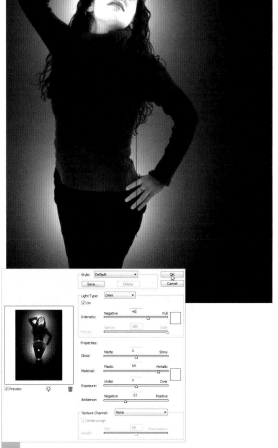

9 Using the square bracket keys ([and]) to alter the size of the brush, zoom in to 100%, and get right up to the edge of the subject to paint out the remainder of the shadow. Make sure you paint any background visible through curls of hair. If you make a mistake, switch the color to white and restore the effect.

6 Holding down the Alt/⌥ key to duplicate it, click and drag the light bulb icon in the Preview window down onto the leg area. Increase the strength to 45. Don't change the Ambience as this is a universal figure for both lights.

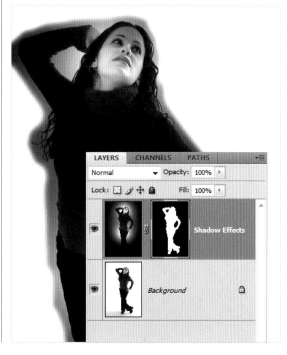

10 To finish, merge the layers and apply a small contrast adjustment of 5% using Brightness/Contrast.

ARTISTIC EFFECTS

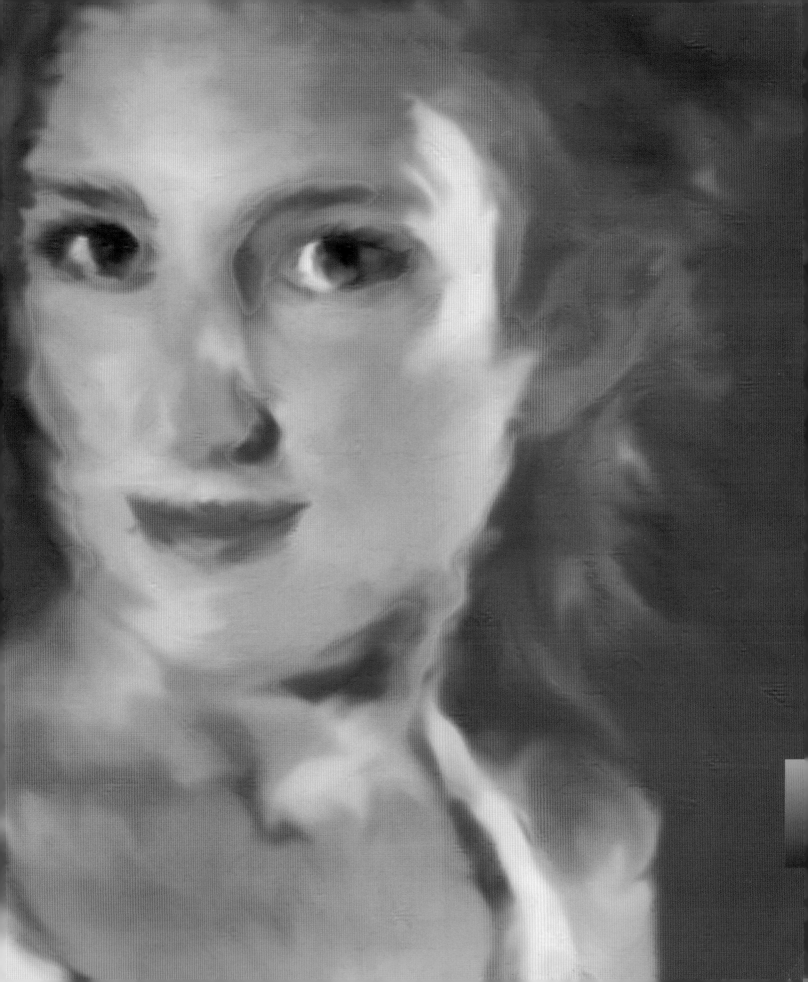

PORTRAITS IN OIL

Without a doubt, for authentic, natural media results with impasto oil effects, Corel's Painter program reigns supreme. Some very pleasing results, however, can be obtained using Photoshop. The intention here is not to draw or paint an original picture, but to take a portrait photograph and give it a natural, oil-paint finish. A studio shot is the most suitable type of picture to use as a source image, as most portraits in oils were also produced in a studio setting.

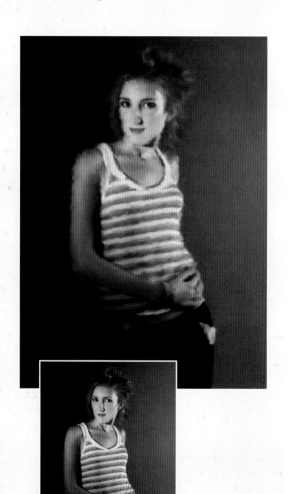

1 Open the picture and create a duplicate layer (Ctrl/⌘ + J); name it Paint layer. Select the Art History brush and pick the Tight Short style in the Options bar. Use a small brush of approximately 20 pixels and zoom in to the image so you can see what you are doing. The biggest mistake is to use too large a brush and lose all the detail. In the Options bar set Opacity to 50% and pixel size to about 20.

2 Start with the hair, making single, short, repetitive strokes in the direction that the hair naturally falls. If you make a stroke that looks wrong, stop, press Ctrl/⌘ + Z and redo it.

3 When you begin work on the face, paint in a circular motion, leaving the lips and eyes to the end. Change the size of the brush to 10 pixels and carefully do the eyes. Avoid placing the brush in the center of the iris as it tends to produce an exaggerated, bug-eyed look.

4 Switch to a 20-pixel brush and tackle the rest of the body in the same way as the hair. Ensure that you follow the natural lines of the figure—follow the arms in a downward direction, make horizontal strokes for the stripes on the vest, work in a circular motion around the bangle, and so on.

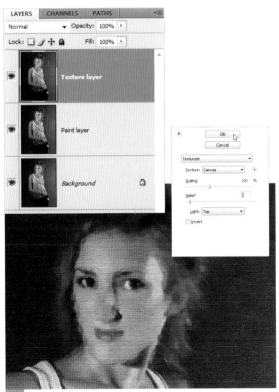

5 Switch the brush size to 50 pixels and paint the background in large strokes, avoiding the edges of the figure. Duplicate the Paint layer and name this the Texture layer. Go to **Filter > Texture > Texturizer** and select Canvas. Set the Size to 100% and Relief to 3; leave Light at Top.

6 Select the Smudge tool and set the Size to 20 pixels and the Strength to 50%. Repeat the painting process as before, going over the entire figure, except that the brush strokes should be very short and there should be more of them. Reduce the brush to 10 pixels to do the eyes and lips.

7 For the rest of the body, increase the brush size to 30 pixels and, rather than work in a single direction, make backward and forward motions for a more natural effect. If the odd patch of canvas texture shows through, that's OK, just make sure that there are no large areas of texture. The background canvas can be painted if you wish. However, the canvas pattern can look repetitive, and a little artificial, so paint it with a 90-pixel brush. Once printed, it looks fine.

8 Reduce the Texture layer to 75% and merge all the layers together. Create a new duplicate layer and then run the **Filter > Texture > Craquelure**. Enter the Spacing at 100, the Depth at 6, and the Brightness at 8. Reduce this layer to 10% Opacity and merge it.

WATERCOLORS

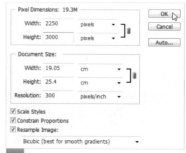

The watercolor treatment can be produced in Photoshop using the Art History brush and a selection of natural-media brushes, which, combined with filters, can produce very pleasing and authentic effects. This is particularly the case if the image is printed onto a canvas or fine-art paper stock. In keeping with its painterly origins, the best subject for this effect is one set in a pastoral scene, rather than an urban environment.

1 The advantage of this kind of process is that the original resolution of the image isn't as crucial. This family shot on the Isle of Skye was taken as a 2-megapixel JPEG file, and zooming in close reveals its limitations. Bumping the image up to 6 megapixels would not normally be viable, but the image is going to be rendered as watercolor, so it is more than possible. Go to **Image > Image Size** and increase the resolution to 3000 x 2250 pixels.

2 Go to the Layers palette and drag the background thumbnail over the Create A New Layer icon to duplicate the original and call it Working layer. This is useful in case you make a mistake—you can delete the layer and create a new one. Save this file as a Photoshop PSD file with a color profile and all layers. Close the project, then load it again. This is necessary because the Canvas Size has changed and the Art History brush uses the original image to work from. By saving and loading again, the new, expanded image becomes the original.

3 Select the Art History brush and click on the down arrow next to the Brush Size. In the brush dialog, click on the right-pointing arrow at the top and load the Wet Media brush set. Select the Watercolor Light Opacity brush (it's the last on the list) and set the size to 20 pixels.

4 Paint over the figure in the foreground, making sure that facial features are not distorted. If they are, repaint them until you are satisfied with the result.

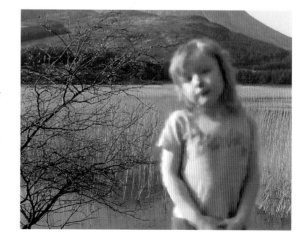

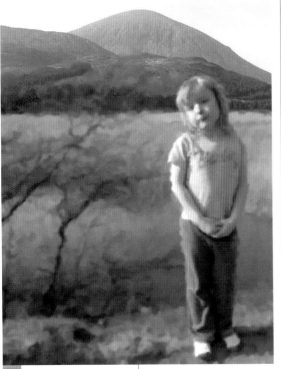

Set the Opacity of the top layer to 50%, and, if it looks good at this stage, flatten the image with **Layer > Flatten Image.**

5 Change the brush size to 40 pixels and paint over the rest of the foreground, right up to the mountains. Then change it to 60 pixels and paint over the mountains and distant detail.

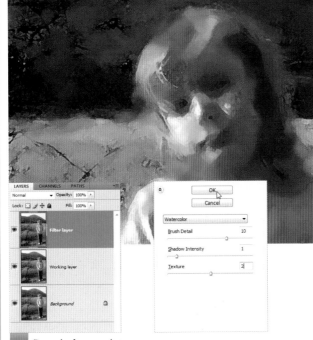

6 Go to the Layers palette and duplicate the working layer, and call it Filter layer. Go to the Filters menu and select **Artistic > Watercolor**. Set the Brush Detail to 10, the Shadow Intensity to 1, and the Texture to 2. Apply.

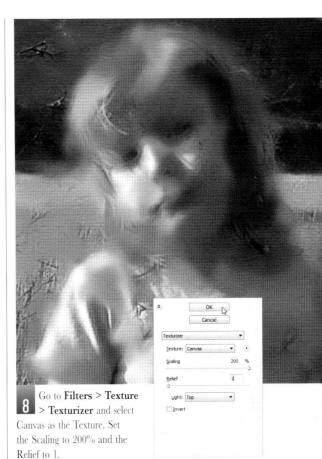

8 Go to **Filters > Texture > Texturizer** and select Canvas as the Texture. Set the Scaling to 200% and the Relief to 1.

9 Finally, go to **Image > Adjustments > Curves** and grab hold of the middle of the line. Drag it up and to the left to brighten up the entire image. To complete this picture, I've used third-party software to create a pleasing edge effect that enhances the watercolor look of the image.

CHARCOAL DRAWINGS

Although there is a so-called Charcoal and Chalk filter within Photoshop itself, it's fair to say that you'll find the results rather disappointing and mechanical. So here we're going to demonstrate a really easy technique that requires just the use of the Black and White command, a little layer masking, and lots of scribbling to give a super-realistic result! Key to this effect are Photoshop's rather more advanced brushes, which are contained in separate additional libraries, accessible from the Brush Picker. You can set these brushes up, not only to paint with varying opacity, but also, by default, they paint with really effective texture within their stroke. This is what lends this technique so much realism.

Remember, the key here is working on layer masks, where we can completely hide the associated image layer and then reveal it just within the brush marks made directly on the layer mask. Each time before you start to scribble, make sure that you click directly on the layer mask for that layer, and not on the image layer itself.

Once the sketch is finished, you can always return to each image layer and use the Black and White command again, adjusting the sliders to affect the tone of the finished drawing.

1 Duplicate the Background Layer (Ctrl/⌘ + J), then go to **Image > Adjustments > Black and White**. Choose the High Contrast Red filter from the presets and click OK. Now go to **Filter > Blur > Surface Blur**. Use a Radius of 10 and a Threshold value of 27. Click OK.

2 Choose **Filter > Noise > Add Noise**. Use an Amount of 9% and choose Gaussian for Distribution. Check Monochromatic and click OK. Now go to **Image > Adjustments > Curves**. Click two points on the curve and drag them to bend the curve upwards slightly to lighten the highlights and midtones. Click OK.

3 Open the paper image and go to **Select > All**, followed by **Edit > Copy**. Return to the portrait and go to **Edit > Paste**. The paper may need to be resized to cover the image. If this is the case, go to **Edit > Transform > Scale**. Simply drag on the handles around the Bounding Box to fit the paper to the image and click the Commit tick in the Options Bar when you're done.

4 Choose **Layer > Arrange > Send Backward** then click on the upper black and white layer, and set the Blending Mode to Multiply in the Layers panel. Click the tab for the Masks panel, hold down the Alt/⌥ key, and click the Add A Pixel Mask button to add a black filled mask.

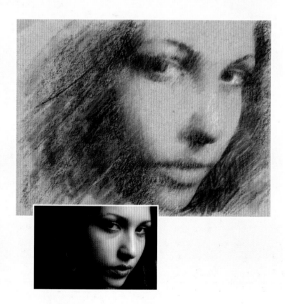

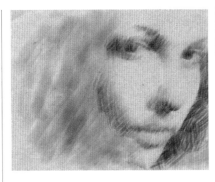

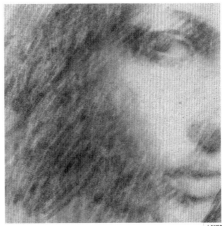

8 Continue to build up the drawing using the same technique. You need to use the brush at a much smaller size, and at a higher Opacity around the main facial features. You can use nice loose strokes around the outer areas of the image to give it some spontaneity.

5 Ensure your Foreground color is White and choose the Brush tool. Click in the Brush Picker, hit the right-pointing arrow, and choose the Natural Brushes library. Now choose the thumbnail for the Charcoal 59 brush. Display the Brushes palette (F5). Click on the Other Dynamics category and set Opacity Control to Pen Pressure. In the Options Bar, reduce the Brush Opacity to 40%.

7 In the Layers palette, click directly on the layer mask and go to **Edit > Fill**, choosing Black for Contents. Click in the Brush Picker again and choose Reset Brushes. Double click the Chalk Brush thumbnail. Use this brush in short hatching strokes to add more detail and shading to the drawing, using white as foreground and painting directly on the black layer mask.

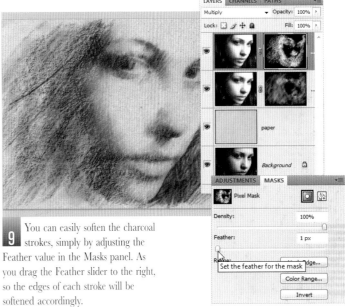

9 You can easily soften the charcoal strokes, simply by adjusting the Feather value in the Masks panel. As you drag the Feather slider to the right, so the edges of each stroke will be softened accordingly.

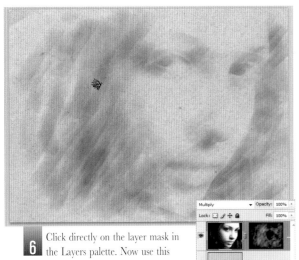

6 Click directly on the layer mask in the Layers palette. Now use this brush at a fairly large size to roughly scribble over the image and establish the tones. When you're happy, duplicate this layer (Ctrl/⌘ + J).

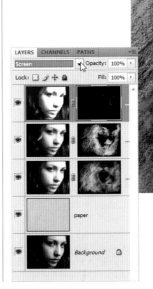

10 Finally, duplicate this layer for a final time and fill its layer mask with black via **Edit > Fill**, choosing Black for Contents. Set the Blending Mode for this layer to Screen in the Layers panel. Now use the same brush, with white, painting on to the layer mask to add some highlight strokes to the lighter areas of the face.

ADDING SMOKE AND MIST

Evoking images of the lonely, barren moors of *Wuthering Heights*, drifting mist or smoke creates an eerily atmospheric effect. The actual appearance of these two very similar phenomena can vary from a barely visible suggestion of drifting fog to constantly shifting ribbons of smoke, blown and coaxed into ever-changing shapes by the breeze. In this image you'll create and combine both of these to conjure up a truly evocative image, charged with mystery. The ubiquitous Clouds filter will supply the mist, together with layer blending modes and a little masking for subtlety. Random ribbons of smoke are whipped into shape by the Shear filter.

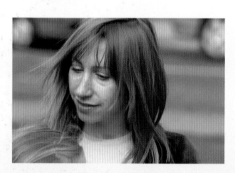

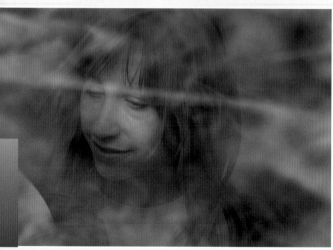

1 Set the scene with the Lighting Effects filter. Open your image and duplicate the Background layer (Ctrl/⌘ + J). Go to **Filter > Render > Lighting Effects**. For the Light Type, choose Omni. Click the Materials color swatch and choose a very dark blue or black. Choose white for the Light color swatch and reduce the Intensity to 13. Reduce the size of the light pool with the handles around it so that it just covers the girl's face. Click OK.

2 Go to **Layer > New Adjustment Layer > Hue/Saturation** and click OK. Check the Colorize box and set the Hue slider to 214 and Saturation to 21. Click OK. Choose the Brush tool and a large, soft brush from the Brush Picker. Paint a little black at low opacity over the face to reveal a little color.

3 For the first mist, add a new layer (Ctrl/⌘ + Shift + N), call it Mist 1. Choose the Rectangular Marquee tool and drag a rectangle in the center of the image. Hit D to revert to default colors and go to **Filter > Render > Clouds**. Hit Ctrl/⌘ + D to deselect. Go to **Edit > Transform > Scale** and stretch the clouds to cover whole image, then hit Enter.

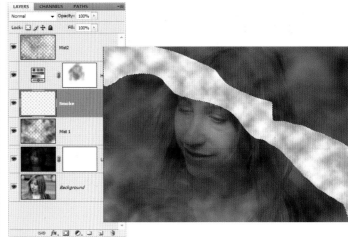

4 Go to **Filter > Blur > Gaussian Blur**, using a Blur Radius of 27 pixels. Set the blending mode for this layer to Screen. Reduce the layer Opacity to 52%. Move the Mist layer down so it sits over the Lighting Effects layer.

6 Add another new layer (Ctrl/⌘ + N), call it Mist 2. Make another rectangular selection in the center of the canvas. Go again to **Filter > Render > Clouds**. Go to **Filter > Stylize > Glowing Edges** and use these settings: Edge Width 12, Edge Brightness 12, and Smoothness 14. Hit Ctrl/⌘ + D to deselect, go to **Edit > Transform > Scale** and stretch to cover whole image area.

5 Choose the Eraser tool and use this at low opacity (set in the Options bar) to erase some of the mist from the girl's face.

7 Go to **Filter > Distort > Wave**. Set Number of Generators to 16, Wavelength to 52min and 174max, and Amplitude to 1min and 20max. Go to **Edit > Fade Wave**, reduce the Opacity to 90%, and choose Lighten for mode.

8 Go to **Filter > Blur > Gaussian Blur** and use a Blur Radius of 19 pixels. Set the blending mode for this layer to Screen and reduce the Opacity to 44%. Again, use the Eraser tool to remove a little of this layer here and there.

9 Next, some final wisps of smoke. Move the Mist 2 layer to the top of the Layers palette. Click on the Mist 1 layer, add another new layer (Ctrl/⌘ + N), and call it Smoke. Choose the Lasso tool and draw a broad, curved strip across the canvas. Click the Foreground color swatch and choose a light gray, ensuring you have white for the background color. Go to **Filter > Render > Clouds**. Hit Ctrl/⌘ + D to deselect.

10 Set the blending mode for this layer to Screen and reduce the Opacity to around 50%. Blur this layer a little via **Filter > Blur > Gaussian Blur**, using a Blur Radius of 42 pixels. Go to **Filter > Distort > Shear**. Drag the shear line into a shape similar to the one in the screenshot. You can experiment quite a bit here, bending the line until you like the shape of the drifting smoke in the Preview. Click OK to apply the shear.

11 Go to **Filter > Blur > Motion Blur**. Set the Angle to -65 and the Distance to 78. Set the blending mode to Hard Light. You can now use the Eraser tool on this layer to partially erase some of this smoke here and there to make it more subtle.

STAINED GLASS

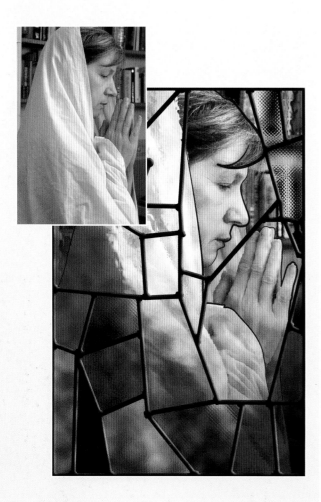

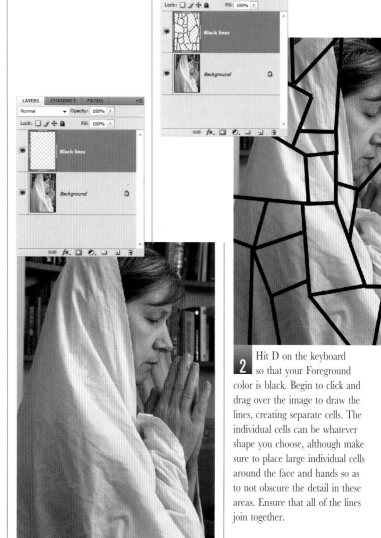

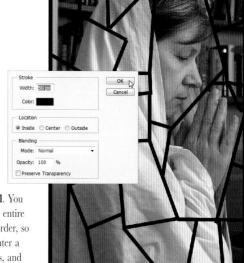

Churches around the world have some of the most stunning examples of stained glass. In bright sunshine, there is little to match the vibrant, glowing color of a stained glass window. Constructing stained-glass panels demands a highly skilled craftsman, but we can create a Photoshop version of this technique in just a few simple steps.

The praying figure used to demonstrate this technique obviously lends itself very well to the effect of stained glass, but you can adapt your own image. First you'll need to build a framework with the Line tool, and then fill separate cells with color. Photoshop has its own Glass filter, which can be very effective when used imaginatively. The Lighting Effects filter finally adds a touch of magic.

1 Open a suitable image, add a new layer (Ctrl/⌘ + Shift + N), and name it Black lines layer. We need to construct a network of black lines on this layer, which will create the effect of the leading in the stained glass. Choose the Line tool from the Toolbar. Click on the Fill Pixels icon in the Options bar. Enter 50 for Weight.

2 Hit D on the keyboard so that your Foreground color is black. Begin to click and drag over the image to draw the lines, creating separate cells. The individual cells can be whatever shape you choose, although make sure to place large individual cells around the face and hands so as to not obscure the detail in these areas. Ensure that all of the lines join together.

3 Go to **Select > All**. You need to enclose the entire image with an outline border, so go to **Edit > Stroke**. Enter a Stroke Width of 50 pixels, and choose Inside for Location.

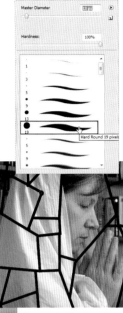

4 Choose the Brush tool from the Toolbar and select a hard, round brush from the Brush Picker. With the right-facing square bracket key on the keyboard, increase the brush size to around 90 pixels. Paint blobs of black over all of the intersections of the lines. This will later give the impression of soldered metal.

6 With these selections active, return to the Color layer. Click on the Foreground color swatch and choose a color for these areas of glass from the Color Picker. Go to **Edit > Fill**, choosing Foreground color for Contents to fill these cells with your chosen color. Hit Ctrl/⌘ + D to deselect.

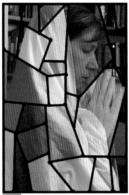

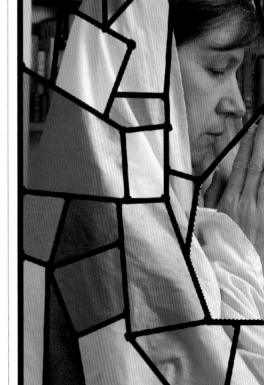

5 Next, fill these cells with color to represent the separate pieces of colored glass. Add a new layer (Ctrl/⌘ + Shift + N) and name it the Color layer. In the Layers palette, change the blending mode for this layer to Overlay. Choose the Magic Wand tool

and click the Add To Selection icon in the Options bar. Ensure that Use/Sample All Layers is unchecked, Contiguous is checked, and enter 80 for Tolerance. Return to the Black lines layer and click with the Wand tool in three or four of the cells throughout the image.

7 Repeat this procedure until all of the cells are filled with color. Remember to click on the Black lines layer to make the selections, and return to the Color layer to fill the individual cells with color. Choose different colors for each group of cells, and distribute the colors randomly around the image.

8 Further adjust the color of each cell by selecting the cell from the Black lines layer, returning to the Color layer, and going to **Image > Adjustments > Hue/Saturation**. Make the adjustments via the Hue and Saturation sliders.

STAINED GLASS

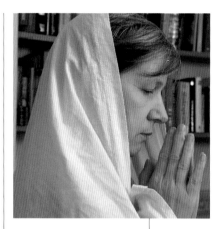

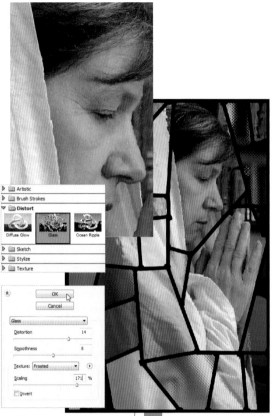

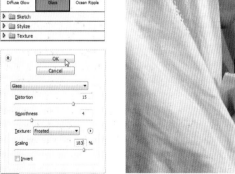

9 Next, apply the glass textures. Click the Background layer, duplicate it (Ctrl/⌘ + J), and call it Glass Textures. Return to the Black lines layer and make a few selections with the Magic Wand tool. Select the Background Copy layer and go to **Filter > Distort > Glass**. In the

Glass filter dialog, choose the type of glass you want to use for these cells from the Texture box. Further adjustments can be made to the texture via the Distortion, Smoothness, and Scaling sliders. Check the amount of distortion in the Preview pane. Click OK to apply the glass to these cells.

10 Hit Ctrl/⌘ + D to deselect, return to the Black lines layer, and make a few more selections with the Magic Wand. Again, back to the Background Copy layer and add glass texture to these areas via **Filter > Distort > Glass**. This time, choose a different Texture in the dialog. Continue making selections and applying the glass filter to the rest of the cells.

11 Click on the Color layer and add a new layer (Ctrl/⌘ + Shift + N) and call it Line. Hide the Color layer, the Black lines layer, and the Glass Textures layer by clicking the visibility eye for each in the Layers palette, so that only the original Background layer and the line layer are visible. Choose the Pen tool from the Toolbar. Use the Pen tool to trace the main outline of the figure. Just trace a little at a time, clicking and dragging with the Pen tool to create smooth, flowing lines.

12 Choose the Brush tool and select a medium-sized hard brush from the Brush Picker. Hit F5 to display the Brush Options, click the Shape Dynamics category, and set the Size Jitter control box to Pen Pressure. Hit D on the keyboard to revert to default Foreground/ Background colors. Return to the Pen tool and bring up the Paths palette. Click on the small arrow and select Stroke Path from the menu. Choose Brush for Tool in the Stroke Path dialog and check Simulate Pressure. Click OK.

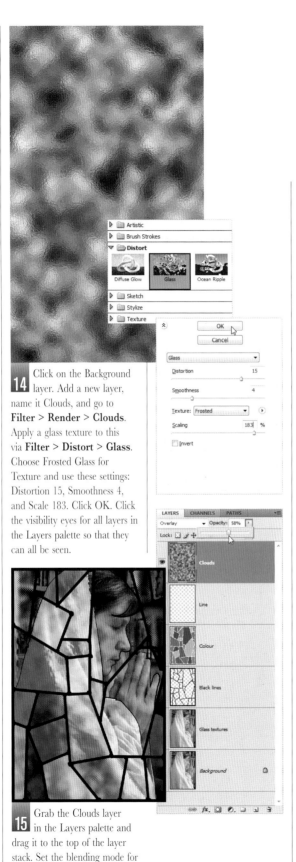

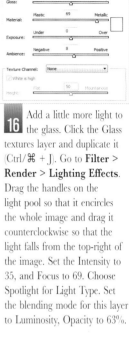

13 Once the path has been stroked, right-click (Ctrl-click) the path again and choose Delete Path from the menu. Continue to trace other parts of the figures outline, stroking each path by the above method. Remember, when using the Pen tool, click and drag to make curved lines. If you need to make a sudden and dramatic change of direction with the path, simply hold down the Alt key and click on the previously plotted point.

14 Click on the Background layer. Add a new layer, name it Clouds, and go to **Filter > Render > Clouds**. Apply a glass texture to this via **Filter > Distort > Glass**. Choose Frosted Glass for Texture and use these settings: Distortion 15, Smoothness 4, and Scale 183. Click OK. Click the visibility eyes for all layers in the Layers palette so that they can all be seen.

15 Grab the Clouds layer in the Layers palette and drag it to the top of the layer stack. Set the blending mode for this layer to Overlay, and the Opacity to 58%.

16 Add a little more light to the glass. Click the Glass textures layer and duplicate it (Ctrl/⌘ + J). Go to **Filter > Render > Lighting Effects**. Drag the handles on the light pool so that it encircles the whole image and drag it counterclockwise so that the light falls from the top-right of the image. Set the Intensity to 35, and Focus to 69. Choose Spotlight for Light Type. Set the blending mode for this layer to Luminosity, Opacity to 63%.

17 For the finishing touch, emboss the lead strips for more authenticity. Click on the Black line layer and go to **Layer > Layer Style > Bevel and Emboss**. From the Style box in the dialog choose Inner Bevel, from the Technique box choose Smooth. Use these settings: Depth 100, Size 29, and Soften 16. Click OK to apply. As soon as you're happy with the result, go to **Layer > Flatten Image** and save.

FRAMES AND COMPOSITIONS

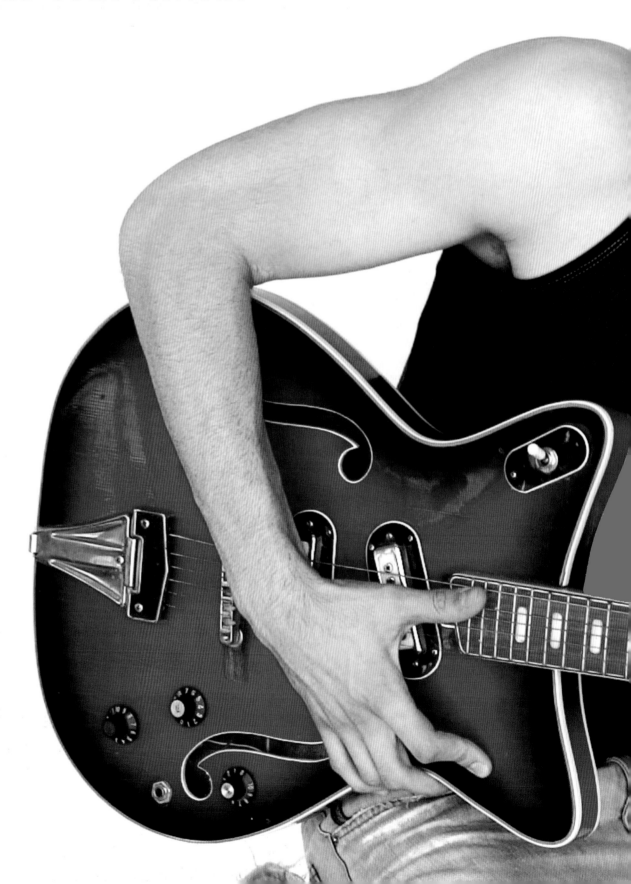

DIGITAL FRAMES

Width: 200 pixels
OK
Cancel

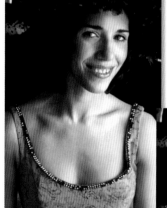

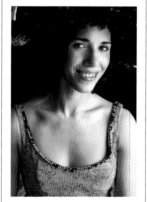

Spanish Lady by Duncan Evans LRPS

Digitally adding a frame to your picture can give it a professional finishing touch. Creating your own frames can be as straightforward or as elaborate as you want. From simple key lines to fancy, ornate renditions of traditional oil-painting frames, the world is your oyster. With this exercise, we're going to create a diffused border based on the image content—something that simply cannot be done with a physical frame.

Expand By: 50 pixels
OK
Cancel

1 There are a number of variations you can try with this concept. First, go to **Select > All** (Ctrl/⌘ + A), which selects the outside of the image. Go to **Select > Modify > Border** and enter a value of 200 pixels.

2 This is the maximum, so next go to **Select > Modify > Expand** and enter 50 to make the exterior selection much larger.

3 Go to **Edit > Copy** (Ctrl/⌘ + C) and then **Edit > Paste** (Ctrl/⌘ + V) to paste in the border as a new layer. In the Layers palette rename this layer Frame edge layer.

Click on the Background layer in the Layers palette and create a duplicate (Ctrl/⌘ + J). Call this layer the Working layer and ensure that it is underneath the Frame edge layer.

OK
Cancel
☑ Preview
25%
Radius: 25 pixels

4 Click on the eye icons for both Background layers so that they are invisible and select the Frame layer. Go to **Filter > Blur > Gaussian Blur** and enter a value of 25 pixels.

Expand By: 100 pixels
OK
Cancel

5 Select the Magic Wand and in the Options bar set the Tolerance to 0, then click inside the blank area of the frame layer. Expand the selection by 100 pixels under **Select > Modify > Expand**. Now go to **Select > Modify > Border** and enter a value of 5 pixels.

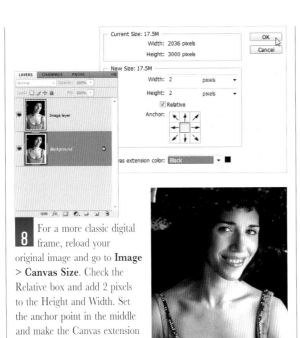

6 Click on the Create A New Layer icon at the foot of the Layers palette and create a new layer. Select the Paint Bucket tool and a complementary color that will also stand out against the picture—deep red, for example. Select the blank layer. The selection from the layer underneath should still be visible. The check box for Contiguous should be selected, but not the one for All Layers. Click in the middle of the layer and the selected area will be filled.

7 Deselect the selection (Ctrl/⌘ + D) and in the Layers palette make sure the top three layers are visible by clicking the visibility eyes. Go to **Layer > Merge Visible**. Select All (Ctrl/⌘ + A) and go to **Select > Modify > Border** and enter a value of 12 pixels. Use the same color and the Paint Bucket tool again and fill in this border. Deselect and go to **Layer > Flatten Image**, then save (Ctrl/⌘ + S).

8 For a more classic digital frame, reload your original image and go to **Image > Canvas Size**. Check the Relative box and add 2 pixels to the Height and Width. Set the anchor point in the middle and make the Canvas extension Black; click OK. Duplicate this layer in the Layers palette (Ctrl/⌘ + J) and call the new layer Image layer.

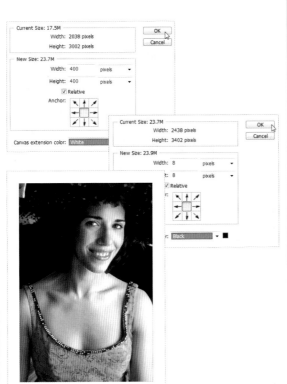

9 Click on the Background layer and go to **Image > Canvas Size** again. This time enter 400 pixels in the Width and Height boxes and set the Canvas color to white. Click on OK to extend it. Go back to Canvas Size for the third time. Enter 8 pixels as the extension and set the color to black to add a 4-pixel border.

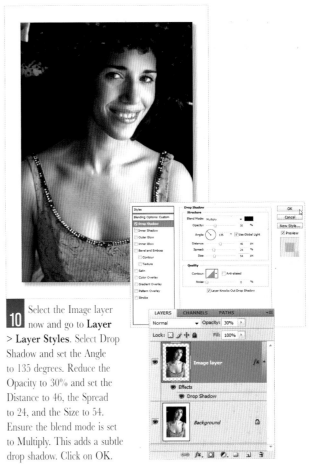

10 Select the Image layer now and go to **Layer > Layer Styles**. Select Drop Shadow and set the Angle to 135 degrees. Reduce the Opacity to 30% and set the Distance to 46, the Spread to 24, and the Size to 54. Ensure the blend mode is set to Multiply. This adds a subtle drop shadow. Click on OK.

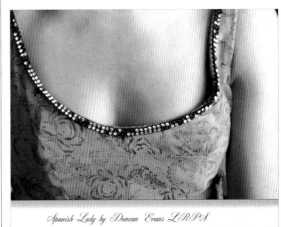

Spanish Lady by Duncan Evans LRPS

11 As a final touch add some text within the frame. Select the Text tool and choose an ornate font such as Ancestry and set the Size to around 70 point. Type in your title and name. Go to **Layer > Flatten Image** and save.

Adding Edges

There are numerous third-party packages featuring pre-designed edge effects and it is possible to spend hours searching for the one that's perfect for your image. For very fancy edge effects, you can't beat AutoFX's Photo/Graphic Edges 6. But if you don't want to spend the money and would like to try something yourself, you can create your own personalized soft-edge effect.

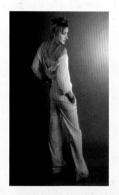

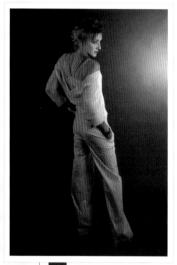

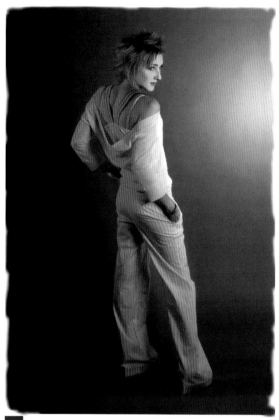

1 Your first consideration is whether you have the room to incorporate an edge effect. Unlike a frame, which is outside the image, an edge eats into the image. Depending on the content, it can obscure parts of the image and make it look a little cramped. This one is a little tight at the top and bottom so your first step is to expand the canvas by 150 pixels. If the background is uniform, choose that color for the extended canvas. If not, leave it as white for the moment.

2 Select the Clone Stamp tool at 100% Opacity and set the sampling point just inside the original border. Clone out and around to fill it in. Cover the join between the existing photo and the new border—you can do this in two passes.

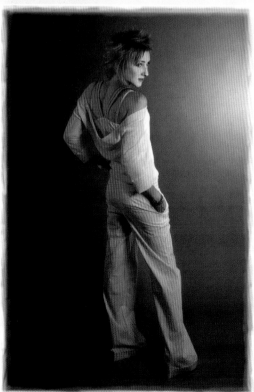

3 Create a duplicate layer (Ctrl/⌘ + J), call it Edge effect, then select the Rectangular Marquee tool. Draw inside the edge of the picture, marking where you want the edge effect to start. Go to **Select > Feather** and feather the selection by 10 pixels. Go to **Select > Invert** (Ctrl/⌘ + Shift + I).

4 Select the Brush tool and a brush size that is about half the width of the edge area and select white as the Foreground color if the background of the picture is dark, or black if the background is predominantly white. Set the Opacity of the brush to 50%. With the Edge effect layer still active, use the brush to make strokes back and forth in and out of the edge area, but generally using vertical strokes on the sides and horizontal strokes on the top and bottom.

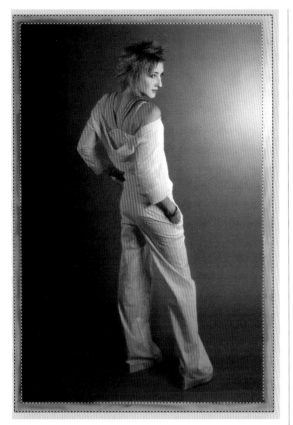

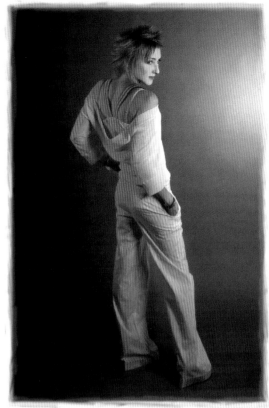

5 Go back over the area again, but this time ensure that you work on the very outside edge of the image so that the edge is completely painted over. Use short brush strokes and, as you do so, you will leave an edge effect where it borders the remainder of the photograph.

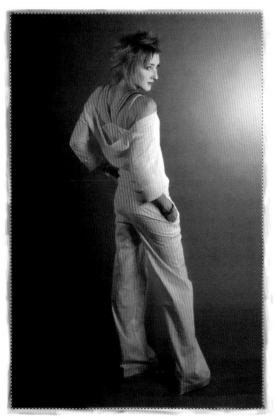

6 Return to the Edge effect layer, deselect the selection, then change the Opacity of the brush to 15%. Lightly dab where the edge joins the photo, all the way round. Also use this to clean up any stray areas of the edge where it looks rough. You can either merge and save this, which will give you a white outside edge to the effect, or you can change the blend mode of this layer to Luminosity, which will add original colors from the image to the edge area.

OUT OF THE FRAME

Traditionally, images have been framed in specific ways in order to present them for display. Often, the frame consists of a white border, or the image is printed and presented in a literal picture frame—either way, the image is contained within the framing device. But with Photoshop you can play with the framing to create something different. After all, rules are meant to be broken and this is one occasion when you can do so. Here you're going to construct a framed image for the subject—and then show him breaking free! All you need to do is make an accurate selection, a couple of pasted layers, a fill or two, and an effective and convincing shadow, and the image is complete.

1 Open the figure image and choose the Brush tool. Choose a hard brush from the Brush Picker. Hit Q to enter Quick Mask mode. Carefully paint over the entire figure with black as your Foreground color. Take care to keep exactly to the shape and outline of the figure. If you accidentally paint the mask over the edge of the figure, simply paint with white to erase that part of the mask. When you're done, hit Q again to exit Quick Mask.

2 Go to **Select > Inverse** (Ctrl/⌘ + Shift + I) to select the figure instead of the background. Save this selection via **Select > Save Selection**, naming it Figure. Go to **Layer > New > Layer Via Copy** (Ctrl/⌘ + J), to paste a copy of the selected figure onto another layer.

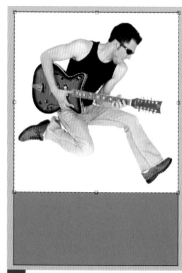

3 Ensuring that the Background color swatch is black (hit D to set default Foreground/Background colors, then hit X to reverse them), choose the Crop tool and crop away the unwanted area at the bottom of the image.

4 Zoom out from the image and increase the size of the box so that you can see a gray surround. Again, with the Crop tool, drag a crop box around the entire image, then drag each of the central handles outward on all four sides of the crop box. Make sure that the border around the image is roughly equal. Hit Enter to commit the crop.

5 Add a new layer (Ctrl/⌘ + Shift + N) for the mount, and choose a color for the mount itself from the Foreground color swatch. Choose the Rectangular Marquee tool, and drag a selection over approximately half of the central image. Invert the selection via **Select > Inverse** (Ctrl/⌘ + Shift + I). In the Layers palette drage the Mount layer to beneath the Figure layer. To create the mount area, go to **Edit > Fill**, choosing Foreground color for Contents. Hit Ctrl/⌘ + D to deselect.

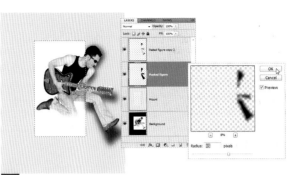

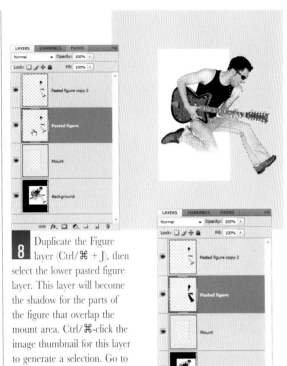

6 Next, crop again to even up the sides of the mount. Choose the Crop tool and drag a crop over the whole image. Drag the central handle on the right-hand side of the crop box inward so that the width of the border matches that on the left. Hit Enter to commit the crop.

7 Click on the pasted Figure layer, and then Ctrl/⌘-click the filled Mount layer to generate a selection from it. Invert the selection via **Select > Inverse** (Ctrl/⌘ + Shift + I) and hit the Backspace key to delete the parts of the figure within the actual picture space within the mount. The thumbnail image of the figure in the Layers palette should show half the figure missing. Hit Ctrl/⌘ + D to deselect.

8 Duplicate the Figure layer (Ctrl/⌘ + J), then select the lower pasted figure layer. This layer will become the shadow for the parts of the figure that overlap the mount area. Ctrl/⌘-click the image thumbnail for this layer to generate a selection. Go to **Edit > Fill**, using Black for Contents. Hit Ctrl/⌘ + D to deselect.

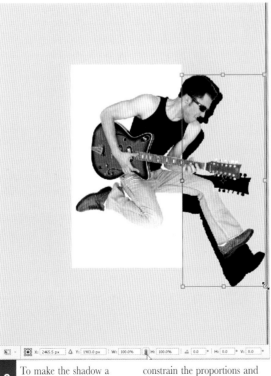

9 To make the shadow a little bigger, go to **Edit > Transform > Scale**. Click the link between the two dimension values in the Options bar to constrain the proportions and drag the lower right corner handle on the bounding box to increase the size of the shadow.

10 Blur this shadow using **Filter > Blur > Gaussian Blur**. Use a Blur Radius of 45 pixels. Click OK to apply. Ctrl/⌘-click the image thumbnail for the Mount layer to generate a selection. Go to **Select > Inverse** (Ctrl/⌘ + Shift + I) and then select the Shadow layer. Use the Eraser tool to erase any of the shadow that falls within the inner aperture of the mount. Go to **Select > Deselect** when you're finished.

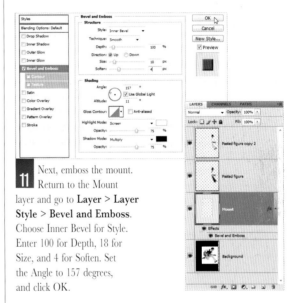

11 Next, emboss the mount. Return to the Mount layer and go to **Layer > Layer Style > Bevel and Emboss**. Choose Inner Bevel for Style. Enter 100 for Depth, 18 for Size, and 4 for Soften. Set the Angle to 157 degrees, and click OK.

12 To add a subtle canvas texture to the mount, with the Mount layer still selected, go to **Filter > Texture > Texturizer**. Use Canvas for Texture, set a Scaling value of around 160%, and choose Top Left for Light Direction. Flatten the image (**Layer > Flatten Image**) and save.

FOREIGN HOLIDAY

There's no better antidote to life's stresses and strains than a fortnight of fun in the sun. But if your bank balance won't stretch to the vacation of your dreams, turn to Photoshop and you can simply fake those memorable vacation snaps to make it look as though you've been somewhere exotic. In this exercise, you will learn how to drop a decidedly domestic figure into a Caribbean beach scene. The key to the technique is the powerful Extract command in Photoshop, then using some careful tonal adjustments and a few faked dappled shadows to complete the effect.

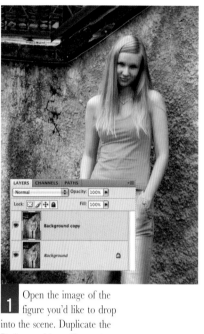

1 Open the image of the figure you'd like to drop into the scene. Duplicate the Background layer (**Layer > Duplicate Layer**), and then go to **Filter > Extract**.

2 In the Extract dialog, choose the Edge Highlighter tool from the Toolbar. Using the tool at a fairly small size, carefully paint around the outline of the figure. Make sure that your green highlight line around the figure actually overlaps the figure outline, and make sure there are no gaps in the outline. You can use the Zoom tool in the Toolbar to zoom into the image for more accuracy.

3 Choose the Fill tool and click inside the figure to flood-fill the area for extraction. Click the Preview button to preview the extraction. If there are some broken edges, choose the Cleanup tool and use this around the edges. To make parts of the mask opaque, hold down the Alt/⌥ key while painting with the tool. When you're happy with the extraction, click OK.

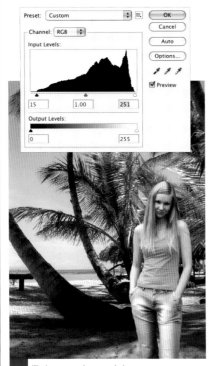

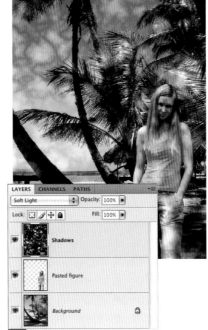

4 Go to **Select > All** (Ctrl/⌘ + A) and then **Edit > Copy** (Ctrl/⌘ + C) to copy the extracted figure onto the Clipboard. Close this image and open the Caribbean shot. Go to **Edit > Paste** (Ctrl/⌘ + V) to paste the figure into the scene.

6 To improve the match between the two images you need to adjust the Levels a little, so go to **Image > Adjustments > Levels**. Drag the white point slider a little to the left, and the black point slider a little to the right to increase the contrast.

8 Set the blending mode for this layer to Soft Light. Now go to **Image > Adjustments > Levels**. Drag the white point slider to the left until it's just under the start of the Histogram. Click OK. Go to **Filter > Blur > Gaussian Blur** and use a Radius of 4 pixels.

10 Zoom into the girl's face and choose the Eraser tool. Reduce the Opacity of the Eraser to 30% in the Options bar, and erase a little of the shadow over the eyes. Click on the Figure layer and choose the Blur tool, reducing the Strength to 10% in the Options bar. Use this tool over any hard outlines around the figure.

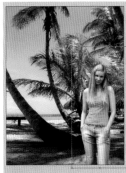

5 To size the figure to fit the scene, go to **Edit > Transform > Scale**. Hold down the Shift key to constrain the proportions and drag on one of the corner handles. Hit Enter to commit the transformation.

7 To cast some dappled shadows onto the figure to give the impression of light through the trees, add a new layer (Ctrl/⌘ + Shift + N), call it Shadows, and hit D on the keyboard to revert to default Background/Foreground colors. Go to **Filter > Render > Clouds**. To improve this random shadow effect, go to **Filter > Render > Difference Clouds**.

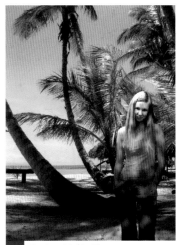

9 You need to isolate the shadows so they are just over the figure. With the Shadow layer selected, hold down the Ctrl/⌘ key and click the image thumbnail for the Figure layer to generate a selection from its transparency. Invert the selection via **Select > Inverse** (Ctrl/⌘ + Shift + I), then hit the Backspace key to delete the unwanted shadows. Hit Ctrl/⌘ + D to deselect. You can reduce the intensity of the shadows simply by reducing the Shadow layer opacity.

11 Finally, with the Figure layer selected, go to **Filter > Render > Lighting Effects**. Choose Spotlight for Light Type and White for the Light color swatch. Rotate the light pool in the Preview pane so that it shines from 11 o'clock. Stretch the light pool with the handles so that it covers the whole figure. Set Intensity to 47 and click OK. Go to **Edit > Fade Lighting Effects** and reduce the Opacity slider to 78%. Flatten the image (**Layer > Flatten Image**) and save.

Medallion Portrait

A Photoshop guru working to your standard deserves a medal! Hopefully that's pretty much how you feel, having improved your skills so much with the help of this book! So why not make your own medal to reward yourself for your efforts!

That's exactly what we're going to do here, and we're going to use some of CS4's most powerful features to do it. The key to this technique are Alpha Channels, which in reality are channels in addition to the usual Red, Green, and Blue varieties found in a standard RGB image. These alpha channels, like the others, work on a purely grayscale principle, and we can also use them as depth maps in conjunction with the Lighting Effects filter to give a thoroughly convincing three-dimensional look to the surface of the medal.

Not only that, but we're going to use the Lighting Effects filter as a Smart Filter, which means that you can change the settings within the filter again and again to give the medal itself lots of different looks. With Smart Filters the possibilities are endless. When you've finished working through the tutorial, try adding a Curves adjustment layer at the top of the stack using the same settings as in the Goldfinger project on page 168 to add a little more shine. OK, are you ready for your award?

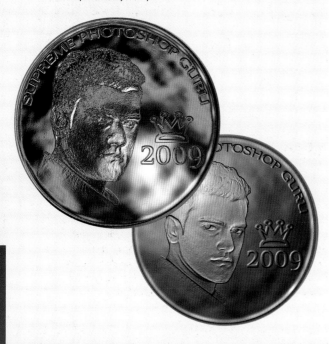

1 Go to **File > New** and create a new document, using the values shown in the screenshot. Make sure that the Background Color is White. Choose the Ellipse Tool, and in the Options Bar choose the Fill Pixels button. In the Options Bar, click the small arrow next to the shapes and choose Circle from the Ellipse options. Ensure that Anti-Alias is checked.

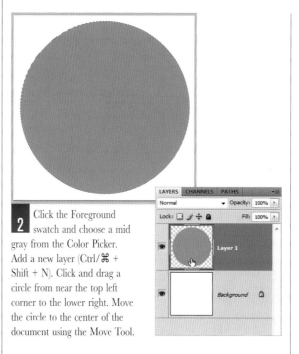

2 Click the Foreground swatch and choose a mid gray from the Color Picker. Add a new layer (Ctrl/⌘ + Shift + N). Click and drag a circle from near the top left corner to the lower right. Move the circle to the center of the document using the Move Tool.

3 Hold down the Ctrl/⌘ key and click the thumbnail for this layer in the Layers palette to generate a selection. Ensure that you have a mid gray for Foreground and White for background and click **Filter > Render > Clouds**. Once the clouds are generated, use **Filter > Blur > Gaussian Blur** with a radius of around 13 and click OK.

4 Hit Ctrl/⌘ + D to deselect, then Ctrl/⌘-click the layer and choose a slightly darker gray for the Foreground swatch. Add a new layer and go to **Edit > Stroke**. Enter 25 for Width and choose Outside for Location. Click OK. Ctrl-click this layer and go to **Filter > Blur > Gaussian Blur**. Use a Radius of 4 and click OK.

5 Open your portrait image and go to **Select > All**, followed by **Edit > Copy**. return to the medallion image and go to **Edit > Paste**. Go to **Edit > Transform > Scale**. Hold down the Shift key and scale the portrait to fit the medallion. Hit the Commit Tick in the Options Bar when you're done.

6 Choose the Quick Selection Tool. Click on the Add To Selection button in the Options Bar and check Auto-Enhance. Drag the tool around the head to select the unwanted background. With the selection active, hit the Backspace key on the keyboard to delete. Deselect (Ctrl/⌘ + D).

7 Go to **Image > Adjustments > Black and White**. Choose the High Contrast Red Filter from the Presets and click OK. Reduce the noise in the image a little via **Filter > Noise > Reduce Noise**. Set Strength and Reduce Color Noise to the maximum and set the other two sliders to zero. Click OK. Now use the Eraser Tool to erase any parts of the portrait that fall outside the medallion.

8 Add some text to the medal using the Horizontal Type Tool, adjusting the Font and Size in the Option Bar. You can bend the text around the top of the medal by hitting the Create Warped Text button in the Options Bar, choosing Arc for Style and adjusting the Bend slider to fit.

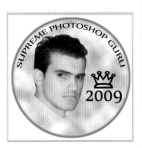

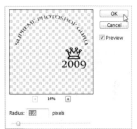

9 Once you've finished the text and added any decoration in black, right-click the text layer and choose Rasterize Type. Now go to **Filter > Blur > Gaussian Blur**. Use somewhere between 1 and 2 for the Radius and click OK.

10 Hide the Background Layer by clicking its visibility eye. Now, on the Keyboard, hold down the Ctrl/⌘ + Shift + Alt/⌥ keys, and with them held down hit the E key to stamp the visible layers to a new layer. Click on this merged layer at the top of the stack and go to **Select > All**, followed by **Edit > Cut**.

11 Click the tab for the Channels palette. At the base of the palette, hit the Create New Channel button. Now go to **Edit > Paste**. Click on the RGB channel at the top of the stack and return to the Layers palette. In the layers palette, delete the type and portrait layers by right-clicking them and choosing Delete layer.

12 Make the Background Layer visible again via its visibility eye. Click on the top layer in the stack and go to **Layer > Merge Down**. On the merged medallion layer go to **Filter > Convert For Smart Filters**. Now go to **Filter > Render > Lighting Effects**. Use similar settings within the Lighting Effects

dialog to those shown in the screenshot. make sure to choose your previously created Alpha Channel (Alpha 1) from the Texture Channel option. Because we've applied this filter as a Smart Filter, you can always re-edit the filter settings later simply by double-clicking the filter entry in the Layers pannel.

MP3 SILHOUETTE

If you're in to music and you're download crazy then you'll recognize these sort of images immediately! Although these funky silhouettes are fairly uncomplicated images, to do them well you need to create something within a little more depth than just a solid black silhouette, and here we're going to show you how!

Layer masks play a major role in this technique, and the new Refine Mask edge feature in Photoshop CS4's Masks panel means that you can tweak the outline of the mask with a whole new level of accuracy and control.

We'll use a simple solid color layer for the vibrant background fill, and the advantage of this is the fact that you can change this color fill with just a couple of mouse clicks, simply by double-clicking the solid fill layer in the layers palette and choosing a new fill color from the color picker.

Put those headphones on, fire up CS4, and get down and boogie!

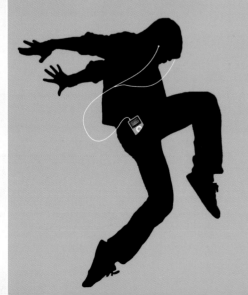

1 Open the start image and grab the Quick Selection tool from the Toolbar. In the Options Bar check Auto-Enhance. You need to zoom well in to the image and choose a hard brush from the brush picker in the Options Bar. Use this brush at a very small size to carefully trace around the outline of the figure.

3 Now it's a case of selecting and deselecting with these two tools. Use the Add To Selection brush to select around the figure and use the Subtract From Selection brush to deselect any areas of the figure that get selected. Use the brushes at a very small size and take your time with this. When you're happy with the selection, click the Refine Edge button in the Options Bar. Use a Smooth factor of 4 and a contrast of 10%. Leave all other sliders set to zero and click OK.

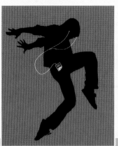

2 This is quite a complicated shape to generate a selection around, and every now and then the Quick Selection tool may select a little of the figure as well as the background. If this happens, click on the Subtract from Selection button in the Options Bar and simply stroke within the area to deselect it again.

4 Go to **Select > Save Selection**. Name the selection Outline and click OK. Right-click the Background Layer and choose Duplicate Layer. Click on the top layer in the stack and in the Masks panel hit the Add Pixel Mask button.

5 Click on the Background Layer and go to **Layer > New Fill Layer > Solid Color**. Choose your desired background color from the Color Picker and click OK.

7 In the Masks panel, click the mask Edge button. In the Refine Mask dialog hit the Default button, then drag the Contract/Expand slider to the left to a value of -1.

9 Source an image of an MP3 player and paste it into the image. Use a layer mask to mask out any unwanted areas around the player. Scale the player via **Edit > Transform > Scale**. Rotate it via **Edit > Transform > Rotate**, dragging the mouse near the corner of the bounding box. Hit Enter to commit. Position the player wherever you like using the Move Tool (V).

6 Click directly on the layer mask attached to the top layer and choose the Brush tool. Choose a very small hard brush from the Brush Picker and set brush Opacity to 100%. Then use this brush at a tiny size to correct the mask, using black to expose more of the underlying color fill layer and white to correct the figure.

8 Right-click the masked top layer in the stack and choose Duplicate Layer. Click on the image thumbnail on this layer and go to **Edit > Fill**, choosing Black for Contents. We want a little detail from the lighter areas within the figure to be visible within the silhouette, so change the Blending Mode for this layer to Multiply and reduce the Opacity to 88%.

10 To add the headphones, add a new layer and choose the Pen tool. In the Options Bar, choose the Paths button. Now draw a simple path by clicking and dragging to create the first wire. Choose the Brush tool and set the size of the brush to just four pixels. Make sure your Foreground color is white and return to the Pen tool.

11 Right-click the Path with the Pen Tool and choose Stroke Path. Choose the Brush for Tool and make sure that Simulate Pressure in not checked. Click OK. Repeat this for the other wire. Use the Brush tool to add the joints and ear pieces.

PHOTO MOSAIC

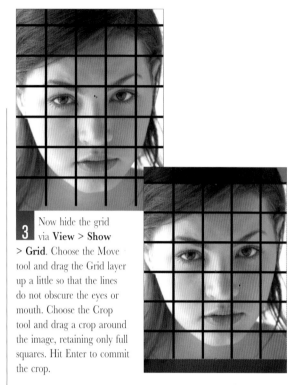

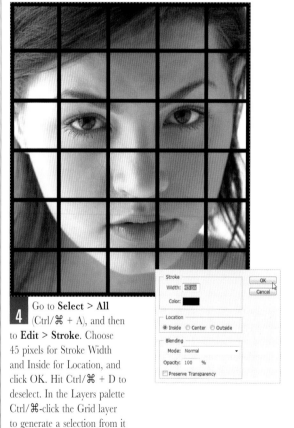

There are times when you really don't have to have a good reason to try something a bit different—the very fact that the result makes a pleasing, decorative image is reason enough to give it a go. Pure experimentation was the inspiration for this project, and the result, printed at a large size, really makes an impact. To create this project, you'll break up a single portrait into a series of embossed tiles by making a grid of lines with the Line tool and deleting the parts of the image beneath. A couple of simple Layer Styles adds some subtle embossing and shadows.

1 Open up your start image and duplicate the Background layer (Ctrl/⌘ + J). Go to **View > Show > Grid**. Add a new layer (Ctrl/⌘ + Shift + N) and choose black for the Foreground color. Click and hold the currently displayed Shape tool in the Toolbar and choose the Line tool from the fly-out.

2 Choose the Fill Pixels icon at the far left-hand end of the Options bar and enter 45 in the Weight box. Using the grid as a guide, draw equally spaced straight lines down and across the image. I've placed a line over every alternate bold line on the grid. To ensure that you're drawing straight lines with the tool, hold down the Shift key while you click and drag with the Line tool.

3 Now hide the grid via **View > Show > Grid**. Choose the Move tool and drag the Grid layer up a little so that the lines do not obscure the eyes or mouth. Choose the Crop tool and drag a crop around the image, retaining only full squares. Hit Enter to commit the crop.

4 Go to **Select > All** (Ctrl/⌘ + A), and then to **Edit > Stroke**. Choose 45 pixels for Stroke Width and Inside for Location, and click OK. Hit Ctrl/⌘ + D to deselect. In the Layers palette Ctrl/⌘-click the Grid layer to generate a selection from it and go to **Select > Modify > Smooth**. Enter a Sample Radius of 15 pixels. This will round the corners of the individual cells.

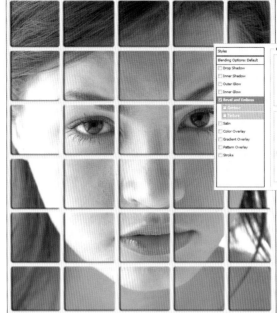

5 Click on the Background Copy layer, and hide the Grid and Background layer by clicking the visibility eye for each in the Layers palette. With the selection still active, hit the Backspace key on the keyboard to delete the areas between the cells. Hit Ctrl/⌘ + D to deselect. Drag the Grid layer to the trash can in the Layers palette.

6 Click on the Background layer and click its visibility eye. Choose a light cream color from the Foreground swatch. Now go to **Edit > Fill**, choosing Foreground color for Contents.

7 Click on the Mosaic layer in the Layers palette and apply a Layer Style to give the effect of individual tiles. Go to **Layer > Layer Style > Drop Shadow**. Set Distance to about 25 and Size to about 10. Go back to **Layer > Layer Style** and this time select Bevel and Emboss. In the Bevel and Emboss dialog choose Emboss from the Style box. Set the Depth slider to 121%, the Size to 10, and Soften to 12. Click OK to apply the styling.

8 In the Layers palette, Ctrl/⌘-click the image icon for the Mosaic layer and choose Select Layer Transparency. Add a new layer (Ctrl/⌘ + Shift + N) and set the layer blending mode for this layer to Overlay in the Layers palette. Choose the Brush tool and choose a color from the Foreground swatch. Select a hard brush from the Brush Picker and paint with this color inside a few of the tiles.

9 Choose another Foreground color, and continue to paint inside random tiles with the brush. Make sure that you randomly position tiles of a particular color throughout the image for variety. Control the intensity of the Color layer by reducing the layer opacity. Experiment with the tile effect by clicking on the words Bevel and Emboss in the Layers palette. Once you're happy with the result flatten the image (**Layer > Flatten Image**) and save.

SWAPPING HEADS

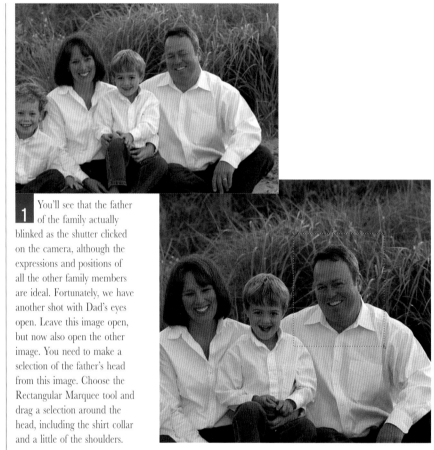

1 You'll see that the father of the family actually blinked as the shutter clicked on the camera, although the expressions and positions of all the other family members are ideal. Fortunately, we have another shot with Dad's eyes open. Leave this image open, but now also open the other image. You need to make a selection of the father's head from this image. Choose the Rectangular Marquee tool and drag a selection around the head, including the shirt collar and a little of the shoulders.

It's a classic scenario. You've photographed a family group, and three out of the four subjects are perfectly posed and have great expressions. The shot is almost perfect—or would be, if it weren't for the fact that the father of the family has his eyes closed! Fortunately, you have another shot where dad's eyes are open. Big problem? Not with Photoshop. You can simply swap one head for another—a fundamental Photoshop technique. Many labs charge a heavy fee for such a service, but the process itself is really not as difficult as you might think. With careful use of the Clone Stamp tool and a bit of work on a layer mask you can create a seamless head swap in just a few steps.

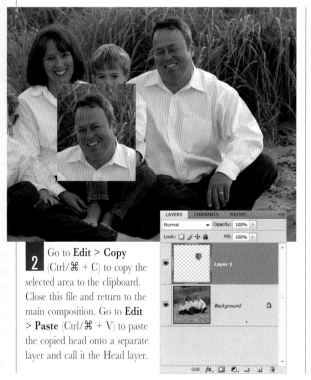

2 Go to **Edit > Copy** (Ctrl/⌘ + C) to copy the selected area to the clipboard. Close this file and return to the main composition. Go to **Edit > Paste** (Ctrl/⌘ + V) to paste the copied head onto a separate layer and call it the Head layer.

3 Choose the Move tool from the Toolbar. Reduce the Opacity of the Head layer to 60% and drag the new head roughly into position. Because we've reduced the opacity of this layer, you'll be able to carefully match the position of the new head with that of the one beneath. Concentrate on matching the position of the ear and the shirt collar.

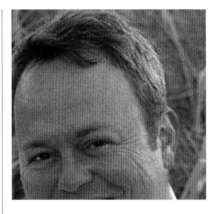

4 If you find that the heads are slightly different sizes, you can correct this via **Edit > Transform > Scale**. Make sure to activate the chain link in the Options bar between the Height and Width dimensions so as to maintain the original proportions. Simply drag on the corner handles around the bounding box to reduce or increase the size of the head. Hit Enter to apply the transformation.

5 Hide some of the unwanted head on the Background layer. For the moment, hide the new head by clicking the visibility eye next to the layer in the Layers palette. Click on the Background layer. Zoom well into the head area and choose the Clone Stamp tool from the Toolbar. Choose a soft brush from the Brush Picker. Ensure that Aligned is checked in the Options bar and that Use/Sample All Layers is unchecked.

6 To set the clone source point, hold down the Alt/⌥ key and click with the Clone Stamp tool very close to the left-hand side of the face. Make sure that the brush outline does not actually overlap the face, but is directly next to it. Release the Alt/⌥ key and begin to click over the outline of the face. As you work around the outline of the head, regularly change the source point by Alt/⌥-clicking in a nearby area of grass.

7 Be careful not to clone in any obviously repeating patterns by changing your clone source point regularly. You can clone some plainer areas of grass over the head outline from anywhere within the grass.

8 Once you've completed cloning out the outermost parts of the head, click on the pasted Head layer again and click its visibility eye to make it visible. Increase the layer Opacity back up to 100%. You'll notice that the white of the shirt is a little darker on the pasted layer, so go to **Image > Adjustments > Levels**. Grab the white point marker below the histogram and slowly drag it to the left until the tones match.

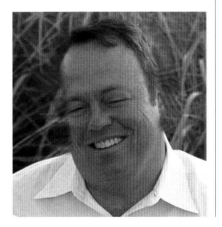

9 Add a layer mask to this layer via **Layer > Layer Mask > Reveal All**. Hit D to revert to black/white Foreground and Background colors and choose the Brush tool. Select a very small soft brush from the Brush Picker. Click on the icon for the layer mask in the Layers palette. Paint very carefully with black around the head to erase the pasted grass. Next, paint over the pasted parts of the shoulders, leaving just the overlaid head visible. Zoom into the image and reduce the brush to a very small size to erase the grass accurately around the head.

10 Click the visibility eye for the Background layer so you can check you've erased all the unwanted parts of the upper layer. If you accidentally paint over part of the head, simply paint back into the mask with white to reveal that part again. Show the background layer again, flatten the image via **Layer > Flatten Image**, and save.

RESTORING OLD FAMILY PHOTOS

Photographs are precious embodiments of our memories and history. It's sad, but time can take its toll on vintage family photographs. The chemicals and materials deteriorate with prolonged exposure to air and light. Often, as well as taking on the ubiquitous sepia tinge, images can almost disappear completely. However, with Photoshop, we can reverse this process and preserve images for future generations. Begin by scanning your original image. Remember to scan in full color to get as much information as possible and use a resolution of at least 300 ppi. We'll use a number of restoration techniques in this exercise, all of which will enable you to save your own family's precious memories.

1 To begin, correct the alignment of the image and crop it. Choose the Measure tool from the Toolbar and position the tool against the top of the window opening. Click and drag a measure line down to the bottom of the window to establish an upright. Go to **Image > Rotate Canvas > Arbitrary**. Photoshop will automatically calculate the required degree of rotation—all you need to do is click OK.

2 Choose the Crop tool and drag a crop around the image, cropping out all unwanted and damaged edges. Hit Enter to execute.

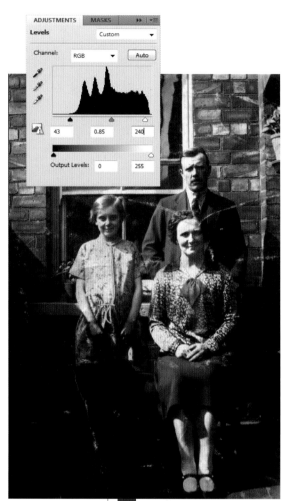

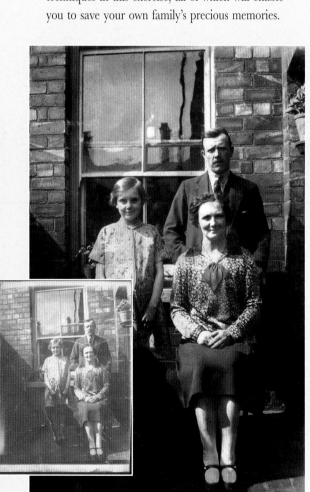

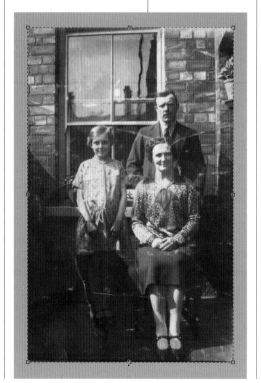

3 Next, desaturate the image to get rid of the sepia tint. Go to **Image > Adjustments > Desaturate**. A Levels adjustment is required to bring back the correct tones in the image. Go to **Image > Adjustments > Levels**. Drag the white point slider to the left until it is just under the start of the histogram. Repeat with the black point slider. Drag the midpoint slider to the right a little to darken the midtones. Click OK to apply the Levels.

4 The next part of the restoration demands patience as much as ability. Add a new layer and name it Clone Stamp. Choose the Clone Stamp tool from the Toolbar and a soft brush from the Brush Picker. Ensure that Aligned and Sample All Layers are checked in the Options bar. Zoom into the image and position your pointer by the side of one of the major creases, hold down the Alt/⌥ key, and click with the mouse to set a cloning source point. Begin to click along the crease to clone over it.

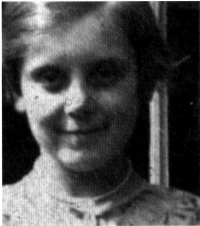

5 Continue cloning out the major flaws in the image. Make sure that you use a brush that is just a little bigger than the crease or mark you're covering up, and that you regularly Alt/⌥-click next to the mark to set the cloning source point. It's very important that you set the source point in an area which is similar in tone and pattern to the area you're repairing. Because you're cloning onto a layer, you can always erase an area of cloning and try again if the repair is not convincing.

6 When you have lighter flaws in mainly dark areas, try changing the blending mode from Normal to Darken in the Options bar. When you clone, just the lighter areas will be concealed.

7 You can see the Cloning layer in isolation with the Background layer hidden, showing the relatively small amount of cloning in the image. When you've cloned out all of the flaws in the image, flatten the image via **Layer > Flatten Image**.

8 Make a final and subtle tonal adjustment. You need to introduce a few more midtones and achieve a little more tonal latitude. Go to **Image > Adjustment > Curves**. Place a point on the curve in the center of the graph, and then click on the curve halfway between this point and the top-right corner. Drag this point down a little. You can see the required shape of the curve in the screenshot.

9 Finally, fine-tune the tones to bring out some detail in the faces. Choose the Burn tool from the Toolbar and, in the Options bar, set the Range to Shadows, and set the Exposure to 7%. Gently use this tool over the features and darker areas in the faces. Using this tool over the smaller, darker details will give the illusion of sharpness in these areas.

10 For a little extra sharpness, duplicate the Background layer (Ctrl/⌘ + J) and go to **Filter > Other > High Pass**. Use a Radius of 2.2 pixels. Change the blending mode for this High Pass layer to Overlay. You can control the degree of sharpening by reducing the opacity of this layer.

GOLDFINGER

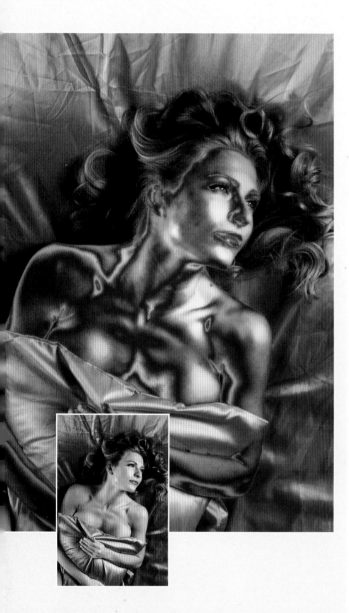

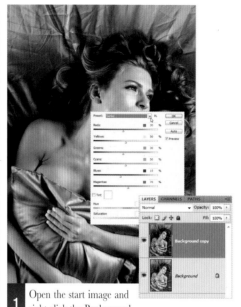

1 Open the start image and right-click the Background Layer, choosing Duplicate layer. Now go to **Image > Adjustments > Black & White**. From the Presets within the Black and White dialog choose Darker. Click OK.

3 When you're happy with the curve and the effect, hold down the Ctrl/⌘ key on the keyboard and click the black and white image layer below. Now go to **Layers > Merge Layers**. Now right-click this merged layer and choose Duplicate Layer. Now go to **Filter > Blur > Gaussian Blur**. Use a Radius of 6.5 pixels and click OK.

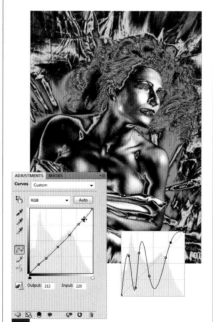

As any James Bond fan will testify, being covered in gold paint from head to toe is not exactly good for your health. Nevertheless, in *Goldfinger* it proved to be a really memorable effect, and one you can recreate in Photoshop. We're first going to call upon the Black and White command for a punchy grayscale image to manipulate, then a complicated Curve to add the metallic sheen. To add the gold color we'll use the Lighting Effects filter and the power of Smart Filters. The effect itself is brought together and finished off with some careful layer masking, so the color is applied only where we want it.

2 In the Adjustments panel choose Curves. Start by clicking six points along the curve. Now drag the points along the curve as shown. Use the grid lines and the Histogram overlay as a guide for this. This curve will give the skin a very reflective, metallic appearance.

4 Set the Blending Mode for this layer to Luminosity and set the Opacity to around 60%. Hold down the Ctrl/⌘ key and click the layer beneath and go to **Layer > Merge Layers**.

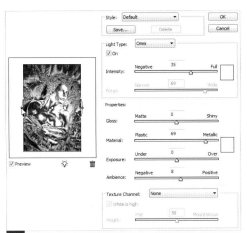

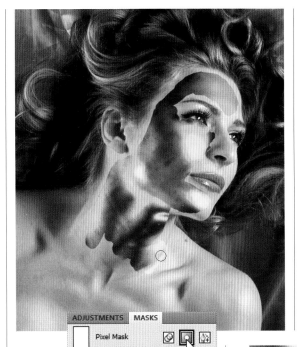

5 Now we need to light and color this layer, so, with the layer active in the Layers palette, go to **Filter > Convert for Smart Filters**. Click OK to any message about converting the layer. In the Lighting Effects dialog, for the Light Type choose Omni. Now grab one of the handles around the light pool in the Preview pane and drag it outwards so that the pool encompasses the main figure.

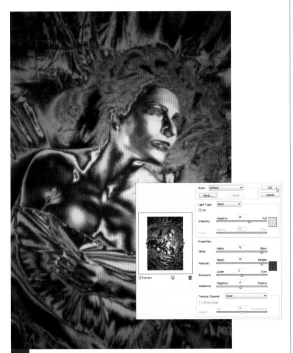

6 Click the Light Color swatch and in the Color Picker choose a light yellow/gold color. Click OK, then click the Material Color swatch and choose a mid red/brown. In the Properties panel enter these values: Gloss: 78, Material: 78, Exposure: 0, Ambience: -6. Set the Light Intensity slider to 30 and click OK. Because this is a Smart Filter we'll be able to return to this filter later and tweak the settings if needed.

7 Go to the Masks panel and click the Add A Pixel Mask button, then hit Invert within the panel. Choose the Brush tool and ensure your Foreground color is White. Click in the Brush Picker and choose a small hard brush. Start to paint over the model's skin to reveal the gold. Don't worry too much about the facial features at the moment, but make sure to follow the outer edges of the figure carefully.

8 If you happen to paint too far over the outline of the figure, simply change your Foreground color to black and paint back into the mask to correct it. Wherever there are natural dark shadow areas, such as between the arms and the breast, reduce the Hardness of the brush in the Brush Picker, and use a lower Opacity for the brush (set in the Options Bar).

GOLDFINGER

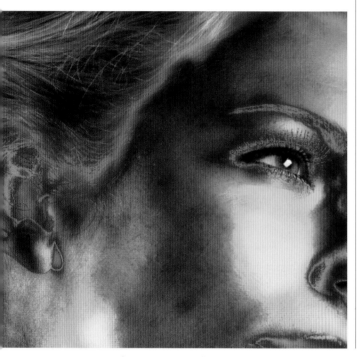

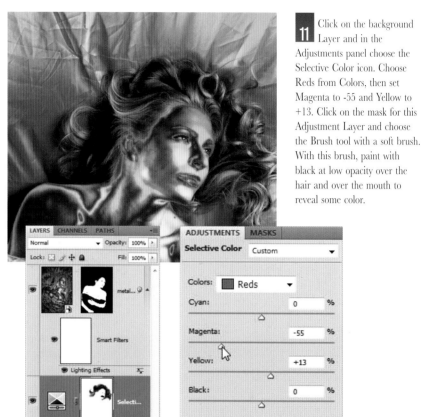

11 Click on the background Layer and in the Adjustments panel choose the Selective Color icon. Choose Reds from Colors, then set Magenta to -55 and Yellow to +13. Click on the mask for this Adjustment Layer and choose the Brush tool with a soft brush. With this brush, paint with black at low opacity over the hair and over the mouth to reveal some color.

9 Use this same soft brush to carefully brush up to the hairline so that you achieve a good blend into the hair.

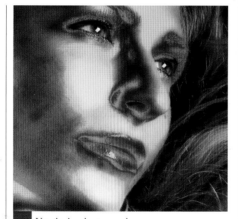

10 Use the brush at a much lower Opacity over the lips, so that the gold covering is far less opaque towards the inner areas of the lips, but maintains high opacity around the edges.

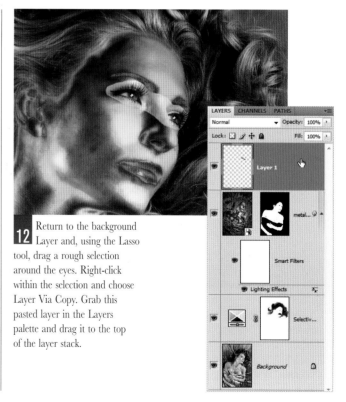

12 Return to the background Layer and, using the Lasso tool, drag a rough selection around the eyes. Right-click within the selection and choose Layer Via Copy. Grab this pasted layer in the Layers palette and drag it to the top of the layer stack.

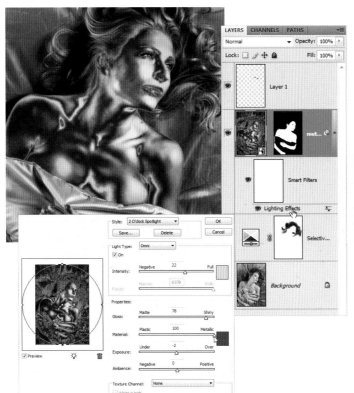

13 In the Layers palette, set the Blending Mode for this layer to darken, then go to **Image > Adjustments > Levels**. To darken the eyelashes, enter these two values in the first two Input Levels boxes from left to right 52, 3.00. Click OK. Now go to **Image > Adjustments > Hue and Saturation**. reduce the Saturation slider to -78 and click OK.

15 At this stage, double-click the entry for the Lighting Effects filter in the layers palette and adjust the settings within. Increase the size of the light pool a little. You can also click in the color swatches and choose slightly warmer colors if needed. You may find that a small increase in the Plastic/ Metal value works well.

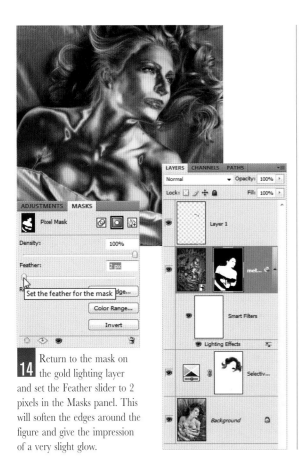

14 Return to the mask on the gold lighting layer and set the Feather slider to 2 pixels in the Masks panel. This will soften the edges around the figure and give the impression of a very slight glow.

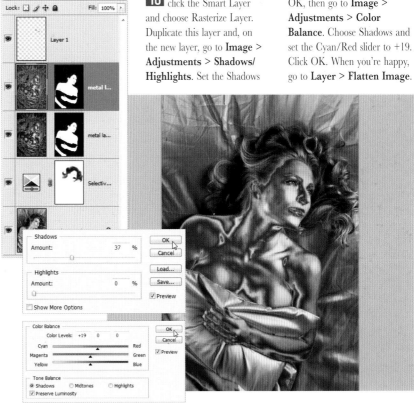

16 When you're done, right-click the Smart Layer and choose Rasterize Layer. Duplicate this layer and, on the new layer, go to **Image > Adjustments > Shadows/ Highlights**. Set the Shadows Amount slider to 37%, click OK, then go to **Image > Adjustments > Color Balance**. Choose Shadows and set the Cyan/Red slider to +19. Click OK. When you're happy, go to **Layer > Flatten Image**.

FILM STAR POSTER

Some of the best Photoshop images are those that combine images and type. This is the ideal project to show the combination of these two elements—a Bollywood-style film poster. Creating an image such as this makes a real change from shifting pixels around the screen, and you can really inject some imagination. You'll need to use a couple of Photoshop filters to create a painterly feel to the main subject. For decoration and texture you'll use a pattern layer, drop in a Custom Shape or two, use stroke paths for hand-drawn outlines, make use of Layer Styles and, of course, add some quirky type. Dive into the depths of Photoshop and indulge your inner film star!

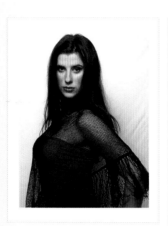

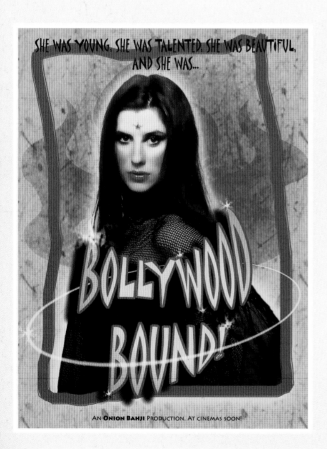

1 Open the main figure image. Duplicate the Background layer (Ctrl/⌘ + J). You need some extra space around the image, so hit D to revert to default colors and go to **Image > Canvas Size**. Check the central Anchor square in the Anchor Map and check Relative. Change one of the measurement units to Percent and enter 20 in both Height and Width. Ensure that Background is chosen for Canvas Extension color.

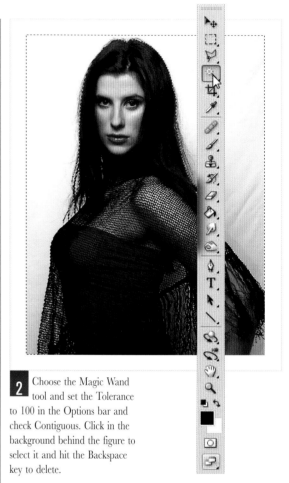

2 Choose the Magic Wand tool and set the Tolerance to 100 in the Options bar and check Contiguous. Click in the background behind the figure to select it and hit the Backspace key to delete.

3 Hit Ctrl/⌘ + D to deselect and click on the Background layer. Add a new layer (Ctrl/⌘ + Shift + N). Go to **Edit > Fill**, choosing White for Contents.

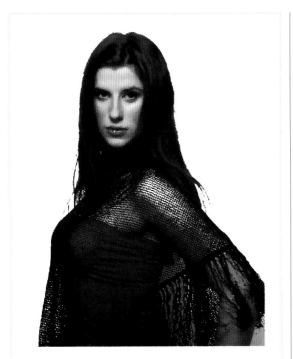

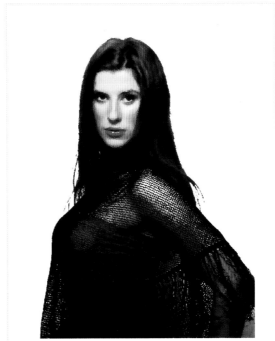

4 Return to the topmost Figure layer. Make this image a little more graphic and simplify it to suit the style of the poster. Go to **Filter > Blur > Smart Blur**. Set the Radius slider to 5 and Threshold to 37. Choose High for Quality and Normal for Mode. Go to **Filter > Artistic > Dry Brush**. Use these settings within the filter dialog: Brush Size 1, Brush Size 5, and Texture 2.

5 Duplicate this layer (Ctrl/⌘ + J), and set the blending mode for the Duplicate layer to Overlay. Go to **Filter > Render > Lighting Effects**. Click in the Light color swatch and choose a deep yellow/gold color. Rotate the light pool with one of the handles so the light falls from above, and extend the pool so that it covers the entire image. Click OK to apply the lighting.

6 Go to **Layer > Merge Down**. Return to the Filled layer in the Layers palette. Choose the Gradient tool from the Toolbar. Click the Foreground color swatch and choose a deep red-orange. For the Background swatch, choose a bright orange-yellow. Click in the Gradient Picker and choose Foreground to Background. Select Radial Gradient from the Options bar. Click and hold in the center of the figure and drag a gradient out to the edge of the image.

FILM STAR POSTER

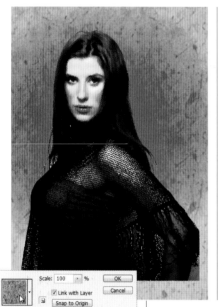

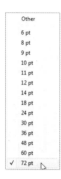

9 Return to the figure layer. We'll add a subtle glow around the figure. Go to **Layer > Layer Style > Outer Glow**. In the Layer Style dialog, click in the Glow color swatch and choose a bright yellow. Increase the Size slider to 133 and the Opacity to 100%.

10 Add some lettering to the poster. Choose the Horizontal Type tool and click in the lower half of the image. In the Options bar, change the Type point size to 72. Choose a Font Face in the Options bar and type "Bollywood." Hit the Return key and type the word "Bound." Hit the commit tick in the Options bar to commit the type.

7 Add some texture. Go to **Layer > New Fill Layer > Pattern**. Click OK to the dialog and then click in the Pattern swatch. Click the small right-pointing arrow, selecting Grayscale Paper from the menu. Choose the Fibers swatch from the paper swatches. Increase the Scale slider to 699%. Click OK to apply the layer and set the blending mode for this layer to Color Burn.

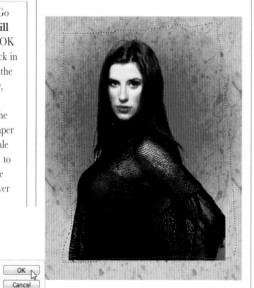

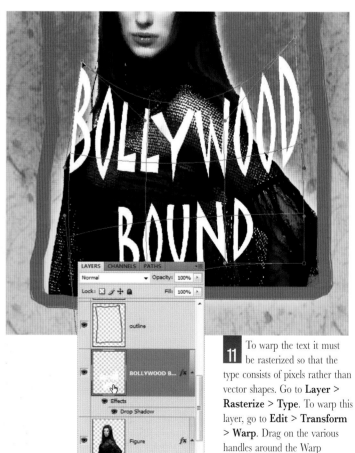

8 Add a new layer (Ctrl/⌘ + Shift + N) and choose the Lasso tool from the Toolbar. Draw a rough rectangle a little way in from the outer edge of the image. Make sure to make this rectangular selection loose to create a hand-drawn effect. Click on the tab for the Paths palette and choose Make Work Path From Selection at its base. Choose the Brush tool and click in the Brush Picker, choosing the Spatter 59 pixels brush. Right-click (Ctrl-click) the Work Path in the Paths palette and choose Stroke Path. Choose Brush for Tool and uncheck Simulate Pressure.

11 To warp the text it must be rasterized so that the type consists of pixels rather than vector shapes. Go to **Layer > Rasterize > Type**. To warp this layer, go to **Edit > Transform > Warp**. Drag on the various handles around the Warp bounding box to warp the text. Hit Enter when you're done.

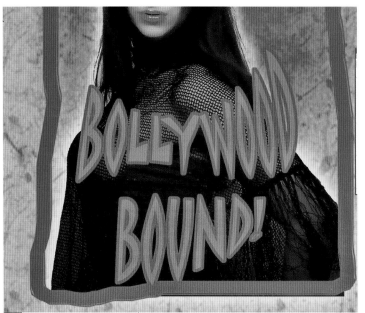

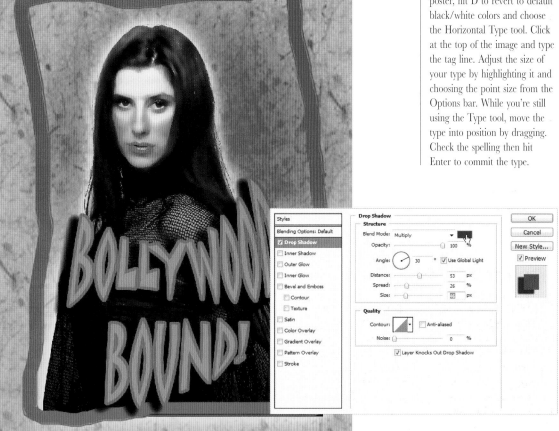

12 Ctrl/⌘-click the thumbnail for this layer to generate a selection from it. Click the Foreground swatch and choose a vivid orange. Go to **Edit > Fill**, choosing Foreground color for Contents. Click the swatch again, choose a bright red, and go to **Edit > Stroke**. Enter 20 for Stroke Width and Outside for Location.

13 Go to **Layer > Layer Style > Drop Shadow**. In the Drop Shadow dialog, set the Angle to 30 degrees, the Distance to 53, Spread to 23, and Size to 46. Click the Shadow color swatch and choose a vivid blue. Click OK to apply the shadow. Drag this Bollywood Bound layer up to the top of the layer stack.

14 To add another line of type at the top of the poster, hit D to revert to default black/white colors and choose the Horizontal Type tool. Click at the top of the image and type the tag line. Adjust the size of your type by highlighting it and choosing the point size from the Options bar. While you're still using the Type tool, move the type into position by dragging. Check the spelling then hit Enter to commit the type.

FILM STAR POSTER

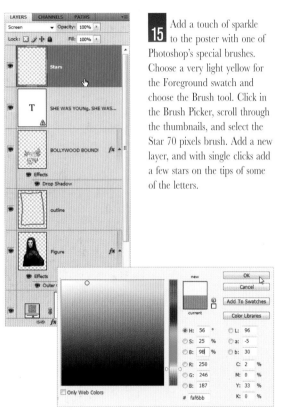

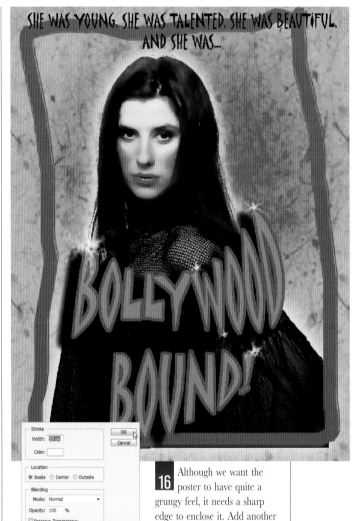

15 Add a touch of sparkle to the poster with one of Photoshop's special brushes. Choose a very light yellow for the Foreground swatch and choose the Brush tool. Click in the Brush Picker, scroll through the thumbnails, and select the Star 70 pixels brush. Add a new layer, and with single clicks add a few stars on the tips of some of the letters.

16 Although we want the poster to have quite a grungy feel, it needs a sharp edge to enclose it. Add another new layer (Ctrl/⌘ + Shift + N), and go to **Select > All**. Choose white for your Foreground color and go to **Edit > Stroke**. Enter a Stroke Width of 35 pixels and choose Inside for Location.

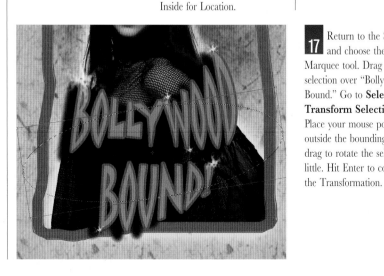

17 Return to the Stars layer and choose the Elliptical Marquee tool. Drag an elliptical selection over "Bollywood Bound." Go to **Select > Transform Selection**. Place your mouse pointer just outside the bounding box and drag to rotate the selection a little. Hit Enter to commit the Transformation.

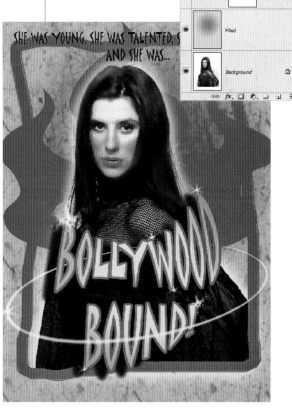

21 Click the Pattern Fill layer and add a new layer for the shape (Ctrl/⌘ + Shift + N). Click and drag with the tool to create the shape just inside the edges of the image area. Set the blending mode for this layer to Soft Light.

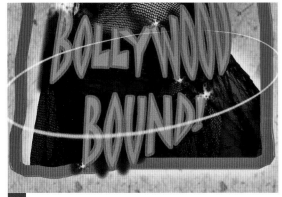

20 As a final touch, choose the Custom Shape tool from the Toolbar (this may be hidden beneath the Line tool or other shape tools). Choose a vivid red for the Foreground color In the Options bar, choose the Fill Pixels icon for the Shape tool and click in the Shape Picker. Hit the small, right-pointing arrow, choosing All from the menu. Scroll through the available shapes and select Fire.

18 Go to the Paths palette and from the base of the palette, choose the Make Work Path From Selection icon. Choose the Brush tool and select a small, soft brush from the Picker. Right-click (Ctrl/⌘-click) the Work Path in the Paths palette and choose Stroke Path from the sub-menu. Under Tool choose Brush and check Simulate Pressure. Click OK to stroke the path. Now drag the Work Path to the trash can in the Paths palette and return to the Layers palette.

19 Ctrl/⌘-click the image thumbnail for the Bollywood Bound layer and use the Eraser tool over the "Bollywood" so that this stroked ring appears to go behind the word itself.

22 For the finishing touch, click on the main figure layer and choose the Blur tool from the Toolbar. Set the Strength to 100% in the Options bar and choose a soft brush from the Brush Picker. Use the tool around the very edges of the figure to soften these a little.

GOTHIC HORROR

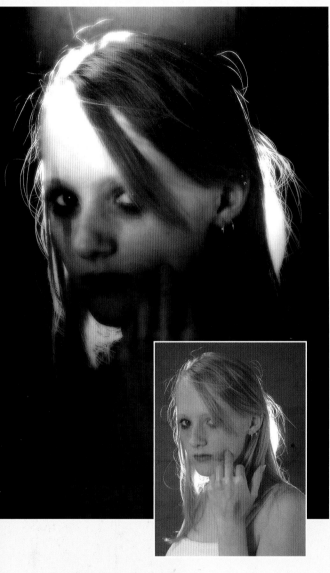

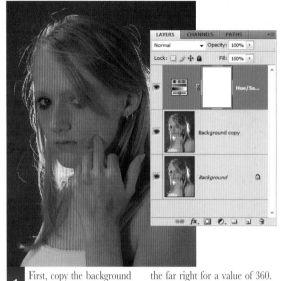

1 First, copy the background layer (Ctrl/⌘ + J). To color the hair, go to **Layer > New Adjustment Layer > Hue and Saturation** and click OK. Check the Colorize box and drag the Hue slider to the far right for a value of 360. Drag the Saturation slider to 56 and click OK. In the Layers palette click on the layer mask attached to the adjustment layer and fill it via **Edit > Fill**, choosing Black for Contents.

Even the most innocent-looking portrait can take on a darker and more gothic feel when it's been treated with a little Photoshop magic. Here you'll look at how to apply a convincing gothic atmosphere to an image, with a result that's worthy of a Stephen King novel. Photoshop's Lighting Effects filter plays a pivotal role setting the scene here, and you can even change the hair color via a Hue and Saturation adjustment layer. Add mystery with the Diffuse Glow filter. A little painting adds the finishing touches to our shop of horrors.

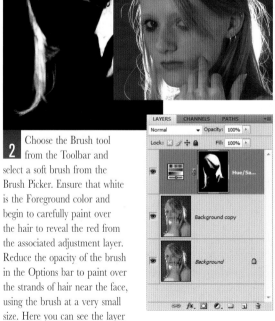

2 Choose the Brush tool from the Toolbar and select a soft brush from the Brush Picker. Ensure that white is the Foreground color and begin to carefully paint over the hair to reveal the red from the associated adjustment layer. Reduce the opacity of the brush in the Options bar to paint over the strands of hair near the face, using the brush at a very small size. Here you can see the layer mask in isolation with the white I've painted onto it. Now go to **Layer > Merge Down**.

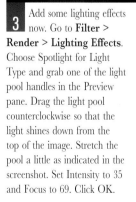

3 Add some lighting effects now. Go to **Filter > Render > Lighting Effects**. Choose Spotlight for Light Type and grab one of the light pool handles in the Preview pane. Drag the light pool counterclockwise so that the light shines down from the top of the image. Stretch the pool a little as indicated in the screenshot. Set Intensity to 35 and Focus to 69. Click OK.

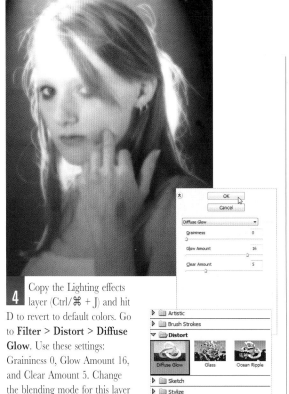

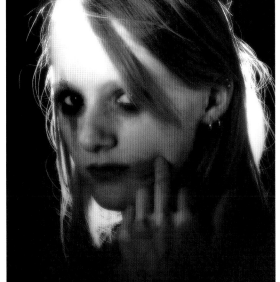

4 Copy the Lighting effects layer (Ctrl/⌘ + J) and hit D to revert to default colors. Go to **Filter > Distort > Diffuse Glow**. Use these settings: Graininess 0, Glow Amount 16, and Clear Amount 5. Change the blending mode for this layer to Hard Light.

7 With the same brush, paint a rough line through the left eye, avoiding the white of the eye itself. Now paint a little of this color roughly over the lips.

5 Return to the lower lighting effects layer and go to **Image > Adjustments > Levels**. Enter 0.70 into the central Input Levels box and click OK. Click on the topmost layer and return to **Image > Adjustments > Levels**. Enter the following in the Input Levels boxes from left to right: 0, 0.83, and 235.

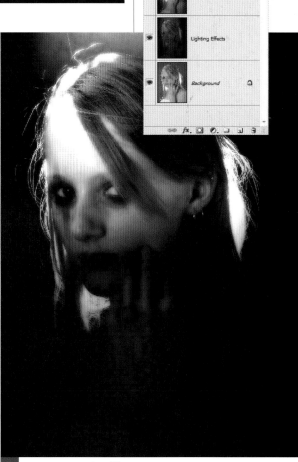

6 Add a new layer (Ctrl/⌘ + Shift + N) and choose the Brush tool. Click in the Brush Picker, hit the small right-pointing arrow and choose Reset Brushes. Scroll down the brush thumbnails and choose Rough Round Bristle. Set the layer blending mode for this new layer to Soft Light. Choose a very dark blue or black for the Foreground swatch. Paint with this brush at 50% Opacity around the eyes. Make these marks fairly random to give the impression of smudged makeup.

8 Add a new layer (Ctrl/⌘ + Shift + N). In the Brush Picker, choose a large, round, soft brush and choose black for the Foreground color. Increase the brush size to around 900 and paint two large, black stripes across the image, leaving a gap over the eyes. Go to **Filter > Blur > Gaussian Blur** and use a Blur Radius of 18.7 pixels. Set the blending mode for this layer to Soft Light. Flatten the image with **Layer > Flatten Image** and save.

PHOTOSHOP KEYBOARD SHORTCUTS

Menu Command	Photoshop CS4 Macintosh	Photoshop CS4 Windows
Auto Color	⌘ + Shift + B	Ctrl + Shift + B
Auto Contrast	⌘ + ⌥ + Shift + L	Ctrl + Alt + Shift + L
Auto Levels	⌘ + Shift + L	Ctrl + Shift + L
Bring Forward/Send Backward	⌘ + [or]	Ctrl + [or]
Bring to Front/Send to Back	⌘ + Shift + [or]	Ctrl + Shift + [or]
Browse	⌘ + ⌥ + O	Ctrl + Alt + O
Clear Selection	Backspace	Backspace
Close	⌘ + W	Ctrl + W
Close All	⌘ + ⌥ + W	Ctrl + Alt + W
Color Balance	⌘ + B	Ctrl + B
Color Balance, use previous settings	⌘ + ⌥ + B	Ctrl + Alt + B
Color Settings	⌘ + Shift + K	Ctrl + Shift + K
Copy	⌘ + C or F3	Ctrl + C or F3
Copy Merged	⌘ + Shift + C	Ctrl + Shift + C
Create Clipping Mask	⌘ + ⌥ + G	Ctrl + Alt + G
Curves	⌘ + M	Ctrl + M
Curves, use previous settings	⌘ + ⌥ + M	Ctrl + Alt + M
Cut	⌘ + X or F2	Ctrl + X or F2
Desaturate	⌘ + Shift + U	Ctrl + Shift + U
Deselect	⌘ + D	Ctrl + D
Exit	⌘ + Q	Ctrl + Q
Extract	⌘ + ⌥ + X	Ctrl + Alt + X
Extras, show or hide	⌘ + H	Ctrl + H
Fade Filter	⌘ + Shift + F	Ctrl + Shift + F
Feather Selection	⌘ + ⌥ + D or Shift + F6	Ctrl + Alt + D or Shift + F6
File Info	⌘ + ⌥ + Shift + I	Ctrl + Alt + Shift + I
Fill	Shift + F5	Shift + F5
Fill from History	⌘ + ⌥ + Delete	Ctrl + Alt + Backspace
Filter, repeat last	⌘ + F	Ctrl + F
Filter, repeat with new settings	⌘ + ⌥ + F	Ctrl + Alt + F
Fit on Screen	⌘ + 0 (zero)	Ctrl + 0 (zero)
Free Transform	⌘ + T	Ctrl + T
Gamut Warning	⌘ + Shift + Y	Ctrl + Shift + Y
Grid, show or hide	⌘ + ' (quote)	Ctrl + ' (quote)

Menu Command	Photoshop CS4 Macintosh	Photoshop CS4 Windows
Guides, show or hide	⌘ + ; (semicolon)	Ctrl + ; (semicolon)
Help contents	Help	F1
Hue/Saturation	⌘ + U	Ctrl + U
Hue/Saturation, use previous settings	⌘ + ⌥ + U	Ctrl + Alt + U
Inverse Selection	⌘ + Shift + I or Shift + F7	Ctrl + Shift + I or Shift + F7
Invert	⌘ + I	Ctrl + I
Keyboard Shortcuts	⌘ + ⌥ + Shift + K	Ctrl + Alt + Shift + K
Layer Via Copy	⌘ + J	Ctrl + J
Layer Via Cut	⌘ + Shift + J	Ctrl + Shift + J
Levels	⌘ + L	Ctrl + L
Levels, use previous settings	⌘ + ⌥ + L	Ctrl + Alt + L
Liquify	⌘ + Shift + X	Ctrl + Shift + X
Lock Guides	⌘ + ⌥ + ; (semicolon)	Ctrl + Alt + ; (semicolon)
Merge Layers	⌘ + E	Ctrl + E
Merge Visible	⌘ + Shift + E	Ctrl + Shift + E
New	⌘ + N	Ctrl + N
New Layer	⌘ + Shift + N	Ctrl + Shift + N
Open	⌘ + O	Ctrl + O
Open As	-	Ctrl + Alt + Shift + O
Page Setup	⌘ + Shift + P	Ctrl + Shift + P
Paste	⌘ + V or F4	Ctrl + V or F4
Paste Into	⌘ + Shift + V	Ctrl + Shift + V
Path, show or hide	⌘ + Shift + H	Ctrl + Shift + H
Pattern Maker	⌘ + ⌥ + Shift + X	Ctrl + Alt + Shift + X
Preferences	⌘ + K	Ctrl + K
Preferences, last panel	⌘ + ⌥ + K	Ctrl + Alt + K
Print	⌘ + P	Ctrl + P
Print One Copy	⌘ + ⌥ + Shift + P	Ctrl + Alt + Shift + P
Print with Preview	⌘ + ⌥ + P	Ctrl + Alt + P
Proof colors	⌘ + Y	Ctrl + Y
Release Clipping Mask	⌘ + ⌥ + G	Ctrl + Alt + G
Reselect	⌘ + Shift + D	Ctrl + Shift + D
Revert	F12	F12
Rulers, show or hide	⌘ + R	Ctrl + R

Painting	Photoshop CS4 Macintosh	Photoshop CS4 Windows
Save	⌘ + S	Ctrl + S
Save for web	⌘ + Shift + Option + S	Ctrl + Shift + Alt + S
Save As	⌘ + Shift + S	Ctrl + Shift + S
Select All	⌘ + A	Ctrl + A
Snap	⌘ + Shift + ; (semicolon)	Ctrl + Shift + ; (semicolon)
Step Backwards	⌘ + ⌥ + Z	Ctrl + Alt + Z
Step Forwards	⌘ + Shift + Z	Ctrl + Shift + Z
Transform Again	⌘ + Shift + T	Ctrl + Shift + T
Undo/Redo, toggle	⌘ + Z or F1	Ctrl + Z
View Actual Pixels	⌘ + ⌥ + 0 (zero)	Ctrl + Alt + 0 (zero)
Zoom In	⌘ + + (plus) or ⌘ + = (equals)	Ctrl + + (plus) or Ctrl + = (equals)
Zoom Out	⌘ + - (minus)	Ctrl + - (minus)
Brush size, decrease/increase	[or]	[or]
Brush softness/hardness, decrease/increase	Shift + [or]	Shift + [or]
Cycle through Healing Brush tools	⌥ + click Healing Brush tool icon or Shift + J	Alt + click Healing Brush tool icon or Shift + J
Cycle through Paintbrush tools	⌥ + click Paintbrush tool icon or Shift + B	Alt + click Paintbrush tool icon or Shift + B
Cycle through Eraser functions	⌥ + click Eraser tool icon or Shift + E	Alt + click Eraser tool icon or Shift + E
Cycle through Focus tools	⌥ + click Focus tool icon or Shift + R	Alt + click Focus tool icon or Shift + R
Cycle through Rubber Stamp options	⌥ + click Rubber Stamp tool icon or Shift + S	Alt + click Rubber Stamp tool icon or Shift + S
Cycle through Toning tools	⌥ + click Toning tool icon or Shift + O	Alt + click Toning tool icon or Shift + O
Delete shape from Brushes palette	⌥ + click brush shape	Alt + click brush shape
Display crosshair cursor	Caps Lock	Caps Lock
Display Fill dialog box	Shift + Delete	Shift + Backspace
Paint or edit in a straight line	Click and then Shift + click	Click and then Shift + click
Reset to normal brush mode	Shift + ⌥ + N	Shift + Alt + N
Select background color tool	⌥ + Eyedropper tool + click	Alt + Eyedropper tool + click
Set opacity, pressure or exposure	Any painting or editing tool + number keys (e.g. 0=100%, 1=10%, 4 then 5 in quick succession=45%)	Any painting or editing tool + number keys (e.g. 0=100%, 1=10%, 4 then 5 in quick succession=45%)

Applying Colors	Photoshop CS4 Macintosh	Photoshop CS4 Windows
Add new swatch to palette	Click in empty area of palette	Click in empty area of palette
Color palette, show/hide	F6	F6
Cycle through color choices	Shift + click color bar	Shift + click color bar
Delete swatch from palette	⌥ + click swatch	Alt + click swatch
Display Fill dialog box	Shift + Delete or Shift + F5	Shift + Backspace or Shift + F5
Fill layer with background color but preserve transparency	Shift + ⌘ + Delete	Shift + Ctrl + Backspace
Fill layer with foreground color but preserve transparency	Shift + ⌥ + Delete	Shift + Alt + Backspace
Fill selection on any layer with background color	⌘ + Delete	Ctrl + Backspace
Fill selection or layer with foreground color	Option + Delete	Alt + Backspace
Fill selection with source state in History palette	⌘ + ⌥ + Delete	Ctrl + Alt + Backspace
Lift background color from color bar at bottom of Color palette	⌥ + click color bar	Alt + click color bar
Lift background color from Swatches palette	⌘ + click swatch	Ctrl + click swatch
Lift foreground color from color bar at bottom of Color palette	Click color bar	Click color bar
Lift foreground color from Swatches palette	Click swatch	Click swatch

PHOTOSHOP KEYBOARD SHORTCUTS

Type	Photoshop CS4 Macintosh	Photoshop CS4 Windows
Align left, center or right	Horizontal type tool + Shift + ⌘ + L, C or R	Horizontal type tool + Shift + Ctrl + L, C or R
Align top, center or bottom	Vertical type tool + Shift + ⌘ + L, C or R	Horizontal type tool + Shift + Ctrl + L, C or R
Edit text layer	Double-click on 'T' in Layers palette	Double-click on 'T' in Layers palette
Move type in image	⌘ + drag type when Type is selected	Cmd + drag type when Type is selected
Leading, increase/decrease by 2 pixels	⌥ + arrow key	Alt + arrow key
Leading, increase/decrease arrow) by 10 pixels	⌘ + ⌥ + ← or → (left or right arrow)	Ctrl + Alt + ← or → (left or right
Select all text	⌘ + A	Ctrl + A
Select word, line, paragraph or story	Double-click, triple-click, quadruple-click or quintuple-click	Double-click, triple-click, quadruple-click or quintuple-click
Select word to left or right	⌘ + Shift + ← or → (left or right arrow)	Ctrl + Shift + ← or → (left or right arrow)
Toggle Underlining on/off	⌘ + Shift + U	Ctrl + Shift + U
Toggle Strikethrough on/off	⌘ + Shift + /	Ctrl + Shift + /
Toggle Uppercase on/off	⌘ + Shift + K	Ctrl + Shift + K
Toggle Superscript on/off	⌘ + Shift + + (plus)	Ctrl + Shift + + (plus)
Toggle Subscript on/off	⌘ + ⌥ + Shift + + (plus)	Ctrl + Alt + Shift + + (plus)
Type size, increase/decrease by 2 pixels	⌘ + Shift + < or >	Ctrl + Shift + < or >
Type size, increase/decrease by 10 pixels	⌘ + Shift + ⌘ + < or >	Ctrl + Shift + Alt + < or >

Making Selections	Photoshop CS4 Macintosh	Photoshop CS4 Windows
Add point to Magnetic selection	Click with Magnetic Lasso tool	Click with Magnetic Lasso tool
Add or subtract from selection	Any Selection tool + Shift or ⌥ + drag	Any Selection tool + Shift or Alt + drag
Cancel Polygon or Magnetic selection	Escape	Escape
Change lasso tool to irregular Polygon tool	⌥ + click with Lasso tool	Alt + click with Lasso tool
Clone selection	⌥ + drag selection with Move tool or ⌘ + ⌥ + drag with other tool	Alt + drag selection with Move tool or Ctrl + Alt + drag with other tool

Making Selections	Photoshop CS4 Macintosh	Photoshop CS4 Windows
Clone selection in 1-pixel increments	⌘ + ⌥ + arrow key	Ctrl + Alt + arrow key
Clone selection in 10-pixel increments	⌘ + Shift + ⌥ + arrow key	Ctrl + Shift + Alt + arrow key
Close magnetic selection with straight segment	⌥ + double-click or ⌥ + Return	Alt + double-click or Alt + Enter
Close polygon or magnetic selection	Double-click with respective Lasso tool or press Return	Double-click with respective Lasso tool or press Enter
Constrain marquee to square or circle	Press Shift while drawing shape	Press Shift while drawing shape
Constrain movement vertically, horizontally, or diagonally	Press Shift while dragging selection	Press Shift while dragging selection
Cycle through Lasso tools	⌥ + click Lasso tool icon or Shift + L	Alt + click Lasso tool icon or Shift + L
Cycle through Marquee tools	⌥ + click Marquee tool icon or Shift + M	Alt + click Marquee tool icon or Shift + M
Delete last point added with Magnetic Lasso tool	Delete	Backspace
Deselect all	⌘ + D	Ctrl + D
Draw out from center with Marquee tool	Option + drag	Alt + drag
Feather selection	⌘ + ⌥ + D or Shift + F6	Ctrl + Alt + D or Shift + F6
Increase or reduce magnetic lasso detection width	[or] (square brackets)	[or] (square brackets)
Move copy of selection	Drag with Move tool + ⌥	Drag with Move tool + Alt
Move selection in 1-pixel increments	Move tool + arrow key	Move tool + arrow key
Move selection in 10-pixel increments	Move tool + Shift + arrow key	Move tool + Shift + arrow key
Move selection area in 1-pixel increments	Any selection + arrow key	Any selection + arrow key
Move selection area in 10-pixel increments	Any selection + Shift + arrow key	Any selection + Shift + arrow key
Reposition selection while creating	Spacebar + drag	Spacebar + drag
Reselect after deselecting	⌘ + Shift + D	Ctrl + Shift + D
Reverse selection	⌘ + Shift + I or Shift + F7	Ctrl + Shift + I or Shift + F7
Select all	⌘ + A	Ctrl + A
Select Move tool	V	V
Subtract from selection	⌥ + drag	Alt + drag

Layers and Channels	Photoshop CS4 Macintosh	Photoshop CS4 Windows
Add spot color channel	⌘ + click page icon at bottom of Channels palette	Ctrl + click page icon at bottom of Channels palette
Add to current layer selection	Shift + ⌘ + click layer or thumbnail in Layers palette	Shift + Ctrl + click layer or thumbnail in Layers palette
Clone selection to new layer	⌘ + J	Ctrl + J
Convert floating selection to new layer	⌘ + Shift + J	Ctrl + Shift + J
Copy merged version of selection to Clipboard	⌘ + Shift + C	Ctrl + Shift + C
Create new layer, show layer options dialog box	⌥ + click page icon at bottom of Layers palette or ⌘ + Shift + N	Alt + click page icon at bottom of Layers palette or Ctrl + Shift + N
Create new layer below target layer	⌘ + click page icon at bottom of Layers Palette	Ctrl + click page icon at bottom of Layers Palette
Create new layer below target layer, show layer options dialog box	⌘ + Option + click page icon at bottom of Layers palette	Ctrl + Alt + click page icon at bottom of Layers palette
Display or hide Layers palette	F7	F7
Disable specific layer effect/style	⌥ + choose command from Layer > Effects submenu	Alt + choose command from Layer > Effects submenu
Move layer effect/style	Shift + drag effect/style to target layer	Shift + drag effect/style to target layer
Duplicate layer effect/style	⌥ + drag effect/style to target layer	Alt + drag effect/style to target layer
Edit layer style	Double click layer	Double click layer
Edit layer effect/style	Double-click on layer effect/style	Double-click on layer effect/style
Select current layer and layer below	Shift + ⌥ + [Shift + Alt + [
Select current layer and layer above	Shift + ⌥ +]	Shift + Alt +]
Group neighboring layers	⌘ + G	Ctrl + G
Intersect with current layer selection	Shift + ⌥ + ⌘ + click layer or thumbnail in Layers palette	Shift + Alt + Ctrl + click layer or thumbnail in Layers palette
Load layer as selection	⌘ + click layer or thumbnail in Layers palette	Ctrl + click layer or thumbnail in Layers palette
Create Clipping Mask in Layers palette	⌥ + click horizontal line in Layers palette	Alt + click horizontal line

Layers and Channels	Photoshop CS4 Macintosh	Photoshop CS4 Windows
Merge all visible layers	⌘ + Shift + E	Ctrl + Shift + E
Merge layer with next layer down	⌘ + E	Ctrl + E
Move contents of a layer	Drag with Move tool or ⌘ + drag with other tool	Drag with Move tool or Ctrl + drag with other tool
Move contents of a layer in 1-pixel increments	⌘ + arrow key	Ctrl + arrow key
Move contents of a layer in 10-pixel increments	⌘ + Shift + arrow key	Ctrl + Shift + arrow key
Move shadow when Effect dialog box is open	Drag in image window	Drag in image window
Move to next layer above	⌥ +]	Alt +]
Move to next layer below	⌥ + [Alt + [
Moves target layer down/up	⌘ + [or]	Ctrl + [or]
Moves target layer back/front	⌘ + Shift + [or]	Ctrl + Shift + [or]
Preserve transparency of active layer	/	/
Retain intersection of transparency mask and selection	⌘ + Shift + ⌥ + click layer name	Ctrl + Shift + Alt + click layer name
Subtract transparency mask from selection	⌘ + ⌥ + click layer name	Ctrl + Alt + click layer name
Subtract from current layer selection	⌥ + ⌘ + click layer or thumbnail in Layers palette	Alt + Ctrl + click layer or thumbnail in Layers palette
Switch between independent color and mask channels	⌘ + 1 through ⌘ + 9	Ctrl + 1 through Ctrl + 9
Switch between layer effects in Effects dialog box	⌘ + 1 through ⌘ + 0 (zero)	Ctrl + 1 through Ctrl + 0 (zero)
Switch to composite color view	⌘ + ~ (tilde)	Ctrl + ~ (tilde)
Ungroup neighboring layers	⌘ + Shift + G	Ctrl + Shift + G
View single layer by itself	⌥ + click eyeball icon in Layers palette	Alt + click eyeball icon in Layers palette

PHOTOSHOP KEYBOARD SHORTCUTS

Masks	Photoshop CS4 Macintosh	Photoshop CS4 Windows
Add channel mask to selection	⌘ + Shift + click channel name	Ctrl + Shift + click channel name
Add layer mask to selection	⌘ + Shift + click layer mask thumbnail	Ctrl + Shift + click layer mask thumbnail
Change Quick Mask color overlay	Double-click Quick Mask icon	Double-click Quick Mask icon
Convert channel mask to selection outline	⌘ + click channel name in Channels palette or ⌘ + ⌥ + number (1 through 0)	Ctrl + click channel name in Channels palette or Ctrl + Alt + number (1 through 0)
Convert layer mask to selection outline	⌘ + click layer mask thumbnail or ⌘ + ⌥ + \ (backslash)	Ctrl + click layer mask thumbnail or Ctrl + Alt + \ (backslash)
Create channel mask filled with black	Click page icon at bottom of Channels palette	Click page icon at bottom of Channels palette
Create channel mask filled with black and set options dialog	⌥ + click page icon at bottom of Channels palette	Alt + click page icon at bottom of Channels palette
Create channel mask from selection outline	Click mask icon at bottom of Channels palette	Click mask icon at bottom of Channels palette
Create channel mask from selection outline and set options dialog	⌥ + click mask icon at bottom of Channels palette	Alt + click mask icon at bottom of Channels palette
Create layer mask from selection outline	Click mask icon	Click mask icon
Create layer mask that hides selection	⌥ + click mask icon	Alt + click mask icon
Disable layer mask	Shift + click layer mask thumbnail	Shift + click layer mask thumbnail
Enter or exit Quick Mask mode	Q	Q
Intersect a channel mask and selection	⌘ + Shift + ⌥ + click channel name	Ctrl + Shift + Alt + click channel name
Subtract channel mask from selection	⌘ + ⌥ + click channel name	Ctrl + Alt + click channel name
Subtract layer mask from selection	⌘ + ⌥ + click layer mask thumbnail	Ctrl + Alt + click layer mask thumbnail
Switch focus from image to layer mask	⌘ + \ (backslash)	Ctrl + \ (backslash)
Switch focus from layer mask to image	⌘ + ~ (tilde)	Ctrl + ~ (tilde)
Toggle link between layer and layer mask	Click between layer and mask thumbnails in Layers palette	Click between layer and mask thumbnails in Layers palette
View channel mask as Rubylith overlay	Click eyeball of channel mask in Channels palette	Click eyeball of channel mask in Channels palette
View layer mask as Rubylith overlay	Shift + ⌥ + click layer mask thumbnail or press \ (backslash)	Shift + Alt + click layer mask thumbnail or press \ (backslash)
View layer mask independently of image	⌥ + click layer mask thumbnail in Layers palette or press \ (backslash) then ~ (tilde)	Alt + click layer mask thumbnail in Layers palette or press \ (backslash) then ~ (tilde)
View Quick Mask independently of image	Click top eyeball in Channels palette or press ~ (tilde)	Click top eyeball in Channels palette or press ~ (tilde)

Paths	Photoshop CS4 Macintosh	Photoshop CS4 Windows
Add cusp to path	Drag with Pen tool, then Option + drag same point	Drag with Pen tool, then Alt + drag same point
Add point to magnetic selection	Click with Magnetic Pen tool	Click with Magnetic Pen tool
Add smooth arc to path	Drag with Pen tool	Drag with Pen tool
Cancel magnetic or freeform selection	Escape	Escape
Close magnetic selection	Double-click with Magnetic Pen tool or click on first point in path	Double-click with Magnetic Pen tool or click on first point in path
Close magnetic selection with straight segment	⌥ + double-click	Alt + double-click
Deactivate path	Click in empty portion of Paths palette	Click in empty portion of Paths palette
Delete last point added with Pen tool or Magnetic Pen tool	Delete	Backspace
Draw freehand path segment	Drag with Freeform Pen tool or ⌥ + drag with Magnetic Pen tool	Drag with Freeform Pen tool or Alt + drag with Magnetic Pen tool
Hide path toggle (it remains active)	⌘ + Shift + H	Ctrl + Shift + H
Move selected points	Drag point with Direct Selection tool or ⌘ + drag with Pen tool	Drag point with Direct Selection tool or Ctrl + drag with Pen tool
Save path	Double-click Work Path item in Paths palette	Double-click Work Path item in Paths palette
Select arrow (direct selection) tool	A	A
Select entire path	⌥ + click path in Paths palette	Alt + click path in Paths palette
Select multiple points in path	⌘ + Shift + click with pen	Ctrl + Shift + click with pen
Select Pen tool	P	P
Make active path a selection	⌘ + Return	Ctrl + Enter

Crops and Transformations	Photoshop CS4 Macintosh	Photoshop CS4 Windows
Accept transformation	Double-click inside boundary or press Return	Double-click inside boundary or press Enter
Cancel crop	Escape	Escape
Cancel transformation	Escape	Escape
Constrained distort for perspective effect	⌘ + Shift + drag corner handle	Ctrl + Shift + drag corner handle
Constrained distort for symmetrical perspective effect	⌘ + Shift + ⌥ + drag corner handle	Ctrl + Shift + Alt + drag corner handle
Freely transform with duplicate data	⌘ + ⌥ + T	Ctrl + Alt + T
Replay last transformation with duplicate data	⌘ + Shift + ⌥ + T	Ctrl + Shift + Alt + T
Freely transform selection or layer	⌘ + T	Ctrl + T
Replay last transformation	⌘ + Shift + T	Ctrl + Shift + T
Rotate image (always with respect to origin)	Drag outside boundary	Drag outside boundary

Crops and Transformations	Photoshop CS4 Macintosh	Photoshop CS4 Windows
Select Crop tool	C	C
Constrain axis	Shift + drag handle	Shift + drag handle

Rulers, measurements and-Guides	Photoshop CS4 Macintosh	Photoshop CS4 Windows
Create guide	Drag from ruler	Drag from ruler
Display or hide grid	⌘ + ' (quote)	Ctrl + ' (quote)
Display or hide guides	⌘ + ; (semicolon)	Ctrl + ; (semicolon)
Display or hide Info palette	F8	F8
Display or hide rulers	⌘ + R	Ctrl + R
Lock or unlock guides	⌘ + ⌥ + ; (semicolon)	Ctrl + Alt + ; (semicolon)
Snap guide to ruler tick marks	Press Shift while dragging guide	Press Shift while dragging guide
Toggle snapping	⌘ + Shift + ; (semicolon)	Ctrl + Shift + ; (semicolon)
Toggle horizontal guide to vertical or vice versa	Press ⌥ while dragging guide	Press Alt while dragging guide

Slicing and Optimizing	Photoshop CS4 Macintosh	Photoshop CS4 Windows
Draw square slice	Shift + drag	Shift + drag
Draw from center outward	⌥ + drag	Alt + drag
Draw square slice from center outward	⌥ + Shift + drag	Alt + Shift + drag
Open slice's contextual menu	Control + click on slice	Right mouse button on slice
Reposition slice while creating slice	Spacebar + drag	Spacebar + drag
Toggle snap to slices on/off	Control while drawing slice	Ctrl while drawing slice
Toggle between Slice tool and Slice selection tool	⌘	Ctrl

Filters	Photoshop CS4 Macintosh	Photoshop CS4 Windows
Adjust angle of light without affecting size of footprint	⌘ + drag handle	Ctrl + drag handle
Clone light in Lighting Effects dialog box	⌥ + drag light	Alt + drag light
Delete Lighting Effects light	Delete	Delete
Repeat filter with different settings	⌘ + ⌥ + F	Ctrl + Alt + F
Repeat filter with previous settings	⌘ + F	Ctrl + F
Reset options inside Corrective Filter dialog boxes	⌥ + click Cancel button	Alt + click Cancel button

Hide and Undo	Photoshop CS4 Macintosh	Photoshop CS4 Windows
Display or hide Actions palette	⌥ + F9	F9 or Alt + F9
Display or hide all palettes, toolbox, status bar	Tab	Tab
Display or hide palettes except toolbox	Shift + Tab	Shift + Tab
Hide toolbox and status bar	Tab, Shift + Tab	Tab, Shift + Tab
Move a panel out of a palette	Drag panel tab	Drag panel tab
Revert to saved image	F12	F12
Undo or redo last operation	⌘ + Z	Ctrl + Z

Viewing	Photoshop CS4 Macintosh	Photoshop CS4 Windows
100% magnification	Double-click Zoom tool or ⌘ + ⌥ + 0 (zero)	Double-click Zoom tool or Ctrl + Alt + 0 (zero)
Applies zoom percentage and keeps zoom percentage box active	Shift + Return in Navigator palette	Shift + Enter in Navigator palette
Fits image in window	Double-click Hand tool or ⌘ + 0 (zero)	Double-click Hand tool or Ctrl + 0 (zero)
Moves view to upper left corner or lower right corner	↖ or ↘	Home or End
Scrolls image with hand tool	Spacebar + drag or drag view area box in Navigator palette	Spacebar + drag or drag view area box in Navigator palette
Scrolls up or down 1 screen	⤒ or ⤓	Page Up or Page Down
Scrolls up or down 10 units	Shift + Page Up or Page Down	Shift + Page Up or Page Down
Zooms in or out	⌘ + + (plus) or - (minus)	Ctrl + + (plus) or - (minus)
Zooms in on specified area of an image	⌘ + drag over preview in Navigator palette	Ctrl + drag over preview in Navigator palette

Function keys	Photoshop CS4 Macintosh	Photoshop CS4 Windows
Undo/redo, toggle	F1	
Help		F1
Cut	F2	F2
Copy	F3	F3
Paste	F4	F4
Display or hide Brushes palette	F5	F5
Display or hide Color palette	F6	F6
Display or hide Layers palette	F7	F7
Display or hide Info palette	F8	F8
Display or hide Actions palette	F9	F9
Revert to saved image	F12	F12

Glossary

Adjustment layer Adjustment layers give you the ability to make non-destructive tonal or color adjustments to underlying image layers. The majority of the usual command-based adjustments are available as adjustment layers, such as Levels, Curves, Hue, and Saturation. The advantages of adjustment layers are twofold. First, you can make adjustment to an image without permanently affecting the layers below, and further adjustments can be made at any point during the image-editing process by simply double-clicking the adjustment layer in the Layers palette.

Alpha channel An Alpha Channel is a special channel in addition to the standard Red, Green, and Blue channels, which stores information relating to pixel transparency. When you save a selection, or add a layer mask, you'll see an Alpha channel in the Channels palette relating to this saved selection or mask.

Anti-alias Anti-aliasing is a method of smoothing the edges of selections in Photoshop to avoid "jaggies" along the edges of copied and pasted image elements. You'll see an Anti-alias option for most of the selection tools in Photoshop, and as a general rule, it's best to ensure this option is selected.

Auto Levels The Auto Levels command automatically adjusts the black and white points in an image, and can be a good quick fix for images which need just a little contrast and brightness adjustments. Auto Levels automatically maps the darkest pixels in the image to 0 (Black) and the lightest highlight pixels to 255 (Pure White). Midtones are distributed throughout the image proportionally.

Background layer When you open an image from a digital camera, it will initially be displayed in Photoshop as a single Background layer in the Layers palette. The Background layer is not a floating layer and you cannot adjust its opacity as you can any other subsequently added layers. The Background layer can be converted to a standard floating layer by double-clicking it in the Layers palette.

Background color The current Background color is indicated by the partially concealed color swatch at the base of the Toolbar. You can easily change the background color by simply clicking on the swatch and selecting a new color from the Color Picker.

Blending modes Blending modes allow you to blend individual layers with the layers below. You select a particular blending mode in the Layers palette. By default, a new layer is always set to Normal mode, where the pixels on the layer have no interaction with those on the layer below. The actual science of blending modes is very complicated indeed, and by far the best method of using blending modes is by trial and error. By experimenting with different blending modes you can often create some very effective and unexpected effects. Blending modes include: Normal, Dissolve, Darken, Multiply, Screen, Hard Light, Soft Light, Color Dodge, Color Burn, Difference, Exclusion.

Blur filters The group of Blur filters can be found via Filter > Blur menu entry. They can be used to generally soften an image or a selection. Blur filters can be especially useful for reducing noise within an image or disguising any artifacts in an image where too much JPEG compression has been applied.

Brush libraries Photoshop is shipped with a selection of additional Brush libraries, which can be accessed via the small right-pointing arrow in the Brush Picker. These sets of brushes range from natural media brushes, through calligraphic versions to special effect brushes.

Brush tool The Brush tool, located in the Toolbar, allows you to literally paint onto an image. You can select many brush footprints for the tool itself and control the size, blending mode, and the opacity of the brush via the Options bar. The brush can also be made to respond to the pressure applied via a pressure sensitive graphics tablet to control size, opacity, and color. The Brush tool always paints with the current Foreground color selected in the Foreground color swatch at the base of the Toolbar.

Clouds filter The Clouds filter creates a random cloud-like fill using random degrees of mix between the current Foreground and Background colors. The filter itself can be used for many effects, the least of these being actually adding clouds to a landscape! The effect of the filter can be softened even more, and made more subtle by blurring the fill after using the filter.

Crop A method of trimming an image to a particular size, using the Crop tool. Cropping an image can also help in terms of composition, cropping out unwanted image elements.

Canvas Size The Canvas Size command adds your chosen amount of extra space around the outside of an image. By default, the size of the available canvas is limited to the actual outer boundaries of the original image. You can choose how much extra canvas to add, and where around the image to add it in the Canvas Size dialog.

Channels A standard RGB image contains three separate color channels, specifically a Red, Green, and Blue channel. Each of these channels is a monochrome representation of which areas in the image contain more or less of that particular channel color. Channels can be treated in much the same way as layers, in the respect that you can make all manner of adjustments to each individual channel. You can even duplicate one or more channels and even merge them together. Via the Channel Mixer command (Image > Adjustments > Channel Mixer) you can control what proportions of each channel are used to make up the RGB image.

Clipboard An area of memory where Photoshop stores copied image data. After using the Edit > Copy command, Photoshop temporarily stores the copied image data here on this virtual clipboard, so that the image data can be used at a later time, for instance by using the Edit > Paste command. All image data in this temporary storage area is lost when closing Photoshop, or by using the Purge Clipboard command.

Copy Accessible via Edit > Copy, this command copies selected image data to the clipboard.

Color picker A color palette where you chose your current Foreground and Background colors from. Using the current Color mode, the picker itself is activated by clicking on the Foreground or Background color swatches at the base of the Toolbar.

Contiguous Contiguous is an option available with the Magic Wand tool. This indicates that any similarly colored pixels must be touching each other or interconnected before they are selected together with the tool. Unchecking this option indicates that similarly colored pixels should be selected together regardless of whether they are interconnected or not.

Dots Per Inch (dpi) The term used to describe the number of dots of ink laid down by an ink-jet printer per inch. You'll often see the Resolution of a printer described as DPI.

Deselect A command available via Select > Deselect which literally deselects or cancels the current selection or Marquee.

Dodge tool A tool which harks back to the days of traditional darkroom techniques which can be used to selectively lighten the tones in a particular area of an image. The effect of the tool itself can be limited to the shadows, midtones, or highlights of an image via the Range Option. The strength of the tool is controlled via the Exposure slider.

Duplicate layer An exact copy of any given layer. A duplicate layer can be created from the current layer via Layer > Duplicate, by right-clicking the layer and choosing Duplicate, or by dragging the layer itself to the

New Layer icon in the Layers palette. It's good practice to always duplicate the original Background layer in an image before any radical manipulation takes place, as this ensures always having a pristine version of the original image available on the Background layer in the event of any mistakes.

Desaturate A method of reducing the amount of visible color and increasing the amount of gray in an image. The command Image > Adjustment > Desaturate completely removes any visible color, while desaturating via Image > Adjustment > Hue/Saturation the amount of visible color can be reduced just partially.

Easter egg A little light relief with humorous images and credits supplied by the Photoshop team, accessible by holding down the Ctrl key while clicking the About Photoshop entry within the Help menu.

Extract A tool or command accessible via Filter > Extract which allows you to extract a particular area of an image layer, designated by outlining and filling the appropriate area within the Extract dialog, and which renders the unwanted areas of the layer transparent.

Eyedropper A tool used to sample colors from an image or from anywhere on the desktop. The sampled color will be used as the current Foreground color. The tool itself can sample the color of a single pixel, or the average color within a predetermined group of neighboring pixels.

Expand Found via Select > Modify > Expand, this command will expand the outer edge of the current selection by 1 to 100 pixels.

Feather A command which softens the edges of a selection by a selectable number of pixels. The pixels around the edge, within the given pixel radius, are made progressively softer towards the outer edge of the selection.

Filters Automated effects available via the Filter menu in Photoshop, which can be used to apply a vast range of preset automated effects ranging from artistic natural media type effects to distortion, brush stroke, and texture variants. Most filters present with a self-contained dialog box from which the variables within the filter can be controlled. The effect on the image can generally be previewed from within the filter dialog before the effect is actually applied to the image.

Flatten The Flatten command, available via Layer > Flatten Image, collapses all visible layers into a single Background layer, enabling the saving of the file to a file type that does not support images containing separate layers, such as JPEG. Once a file has been flattened, the individual layers are no longer accessible, so it's best

practice to save a version of the file first with layers intact as a native PSD file type, and then saving the flattened image under another name.

Foreground color The Foreground color (shown in the foremost color swatch at the base of the Toolbar), is the color which is currently being used to paint with. The Foreground and Background colors can be swapped by hitting X on the keyboard, and their default values are Black for Foreground, White for Background. The default Fore/Back colors can be restore by hitting D on the keyboard. Any color chosen using the Eyedropper tool will be set as the current Foreground color.

Fuzziness The Fuzziness slider, available in the Select > Color Range dialog, controls the degree to which colors matching the current Foreground color are selected by the Color Range selector. A high Fuzziness value will select all colors within an image which are similar to the current color, a very low value will select just those pixels which are a near exact match to it.

Gamma Gamma describe the brightness of the midtone of a grayscale tonal range. In tonal adjustment command such as Curves, the midtone point below the histogram is more accurately described as the Gamma slider.

Gaussian blur One of the collection of Blur filters which can be found via Filters > Blur, also one of the most commonly used Blur filters for accurate and infinitely adjustable blurring on an image or layer. The filter itself blurs an image by applying low frequency detail to the image itself. The name Gaussian is derived from the bell-shaped curve which Photoshop uses for calculating the distribution of the blurring.

Grabber hand Also know as the Hand tool, the Grabber Hand is used to quickly move a magnified image around the screen. It can be quickly accessed simply by pressing the Spacebar on the keyboard, and the image is moved by simple dragging.

Grayscale What we generally think of as the black-and-white display within Photoshop. In this mode, an image can contain a maximum of 256 shades of gray. You can convert a color image to grayscale via Image > Mode > Grayscale. When an image is converted to grayscale, all color information is discarded.

Guides Guides are non-printing lines within Photoshop which can be used for lining up and positioning objects or layers, or for visually dividing the working space. Guides can be simply dragged out from the Ruler bars and positioned wherever you want. Guides can also be moved with the Move tool.

Halftones Halftone images are made up from a pattern of dots, rather than continuous tones of gray, and are commonly used by Laser and Offset printers. The pattern is density of the dots within a haltone print, give the impression of various shades of gray, a lighter density of dots appearing as a very pale gray and dots packed tightly together appearing as near black tones.

Hidden tools Tools which are hidden or nested behind other similar tools in the Toolbar. Hidden tools are indicated by a small arrow next to the currently displayed tool, and can be accessed by simply clicking and holding on the displayed tool.

High key A high-key image is one where the majority of image detail is concentrated in the midtone to highlight areas. High-key images are very soft and flattering in terms of portraiture. A high-key image is easily identified via the histogram, where the majority of pixels will be concentrated towards the right-hand end of the graph.

Histogram A map of the distribution of pixels throughout the 256 levels of brightness within a digital image. The intensity of each level is represented across the graph itself from the darkest at the left to the lightest at the right. The amount of pixels at any particular value is shown by the vertical axis of the graph at that particular point. The graph itself can indicate, amongst other things, whether or not the highlights or shadows in the image are clipped, and this can be corrected by sliding the respective highlight and shadow sliders to the start of the histogram at each of these extremes.

Hue A value which determines the actual color we perceive. In essence, the value which makes Red appear as red, and Blue appear as blue. Where two colors are mixed, the hue changes accordingly. The actual hue of a color within an image can be adjusted via the Hue and Saturation command within Photoshop.

Interpolate To add pixels to increase the physical size of an image. For the actual size of an image to be increased, extra pixels must be added to it, or the resolution decreased. Interpolation is something best avoided if at all possible, as, at best, Photoshop has to guess the color and brightness of the invented pixels, and ultimately this can lead to a decrease in image quality. Interpolation also takes place when a layer is transformed via the Edit > Transform group of commands.

Inverse An option available via Select > Inverse, where the currently selection is literally reversed and unselected areas become selected and vice versa.

Invert Available via Image > Adjustments > Invert, this command literally inverts all of the colors and tones within an image, resulting in what we perceive as a negative image in regard to film photography.

Jaggies Jaggies appear as stepped or jagged edges in digital images, and tend to indicate that the image resolution is too low for the physical size of the image itself. Because of the low resolution, the size of the pixels within the image become too large.

Jitter Available in the Brush Options for controlling the variance and random aspects of a particular brush's dynamics. Opacity Jitter can be very useful when you're using a pressure-sensitive graphics pad and stylus.

JPEG Compression A type of file compression used in the JPEG file format, which reduces the size or weight of the actual file by discarding image data, but maintaining visual quality. Although this form of compression reduces file size very efficiently, it needs to be used with caution, as using too high a compression level, or re-saving a JPEG image many times can result in permanently damaged images. Overuse of JPEG compression can also result in JPEG artifacts visible in the saved image.

Kerning Essentially, kerning is the space between characters in a line of type, as opposed to the space between words. Kerning can be adjusted via the Character palette, displayed via Window > Character.

Knockout Accessed via the layer Blending Options, Knockout is a method of knocking out or hiding part of the tonal range of the current layer or the layers below to expose the content of the Background layer. This doesn't actually destroy any content of the layer, it simply tells Photoshop to regard these areas as transparent in terms of visibility.

Lasso A lasso designates a selected area within an image, enabling changes to be made to this selected area only. The lasso itself is shown by a dotted line, otherwise known as "marching ants." Typically, you would use the Lasso tool to generate this type of selection.

Layers Layers are at the heart of Photoshop image-manipulation and can be thought of as separate sheets of acetate or duplicate images stacked on top of the original Background layer. By using layers, you can manipulate or paint on to an image without actually affecting a single pixel on the underlying layers. When you copy and paste parts of an image, the pasted image data is contained on a new, separate floating layer. Individual layers can be moved within the layer stack in the layers palette, where the topmost layer will always appear to be in front of any underlying layers. When a new layer is added, it is completely blank until image data is added to it. Any parts of a layer which contain no image data remain completely transparent.

Lens flare The Lens Flare filter, accessible via Filter > Render > Lens Flare, mimics the effect of a light shining directly into a camera lens. Within the Lens Flare dialog, you can control the position and intensity of the flare itself, and even reproduce the effect of a flare though lenses of various focal lengths.

Liquify Found under the Filter > Liquify menu, this filter can be used to dramatically distort and smear an image. Within the filter itself you can simply drag with a brush to distort and warp part of an image, or use Pucker and Bloat tools. Traditionally this filter can be used to create surreal caricature-like images, or used very subtly to change a facial expression in a portrait.

Marching ants Marching ants is used to describe the dotted, animated outline around a selection.

Marquee Similar to the above, but this term generally refers to the animated dotted outline around a square, rectangular, or elliptical selection created with any of the Marquee selection tools.

Merge down A way of combining an upper layer with the layer directly below it. With this command, the two layers are merged into a single layer which preserves all of the image data from both layers. Merge Layers will also preserve the transparent areas of the layers where these areas overlap. Merging layers can be useful to reduce the amount of layers in the Layers palette and reduce file size.

Menu The device used for accessing many Photoshop commands. You'll see the various menus across the very top of the Photoshop workspace.

Noise Noise can be thought of as digital grit or grain within an image, and can be used in many forms. The Add Noise filter, available under the Filters menu can be used to add general noise to an image.

Opacity Opacity refers to the extent to which an upper layer obscures the contents of the layer below it. The opacity of the pixels on a layer can be increased or reduced in the Layers palette. By default, a layers pixel content has 100% Opacity, so that any pixels on this layer completely hide the pixels on the layer beneath it, not withstanding the effects of any applied layer Blending Modes. The opacity of some of Photoshop's tools can also be modified, such as the Brush Tool.

Options bar The area in Photoshop, across the top of the workspace, where the various options for the currently selected tool can be modified. These options vary between different Photoshop tools.

Overlay A Color blend mode where black and white are unaffected, and dark areas are darkened and light areas are lightened. Where the blend color is 50% gray it is regarded as Neutral and ignored by the blend mode.

Palette Photoshop uses palettes to contain the essential tool, devices, and components which are used in the image making process. Layers are held in the Layers palette. Each palette can be moved independently around the workspace, and can also be collapsed, hidden, or even grouped together.

Paste An Edit command available via Edit > Paste. Conventionally, this command would be used to paste an area or object into an image after using the Copy command. Paste actually pastes any information held on the virtual Clipboard into the chosen image.

Paths Any shape drawn with the Pen tool. A path is made up of anchor points joined by either a straight or curved line segment. The curved point within a path consist of Bezier curves which feature two direction handles which can be dragged to adjust the actual shape of the curve. A closed path (where both ends of the path are joined) can be converted to a selection. Open paths can be stroked with any of the Photoshop painting or drawing tools.

Pixel A pixel is the very stuff of digital imaging. Any digital Photoshop image, or digital camera image is made up of millions of pixels, each one carrying specific color and brightness information. Although each pixel is a square block of color, when enough pixels are grouped together at a suitable resolution, the human eye interprets the collection of individual pixels an image.

Purge The command used, via Edit > Purge to erase any history of clipboard information from the computers memory. Copied data can take up a lot of available memory, so this command is useful for freeing up this memory capacity.

Quadtones A quadtone is a monochrome image which has been printed using four subtly different process colors to extend the tonal range of a grayscale image. Although quadtones can be created in Photoshop from a standard grayscale image, the images can also be created via the Duotone color mode.

Quick mask An easy and accurate way of creating masks or intricate selections. Quick Mask mode is activated

by hitting Q on the keyboard, and the initial red quick mask can be painted on to the image using any of the Photoshop painting or fill tools. On exiting Quick Mask mode, an active selection is generated, reflecting the shape of the painted mask.

Rasterize Converting a Vector image (made up of paths and shapes) into an image which is made up of individual pixels. When you have applied type to a Photoshop image, or any shape layers, they must first be rasterized before many of the Photoshop filters or painting tools can be used on the layer.

Reselect Found via Select > Reselect, this command will reselect the previous active selection. This can be useful if a selection was deselected in error.

Resolution Describes the number of pixels within a digital image. More specifically, the number of pixels per linear inch of an image. As a general rule, for images destined for print, the resolution of the image needs to be at least 240ppi (Pixels Per Inch). The resolution of an image is increase by crushing the total number of pixels in to a smaller space, thus when the resolution of an image is increase without interpolation the physical size of the image becomes smaller.

RGB color mode The default color mode used within Photoshop. Each RGB image is made up of four Channels, the first three being the Red, Green, and Blue channels—represented by grayscale channels in the Channels palette, each of these describing the proportion of these colors in the image. The fourth channel, the Composite channel is used for displaying the combined RGB channels in color.

Rotate Available via the Edit > Transform menu. With the Rotate command you can rotate any layer (apart from the Background layer), simply by placing your mouse pointer next to a corner on the bounding box and dragging with the mouse.

Saturation Saturation refers to the vividness of any particular color. Just as desaturation removes color, increasing the saturation value of a color makes it move vivid and increases the purity. You can increase the saturatation of colors within an image on a global scale by going to Image > Adjustments > Hue/Saturation and make adjustments to the Saturation slider. To make targeted saturation adjustments, use the Sponge tool.

Similar A selection command located in the Select menu. Once a Color Range or Magic Wand selection has been made, the Similar command will select pixels within the color and brightness range of the selected pixels, but which are not contiguous with these pixels.

Stacking order Stacking order refers to the way layers are arranged within the Layers palette. Any layer elements at the top of the layer stack will appear to be in front of any elements on lower layers in the image itself. The stacking order of the layers in the stack is not fixed, and individual layers can be moved up or down the stack simply by dragging them with the mouse.

Stroke Applying a color, pattern, or gradient to the border of a selection, a path, or a layer. These strokes can be applied with any of the painting tool, via the Edit > Stroke menu or via Layer Styles. Stroking a path with a brush (by right-clicking the path and choosing Stroke) is a very effective way of creating sophisticated line work in an image.

Styles Available via Window > Styles, these are a collection of preset combined layer styles which can greatly enhance objects in an image, such as Type object or fills. The Styles palette itself features many preset styles and other Styles libraries can be loaded via the small right-pointing arrow in the palette.

Threshold A command ideally suited to converting images to high-contrast black and white. The Threshold command, available via Image > Adjustments > Threshold, can be used to modify the darkest and lightest areas of an image, and drastically simplify the image as a whole tonally.

Transform A number of methods of distorting the contents of a layer, available via The Edit > Transform menu. The Transform options include: Scale, Rotate, Skew, Distort, and Apply Perspective. Each of the transformations is made by adjusting the handles around a Transform bounding box. Selections can also be transformed via Select > Transform Selection.

Transparency Parts of a layer which contain no image data are considered by Photoshop to be completely transparent. Photoshop supports 256 levels of Transparency, ranging from a fully opaque color or layer through to completely transparent. Transparency is indicated in Photoshop by a chequerboard pattern, which can be seen around the layers content in the Layers palette, or when the Background layer contains no image data.

Tritones Similar to quadtones, but here, a monochrome image is printed using three similar process color of different tones as opposed to four.

Undo Undo allows you to restore an image, or part of an image to an earlier state. As the Undo command relies on being able to refer back to an earlier History state, the extent of Undo is limited by the number of history states to save, as specified in Edit > Preferences.

Unsharp mask One of the Sharpen filters within Photoshop and one of the most flexible and frequently used. The filter itself works by creating halos around the perceived edges in an image, giving the impression of increased sharpness. Although the filter is very effective, it must be used subtly to avoid these halos becoming too exaggerated and obvious.

USM Unsharp Mask filter.

Vectors Image objects made up a mathematical Bezier curves and paths, such as those created with the Pen tool, or shapes created as Shape layers. The advantage of vectors over images made up of pixels is that vector object are resolution independent and can be enlarged to any size without loss of quality or edge sharpness. Vector objects can be rasterized (converted to pixels), but then become resolution-dependant like any other digital image.

Virtual memory A percentage of the computer's hard disk which an operating system uses as temporary extra memory space when the available RAM memory is full. In Photoshop parlance, this is otherwise known as a Scratch Disk, the capacity and location of which can be specified in Photoshop's preferences.

Warp A method of distorting type in Photoshop. Type can be warped into an arc shape, flag shape, and a number of other custom shapes. The Warp option can be found in the Options bar once the Type tool is activated.

White point The exact point within a histogram where the pixels which are pure white feature. Ideally this point should be directly blow the point in the histogram where the white pixels appear, disregarding any tails in the histogram itself.

Workspaces The arrangement of palette, windows, and tools within the Photoshop interface. Individual and customized workspaces can be saved and later reloaded via Window > Workspace.

Zoom tool The Zoom tool is used to magnify an image within the image window. By default, the tool zooms into the image. Holding down the Alt key while using the tool enables you to zoom out.

INDEX

ACKNOWLEDGMENTS

Tutorials by Duncan Evans: Chemical distortion (p26), Extreme color and contrast (p28), Creating high-key pictures (p44), Low-key portraits (p46), Background lights (p52), Changing eye and hair color (p66), Instant studio backgrounds (p80), Diffuse effects (p88), Vignettes (p90), Mellow monochrome (p102), Early Hollywood (p116), Classic Hollywood (p118), Film Noir (p122), Shoot like Bailey (p126), Newtonesque (p128), 1980s New York look (p130), Swannell style (p132), Portraits in oil (p136), Watercolors (p138), Digital frames (p150), Adding Edges (p152).

Tutorials by Tim Shelbourne: Extreme shadows and highlights (p20), Creating HDR portraits (p22), Colored filters (p24), Cross processing (p30), Hand coloring (p32), Split toning in Adobe Camera Raw (p34), Isolating color (p36), Restoring burnout (p40), Adding directional lighting (p42), Dramatic lighting (p48), Adding candlelight (p50), Multicolored lighting (p54), Turning day into night (p56), Creating silhouettes (p58), Correcting facial blemishes (p62), Changing expressions (p64), Human canvas (p68), Turning back the clock (p70), Advancing the years (p74), Improving holiday photos (p78), Cropping for effect (p82), Body abstract (p84), Depth of field (p86), Super wide-angles (p92), Mirror image (p94), Moody portrait (p98), Halftone black and white (p100), Adding grain and texture (p104), Diffuse glow (p106), Ultimate black and white (p108), Graphic black and white (p110), Aging photographs (p114), Warhol (p118), Charcoal Portraits (p140), Adding smoke and mist (p142), Stained glass (p144), Out of the frame (p154), Foreign holiday (p156), Medal (p158), MP3 silhouette (p160), Photo mosaic (p162), Swapping heads (p164), Restoring old family photos (p166), Goldfinger (p168), Film star poster (p172), Gothic horror (p178).

Duncan Evans would like to acknowledge the assistance of the following excellent models in the creation of some of these tutorials: Yvonne McKay for Newtonesque, Forties Hollywood, and Soot and whitewash (website: www.yvonnemckay.com); Billie Lister for Early Hollywood and 1980s New York look (email: Billie@billiemodel.co.uk, website: www.billiemodel.co.uk); Tryste for Classic Hollywood and Swannell style (website: www.visual-graffiti.com); Linnea for Portraits in Oil and Adding Edges (email: linnea_kvalheim@hotmail.com, website: http://Linnea.net-model.com).

Tim Shelbourne would like to thank: Bibs—couldn't have done this without you babes! Got a great team around me. Many thanks also to Mick and Marion Shelbourne, Elsie King, Duncan, Paul and Sandra, Robert, Uncle Dennis and Welly, and Susannah Fields at www.flashfields.com. Thanks also go to everyone who helped with the project and all models and sitters featured.

Picture Credits: Susannah Fields/Flashfields Photography supplied start images for Aging photographs, Candlelight, Colored filters, Cooling down, Cross processing, Day to night, Diffuse glow effects, Film star poster, Hand coloring, Multicolored lighting, Restoring burnout.

ONLINE RESOURCES

Note that website addresses can change, and sites can appear and disappear almost daily. Use a search engine to help you find new arrivals or check old addresses that have moved.

123di
www.123di.com

Adobe (Photoshop, Illustrator)
www.adobe.com

Alien Skin (Photoshop Plug-ins)
www.alienskin.com

Apple Computer
www.apple.com

Canon
www.canon.com

Casio
www.casio.com

Corel (Paint Shop Pro)
www.corel.com

Digital camera information
www.dpreview.com

Epson
www.epson.co.uk or www.epson.com

Extensis
www.extensis.com

Formac
www.formac.com

Fractal
www.fractal.com

Fujifilm
www.fujifilm.com

Hasselblad
www.hasselblad.se

Hewlett-Packard
www.hp.com

Iomega
www.iomega.com

Kingston (memory)
www.kingston.com

Kodak
www.kodak.com

LaCie
www.iomega.com

Lexmark
www.lexmark.co.uk

Linotype
www.linotype.org

Luminos (paper and processes)
www.luminos.com

Microsoft
www.microsoft.com

Nikon
www.nikon.com

Nixvue
www.nixvue.com

Olympus
www.olympus.co.uk
www.olympusamerica.com

Pantone
www.pantone.com

Pentax
www.pentax.com

Philips
www.philips.com

Photographic information site
www.ephotozine.com

Photoshop tutorial sites
www.planetphotoshop.com
www.ultimate-photoshop.com

Qimage Pro
www.ddisoftware.com/qimage/

Ricoh
www.ricoh-europe.com

Samsung
www.samsung.com

Sanyo
www.sanyo.co.jp

Sony
www.sony.com

Sun Microsystems
www.sun.com

Symantec
www.symantec.com

Wacom (graphics tablets)
www.wacom.com